From
Knowledge

to
Narrative

From
Knowledge

to
Narrative

*Educators
and
the
Changing
Museum*

Lisa C. Roberts

Smithsonian Institution Press
Washington and London

© 1997 by the Smithsonian Institution

Editor: Jenelle Walthour
Designer: Martha Sewall

Library of Congress Cataloging-in-Publication Data
Roberts, Lisa C.
 From knowledge to narrative : educators and the changing museum /
Lisa C. Roberts.
 p. cm.
 Includes bibliographical references and index.
 ISBN 1-56098-706-5 (pbk. : alk. paper)
 1. Museums—Educational aspects—United States—Case studies.
2. Museum exhibits—United States—Case studies. 3. Chicago Botanic
Garden. 4. Museum exhibits—Illinois—Chicago. I. Title.
AM11.R63 1997
069'.0973—dc21 96-37617

British Library Cataloguing-in-Publication Data is available

Manufactured in the United States of America
04 03 02 01 5 4 3

⊗ The paper used in this publication meets the minimum requirements of the
American National Standard for Information Sciences—Permanence of Paper for
Printed Library Materials ANSI Z39.48-1984.

For museum educators

Contents

Acknowledgments

This book marks the culmination of a train of thought that began some twenty years ago. Over the years, it has taken shape with the help of a great many people.

Perhaps more than anyone else, I wish to acknowledge my teachers. Jim Farrell, Neil Harris, and Jonathan Z. Smith all gave more to me than they will ever know.

I am indebted to several people for their careful reading of chapter drafts. Deborah Howes, Carmen MacDougall, Britt Raphling, Danielle Rice, and Beverly Serrell made many insightful contributions to these pages. Numerous other friends and colleagues gave generously when input and direction were needed.

Throughout the course of this study Sue Brogdon, my supervisor at the Chicago Botanic Garden, provided unfailing support that, in many ways, made possible its completion.

Also from the Chicago Botanic Garden, the Linnaeus exhibit-team members deserve acknowledgment for their subjection in these pages to such intensely close, public scrutiny. Each, in their own way, has earned my deepest regard for their respective professional endeavors.

Finally, I wish to thank my family, who stood by me no matter where this train of thought seemed to lead. It is with special gratitude that I acknowledge the one person who was there through thick and thin—my husband and favorite museum companion, John.

Introduction

One summer day in 1988, six museum staff members at the Chicago Botanic Garden met to discuss the creation of an upcoming exhibit. What made the occasion noteworthy was that a group had been given responsibility for the exhibit's development. What made it historic was that an educator was a part of the group.

Once the sole purview of curators or designers, museum exhibits throughout the country have begun to be opened to a new kind of expertise—that of educators. The 1980s were watershed years, as increasing numbers of educators began to sit at exhibit-development tables. How they came to be there and what their presence means is a story about the transformation of the museum institution.

Histories of museums have typically focused on collectors, founders, and visionaries. Although education has been a cornerstone of many institutions, it has never received an adequate place in the historical record. It is only in this century, after all, that staff and departments devoted solely to education have begun to appear in museums. Even then, education has often remained the poor stepchild to such other museum operations as collection, research, and display.

That situation has begun to change. Growing professionalism—along with a climate whose watchwords include accountability, customer service, and educational reform—has made education a serious and central function in museums. It has also increased the pressure on educators to

prove that they can rise to their task, which has itself become a complicated matter. Today's museum educators do more than educate. They are involved in a whole host of activities that relate broadly to education and audiences: for example, program and exhibit development, school field trips, teacher training, continuing education, community outreach, volunteer management, visitor studies, and fundraising.

Despite this expansion of activities, professional-training requirements have lagged far behind. Museum educators come from every background imaginable. The typical career track begins with a foot in the door, usually volunteering or doing low-level work and then gradually moving up the ladder. Until certification requirements are established, this trend will likely continue.[1] In the meantime, the number of educators and their influence continue to grow.

This book tells the story of education in museums. It is a story about the emergence of a new profession,[2] and it is the story of a revolution—in values, knowledge, and power. Museum educators are charged with a responsibility that, on the surface, appears straightforward but actually holds radical implications for what a museum is. Educators have brought visitors' perspectives to bear on the treatment of collections: how they are displayed, what is said about them, and who does the saying. In doing so, they have raised questions about such core tenets as the sanctity of objects and the authority of curators. By insisting on more shared authority over objects and what they represent, educators have given visitors a voice in determining the significance of collections that as a public trust belong to them and to their communities. As a result, traditional scholarly definitions of objects are beginning to be accompanied by or replaced with alternative interpretations based on different criteria of meaning.

The significance of these changes is considerable. They mark the occurrence in museums of a major shift in thought, one that has touched nearly everyone in the business of knowledge. The once prevalent view that knowledge is objective and verifiable has been widely challenged by the notion that knowledge is socially constructed and shaped by individuals' particular interests and values. Language about facts and certainties has been replaced by language about context, meaning, and discourse. Reactions to this shift in perspective have been predictably divisive: where proponents see the inclusion of marginalized voices, critics find the erosion and the politicization of standards.

This shift has important implications for what museums are and do. It would appear that these onetime Towers of Babel comprise, as foretold, not a synopsis of wisdom but a multitude of voices. Theirs is an enterprise that is concerned less with knowledge than with narrative. Indeed, in museums it has become fashionable to speak of the making of meaning by staff, by visitors, or by anyone who holds a relationship to museum collections. Objects, it follows, hold multiple stories and meanings, and, depending on the context, all of those stories and meanings are potentially valid.

The problem with this thinking is that it opens the arena of knowledge to a kind of rampant relativism, where standards of truth become subject to the vagaries of experience. It also calls into question the role of museum educators, whose responsibility traditionally has been to help interpret collections to visitors: if no one meaning is privileged over another, why not just let visitors be and experience our collections as they will?[3]

That question is not an easy one. It has to do with the role of education in a world where knowledge is not transmitted but produced. Far from eradicating the need for education, however, new views of knowledge have rendered it more acute. Now, the task of education is about not just interpreting objects but also deciphering interpretations—in other words, anticipating and negotiating between the meanings constructed by visitors and the meanings constructed by museums. This may be a rather unorthodox definition of education, but it is one that accounts for the existence and the legitimacy of multiple meanings.

This, then, is a significant moment in museum history, for both museum educators and the institution as a whole. Educators are at the forefront of what can only be described as a paradigm shift in museums from Knowledge to knowledges, from science to narrative. Educators also stand to play an important part in adapting the institution to this change.

This book addresses the role of educators in bringing about these changes. More specifically, it addresses the role of educational *perspectives*—from no matter whom the museum professional. Up until now those perspectives have remained largely absent from museum studies literature. This is not to say that educators have not been actively publishing their work, but that their publications have tended to be grounded in quite practical needs and, with few exceptions, do not reflect a broader critical or historical tradition.[4] Most of the critical commentary produced

in recent years has emanated either from the academic establishment[5]—which while strong theoretically, often lacks a practical foundation—or from museum practitioners themselves,[6] who speak from a largely discipline-based perspective. An intriguing body of criticism also has been produced by artists reflecting on the relationship between museums and art.[7] As provocative as all of this work is, it largely overlooks the view of the one group that has been the most active in enacting change: museum educators.

Simultaneously a history, an ethnography, and a critique, this book uses a real-life example of exhibit making to reflect on the current situation in museums and analyzes that process within the wider historical and philosophical context from which it arose. Although the exhibit at the Chicago Botanic Garden is but a small example, it embodies a number of classic tensions resulting from the involvement of educators in the exhibit-development process. By linking the particular to the general and the present to the past, this book illuminates a range of complex issues confronting museums as they approach the new millennium.

In general, museums' educational mission to teach viewers about the collections has remained unchanged for some two hundred years. Within their broad directive, there has been room for enormous variation in content, aims, and methods. These variations, however, always refer back to the core issue of the modern idea of museum education: the nature of museums' responsibility to the public.

Museum education is a distinctly American idea.[8] Most European museums remained enclaves for the scholar or the elite well into the nineteenth century. It was in the newly established museums of revolutionary America that the doors were fully opened to the general public. The first use of the term "education" in museum charters was a politically savvy means of promoting democracy in a republic: equality for all through rational enlightenment. In a newly founded nation with a dearth of schools and a flood of immigrants, museums became what one historian called "great engine[s] of democracy," teaching citizens civic virtue, cultural nationalism, and love of God all through the laws of nature laid out before them.[9] The very idea that museums had a responsibility to the general public was thus born of the same thought that had produced a new nation by, for, and of the people.

In the years that followed, this peculiarly American dictum of "education for the people" would be interpreted in many ways, as the nation's changing social and economic fabric brought new kinds of interests to the fore. From amusement to instruction to simple exposure, education in museums took many forms, while reflecting a particular institution's fluctuations in calling—from popularization to scholarship and back. Just for whom education was intended and what it meant to museum proprietors is an important part of the history this book presents. For that history contains the roots of our modern notions and dilemmas about the nature of museums' responsibility to the public.

With the first appointments of staff "instructors" in museums and the initiation of research studies in the 1920s and 1930s, museum practices for the first time began to be subject to rigorous testing and revision. The possibility of establishing patterns and guidelines for museums brought a whole new set of considerations to the meaning of education and changed its practice forever. Early studies tended to focus on the museum setting, examining how such different variables as exhibit layout, number of artifacts, and guidance devices influenced the educational effectiveness of exhibits.[10] Later studies began to focus on the visitors themselves: who was coming to museums, why they were coming, and what they were learning.[11]

By the end of the 1970s visitor studies had become if not yet widespread at least more common. While they continued to be employed as a tool for improving exhibits and other visitor services, they began to reflect a subtle but critical change. Questions about what visitors learned from exhibits began to shift away from the mechanics of exhibit design to the complexities of visitor experience. "Psychographics" replaced demographics as researchers dove into what they now saw to be the heart of the museum encounter: the interests, needs, attitudes, and values that shaped the way visitors experienced an exhibit.[12]

The implications of this approach to exhibit development were more than technical. They reflected an expanded notion of education that took into account the visitor's background and experience. In short, education was no longer a matter of "filling an empty vessel" but a two-way process whose outcome was unavoidably shaped by what the learner brought to it. Studying this process inspired the adaption to the museum environment of new approaches from the psychological, anthropological, and

social sciences. By the end of the decade "visitor studies" became a sub-profession in its own right.[13]

Two tasks—one political and one scientific—dominated museum education's coming of age in the 1980s and set the stage for understanding its current state. Educators' success in making museum collections more appealing to potential users gave them a solid political foothold in the institution. It also raised old tensions between the two extremes of reaching a general audience and producing scholarship. From a marketing standpoint, education departments' activities made for terrific public relations. From a scholarly standpoint, they left something to be desired. Many curators, long the executive authorities over museum corridors, resisted activities that they felt threatened to trivialize the collections. The result was a situation that pitted the needs of the visitor against the tradition of the collection.[14] Practices like displaying things that visitors could handle (for example, a "touchcart" of bones and feathers in a natural history hall)[15] or that provided familiar links (for example, displaying a cradle next to an Indonesian baby sling)[16] were intended to demystify the inherent strangeness of so many museum collections. To many curators, however, practices like these threatened to mislead visitors and to undermine their own specialized skills and responsibilities. As one historian lamented,

> The establishment of education departments in museums was, in my not-so-humble opinion, one of the more serious errors that museum trustees and staff have made in this century. It has allowed curators to abandon their teaching responsibilities and has exposed visitors to those staff members who are the least well prepared to explain and interpret our collections.[17]

Criticism was coming from outside as well. In 1986 the J. Paul Getty Center for Education in the Arts commissioned a study assessing the state of museum education in U.S. art museums. The result was a deeply critical, widely publicized, highly controversial report. *The Uncertain Profession* sketched a portrait of a field with neither clearly stated aims nor a solid intellectual base.[18] Whether or not the report gave a fair assessment, the museum community, thrown into discussion and debate, was sharply divided.[19]

Even the popular media jumped on the critical bandwagon, decry-

ing a general loss of purpose that it claimed resulted from museums' trying to be all things to all people:

> Over the past 25 years the museum has been told by ideologists that, as a progressive institution, its galleries must be open to ethnic, folk, and political art. It has been told by public officials to display popular works, in every part of the country (even on buses and trains if necessary) if it wishes to retain public funds as a representative, democratic institution. . . . The museum has been told that art is not just art, it can also assist in therapy, crime control, welfare programs, economic development, and income redistribution, serve as an educational tool, and act as part of the entertainment industry. And, in almost every case, the museum has 'responded.'[20]

While this diffusion of mission is a problem of the institution as a whole, it is to educators—with their self-proclaimed expertise about visitors—that the responsibility falls when it comes to bringing museum collections to new audiences and ends.

It is these politics of display that stand at the heart of educators' scientific task as they continue to collect evidence that supports visitor-centered approaches to interpretation and design. The biggest challenge to this endeavor, however, comes not from without but from within, as educators struggle over the implications this evidence has for their work. On the one hand, the scientific study of visitor learning and behavior has given educators an important boost in the museum establishment. It has validated many of their positions and has given them credibility in an institution that has been largely governed by scientists and scholars.

On the other hand, this scientific voice has revealed aspects of visitor experience that are less readily subject to its examination. While experiences such as social interaction, private reverie, fantasy, and play are hardly new, their role in the learning process has begun to be examined more closely by researchers.[21] In so doing, they have raised questions about what is museum education's rightful arena and whether scientific inquiry is the best way of continuing to promote it. Does museum education include *any* experience that somehow broadens one's vista? How does attention to other intangible, affective ways of knowing that elude strict scientific description alter either the meaning or the task of education? Is the museum setting—informal, self-paced, three-dimensional, and multisensory—even suited to the kind of linear, cognitive thinking that

characterizes traditional educational endeavors? What if visitors generate meanings from objects that are different from the interpretations presented by the museum?

It may be that the term "education" has become too restrictive and misleading for the museum setting.[22] In fact, there has been a conscious shift toward the use of language like "learning" (emphasizing the learner over the teacher),[23] "experience" (emphasizing the open-endedness of the outcome),[24] and "meaning-making" (emphasizing the act of interpretation).[25]

Ultimately, however, the issue is more than semantics. It has to do with defining a new category of activity while remaining tied to old patterns of thought and language. But old habits die hard—especially when they permeate the very fabric of an institution. Museums have by tradition upheld an information-driven way of knowing that is accredited by established standards of proof and reliability. To allow for and even to encourage alternative ways of interpreting and experiencing collections represents a challenge not only to museums' power and authority over the object and its display but also to the very basis and credibility of the knowledge that museums presume to possess.

This is quite a cross to bear, especially considering that educators initiated their crusade simply to make museum collections more intelligible. But "intelligibility" has turned out to be not so simple a matter. It has led to the question, "Intelligible according to whom?" It has also raised issues about the basis of knowledge that hold far-reaching consequences for not only the business of education but also the operation of museums as a whole.

Each generation must ask and deal with anew questions about education in light of the conditions and events of the day. Ours is no different. Analysis of education's nature and role in today's museums must refer to real circumstances that give meaning to the question. To anchor such an analysis in the everyday realities of museum education, this book takes as its springboard the primary activity of museums' educational mission: exhibition.

Exhibits are the heart of the museum's public face. They comprise the primary vehicle by which visitors encounter collections. Exhibits also evidence the manifold decisions regarding artifact choice, setting, and

interpretation. These decisions stand on fundamental notions about what it means to educate, what it means to know, and what it means to hold authority to represent knowledge at all. Exhibits, then, may be said to constitute an artifact in their own right, capturing a moment in museum history characterized by its own peculiar interests and assumptions.

This book analyzes a single exhibit in order to explore the assumptions and the debates about education that are buried within its panels. This particular, concrete example thus serves as a vehicle for exploring more universal problems related to defining the nature and role of education in museums.

Two considerations guided my choice of an exhibit appropriate for such an analysis. First, the exhibit had to be contemporary so that it would adequately reflect current tides, issues, and concerns. Second, it had to have available as complete a record as possible of the debates and the decisions surrounding its development. These considerations led me to a recent exhibit in whose development I had participated: "Linnaeus: Lessons and Legacy" at the Chicago Botanic Garden.[26] This exhibit marked the first time the Garden employed a team approach to exhibit design. For the first time, an educator was given authority equal to that of the curator and designer, and for the first time, differences in viewpoints were expressed and explored. The exhibit thus presents early "raw footage" of an institution grappling with diverse professional perspectives on exhibit development. These perspectives and the tensions between them are manifest in the decisions and compromises that resulted in the exhibit's final face. Different perspectives dominate different moments of the exhibit. It is these moments that are the subject of this book: for they embody stories of conflict and compromise that stand on fundamental notions about what it means to educate.

As the writer, my role was by definition nonpartisan. It was my job to translate the exhibit's goals as defined by the exhibit team into copy that was scientifically accurate, educationally sound, technically feasible, friendly, and inviting. My role was not so much to espouse my own views as to represent and to negotiate those of three participating specialties: taxonomy, education, and design. As a result, I became intimately acquainted with the particular debates that arose among differing perspectives. It would belie me to claim that I remained a completely neutral player in this role; it was I, after all, who represented each position through my

own words. But having stood in each team member's shoes, indeed having worn them thin, I became sensitive to the nuances of their special interests and views.

This study draws on three different methods of analysis, two of which have an established participatory tradition. First, it uses ethnography, in that the data includes the voices and actions of the exhibit team (or "culture," if you will). While ethnographic analysis grew out of the study of "other" peoples and cultures, it has also been applied to the study of social settings as diverse as scientific laboratories, school classrooms, and street gangs.[27] Its descriptive power is enormous, encompassing everything from belief systems and behaviors to relationships and rituals. The story of the Linnaeus exhibit is in part a story about the belief systems, behaviors, and relationships of the exhibit team.

While ethnographic fieldwork traditionally conjures the image of a dispassionate, outside observer, there has evolved a school of thought contending that the observer must enter and even participate in the culture to fully comprehend it. This approach emerged from the recognition that prolonged immersion can provide a deeper understanding of phenomena.[28] In the case of the Linnaeus exhibit, it also made possible the inclusion of data that rarely makes it into the archives—the troubleshooting, the impromptu meetings, and the discussions at the coffee machine.

Second, this study employs literary criticism, in that it treats the physical exhibit as a "text." One of the most significant developments in literary theory in recent years has been the expansion of the definition of a "text" to any signifying system, including nonliterary genres such as fashion, architecture, and even exhibits. This idea holds that, like language, entities such as these function as systems of signs and thus bear messages that can be subject to interpretation and critique.

Analysis of those messages itself becomes constructed meaning. In other words, the interpretation of a text is necessarily the product of an interpreter who crafts it. One of the key features of literary theory is its insistence on the productive nature of knowledge and meaning, be it by the text's original creator or by its consumers (readers, viewers, and critics). In analyzing the manifest content of the Linnaeus exhibit, this book uncovers a subtext of messages that have to do with assumptions and attitudes about museum education. Shaped by particular questions and concerns, it is one interpretation of the exhibit among many.

Finally, this study uses historical analysis, in that it refers to the circumstances of the past in order to distinguish and to characterize those of the present.[29] By remembering the events and conditions that preceded today's, it is possible to illuminate not only how different but also how similar some circumstances may be. It is also possible to situate the Linnaeus exhibit in the larger tradition from which it arose and within which it now takes its place.

By employing these three methods together, this book puts into practice one of its central theses: that meaning arises out of multiple contexts. The Linnaeus exhibit is simultaneously the product of its makers' intentions, a critic's interpretations, and its historical context. It is also, by virtue of this analysis, now an exemplum of and a statement on museum education's current state.

"Linnaeus: Lessons and Legacy" was developed at the bequest of Frances Hooper, a Linnaean devotee and collector, who along with eight other donors had contributed funds toward refurbishing a public meeting room to be named after the great naturalist. The Garden allotted monies to the development of an exhibit for the room's walls, and in July 1988 an exhibit team was assembled to begin work.

The team was composed of six staff members. The director of education served as project director; in addition to the writer, the various specialists were represented by a taxonomic botanist, a manager of education, a manager of exhibits, and a graphic designer. The group met on a biweekly basis until the exhibit's opening on Linnaeus's birthday, 23 May 1989.

It was decided early on to target the exhibit toward schoolchildren. The room in which the exhibit was to be installed easily lent itself to use by visiting classes. Furthermore, despite the fact that it was located just off the building's main thoroughfare, it was constantly overlooked by visitors passing through. As a result, the general visitor was considered only a secondary target audience. Over the ensuing months, these considerations fed into the development of exhibit goals, which were based on the exhibit's expected use as well as Mrs. Hooper's wish to honor Linnaeus.

Five exhibit goals were established:

1. Visitors will recognize the contributions of Carl Linnaeus to the plant world.

2. Visitors will realize that Carl Linnaeus brought order to a time exploding in scientific knowledge and exploration through his sexual system of plant classification.
3. Visitors will become involved in the process of classification in order to understand how plants are studied and named.
4. Visitors will understand the importance of binomial nomenclature and how plants are named today.
5. Visitors will realize the application of this system to the organization of the plant world today.

The resulting exhibit consists of two major parts: a wall panel twenty-eight feet long that presents Linnaeus's three major contributions to plant taxonomy: classification, nomenclature, and identification (Linnaeus's "Lessons"); and a twenty-six-foot long panel and display cabinet that compares science in the past and in the present (Linnaeus's "Legacy"). These two panels are situated at right angles to one another and display text, illustrative graphics, photographs, models, interactive demonstrations, a botanical print, and ancient and contemporary objects.

"Linnaeus: Lessons and Legacy" is one small artifact from one moment in history. But embedded in its panels is evidence of problems and issues that are raised by taking seriously educators' perspectives. The work of detecting and interpreting that evidence follows a particular format, which is less a chronicle than it is a series of snapshots. Each chapter begins with a close look at one exhibit component, presenting an account of its preliminary versions along with the debates surrounding its development. These accounts are primarily descriptive. While it was tempting to critique them, they are included not so much to assess the development process as to identify points of contention and debate.

These debates dramatize some key issue in the field, which is itself then situated in a larger historical and critical tradition. Four exhibit components illuminate four issues, each of which penetrates at successively deeper levels the central question of the book—how has the establishment of the museum education profession changed the institution? The story line of this book, then, is structured not around the chronology of the exhibit's development but the subtext of issues the exhibit illustrates.

Chapter 1, "Education as Entertainment," deals with the museum as an institution with particular purposes, responsibilities, and methods of

operation. It introduces a conflict that has stood at the heart of the American museum—scholarship versus popularization—and traces that conflict's various permutations throughout its history. With the emergence of professional museum educators in the early twentieth century, that conflict was transformed forever, as were the political and organizational structures by which museums had traditionally operated. The first chapter, then, concerns itself with shifts in the division of labor, and in particular, with their effect on the definition of education in museums.

Chapter 2, "Education as Empowerment," delves deeper and looks at how those shifts in organization led to more subtle but no less transformative shifts in the nature of authority and knowledge in the institution. These changes are traced through the various approaches that museums have employed to interpret their collections throughout the last century. They offer a glimpse into museums' evolving stance toward the meanings of objects, the authors of those meanings, and the visitors who view them.

Chapter 3, "Education as Experience," peels back yet another layer and inquires into how the nature of the visitor's experience has been altered by these changes. If the presence and activities of educators has affected the nature not only of the institution but of the objects it displays, the question of how visitors have begun to encounter both museum and object must be raised. This is perhaps the most elusive question addressed in these chapters, as it is concerned with nothing as accessible as organizational structure or interpretive method but with the nature of inner experience. Furthermore, it concerns itself less with the conscious experiences that visitors report than the unconscious factors that help explain their attraction to today's museums and exhibits. It draws its evidence largely from historical and ethnographic studies about how people experience objects, and its findings are subsequently applied to the museum setting.

Chapter 4, "Education as Ethics," takes a step back from the first three chapters. It examines the ethical problem of selecting and presenting interpretations in a world that admits multiple points of view. In particular, it analyzes the ways museum activities are by nature ideologically bound and the problems that this poses to their professed responsibility to society's whole range of constituencies. Having moved successively through the institution's working layers to the heart of the visitor experience, then,

the book returns full circle to analyze the museum's role in directing and shaping that experience.

Finally, Chapter 5, "Conclusion: Education as a Narrative Endeavor," summarizes the implications of these analyses for our understanding of education's definition and role in museums. It demonstrates the sense in which education is fundamentally a meaning-making activity that involves a constant negotiation between the stories given by museums and those brought by visitors. As such, it suggests some alternative methods and models for understanding the museum experience as a way of overcoming the inevitable connotations that the word "education" carries. Further, it suggests the institution's gradual transformation into a new sort of genre that is based less on objects as it is on experience.

Ultimately, the aim of this book is twofold: to demonstrate that the emergence of museum educators as a forceful presence has raised questions about value and interest that have rocked the very core of their institutions; and to suggest that these questions in turn hold serious implications for what it means to educate. By studying the peculiar vagaries of a single exhibit, *From Knowledge to Narrative* addresses questions about the nature and role of education in museums as they arise and become problematic. For only thus do the issues of professional and institutional identity become meaningful.

1

Education as Entertainment

I f there is one part of the Linnaeus exhibit that might be viewed as its centerpiece, it is the section on classification. This segment represents the heart of Linnaeus's lessons and legacy, because his system of classification became the cornerstone of modern plant taxonomy.

Beyond its historical significance, Linnaeus's system is an appealing subject for exhibition because it can be readily presented to a wide variety of learners. Classification is among the most basic and universal of human activities. It is the fundamental organizing principle by which infants first distinguish their surroundings; it is also the process by which people sort everything from laundry to knowledge. Classification, in short, is how humans bring order to the world.

The subject thus lends itself to a variety of interpretive approaches. In the Chicago Botanic Garden exhibit these approaches had to lead to Linnaeus's system of plant classification and its superiority to preceding systems. But the opportunity was there to introduce viewers to the concept in a manner that was consonant with their own experience—particularly since this was an experience that exhibit developers could be confident that all viewers shared. How are two things the same and how are they different? These are questions that even four- to five-year-olds could reasonably handle; and in fact, classification was one of the few botanic topics that was treated in the educational classes of Garden's youngest visitors.

The classification panel is the largest of the three topic panels spanning the first wall. Titled "Classifying: Making order out of chaos," it begins thus:

> We organize the world through the activity of classification.
>
> Classification involves judging whether two things are the same as or different from one another.
>
> You do it when you match your socks. Botanists do it when they study plants. Many characteristics can be used for judging "sameness" or "difference": size, color, shape, even smell.

Following this text are six photographs of flower heads: a white trout lily, turk's cap lily, large-flowered trillium, Siberian squill, crown imperial, and blue pearl tulip.

> How would you group these six plants?
> By color?
> By whether the flower faces up or hangs down?
> By the number of flowers per plant?

To see each of these possible groupings, viewers lift a hinged label under which the six plants are organized first into three groups of orange, blue, and white flowers; second into two groups of flowers facing up and flowers facing down; and lastly into two groups of single flower heads and multiple flower heads. The text continues:

> Can you imagine how many ways it is possible to group the more than 300,000 types of plants on our planet?
>
> Can you think of any other characteristics that might be used to group these plants? Linnaeus did. . . .

Two short sections follow. The first deals with Linnaeus's solution to grouping: by the number of a plant's reproductive structures. Viewers discover that by this criterion, all of the six plants pictured belong to the same group: Liliaceae, or plants with six stamens and one pistil.

The next section deals with the reasons that reproductive parts are the best structures for classifying plants: observing reproductive parts is a simple matter of counting; and unlike other characteristics, such as color or shape, reproductive structures vary little from one individual or generation to the next.

A final "tabloid" completes the panel with a series of amusing quotes alternately supporting and criticizing Linnaeus's proposal for a classification system based essentially on sex. Blaring headlines are followed by short "articles":

Enough! Says Goodenough
"To tell you that nothing could equal the gross prurience of Linnaeus's mind is perfectly needless. A literal translation of the first principles of Linnaean botany is enough to shock female modesty. . . ." (Rev. Samuel Goodenough)

Dr. Siegesbeck Outraged!
"[Such] loathsome harlotry would not be permitted in the vegetable kingdom by the Creator. . . . Who would have thought that bluebells, lilies, and onions could be up to such immorality?"

Linnaeus Strikes Back!
In response to charges that he had offended the vegetable kingdom with his "lewd" sexual allusions, Linnaeus yesterday announced that a small-flowered, unpleasant weed would henceforth be called *Siegesbeckia orientalis,* after his nemesis Johann Siegesbeck.

Gronovius Defends Linnaeus
". . . [Linnaeus's taxonomic tables are] so eminently useful that everybody ought to have them hanging in his study, like maps."

Kerner Concurs
"Even laymen studied the Linnaean system with enthusiasm, and it was recommended especially to ladies, as a harmless pastime not overtaxing to the mind."

Of these four sections, the first one, which introduces the concept of classification is by far the most important. The final version detailed here, however, is a far cry from the exhibit's original conception. Only the barest mention is made of visitors' own experiences with classifying: matching socks. Initially conceived as an opportunity to draw on such experiences, the section had become the first testing ground for two distinct approaches to reaching visitors. These two approaches are the subject of this chapter: education versus entertainment.

When first faced with presenting Linnaeus's system of plant classification, the exhibit team decided to focus on the essence of the classification

process as it is employed in any situation. Borrowing a method used in the children's education classes, team members conceived the idea of a game in which viewers would organize a series of disparate objects into groups. Virtually any sort of object could serve the exercise inasmuch as any object could be broken down into and grouped by its component colors, shapes, and so on. Toy blocks, generic flowers, and even the letters of the alphabet were considered.

Two outcomes were crucial to the game's success. First, visitors would have to group the objects themselves so that they could engage directly in the process of observing and comparing. Second, in so doing they would discover that the objects could be grouped in numerous ways depending on the property that they shared.

Calling the classification activity a "game" proved to be an ironically apt choice of words, for it presaged a conflict over museums' entertainment function that has been at the center of much of their history. Surprisingly, it was the educator who was the game's chief critic.[1]

On the surface, to present plant classification in the form of a game or a puzzle was to practice a modern approach to pedagogy that advocates participatory learning, active engagement, and personal appeal.[2] Although fully cognizant of this fact, the educator was unable to resist old habits and admonitions about what education was supposed to be and do. She could not suppress her discomfort over the gap between the game and its lesson, the metaphor of the toy blocks and the vegetable kingdom they represented.

Her stated reason for her discomfort had to do with the fear that the metaphor of the blocks would be so inherently engaging that viewers would have neither the desire nor the motivation to make the leap to plant science. In other words, the game of matching like and unlike objects would become its own end; visitors would stop and play and then move on to the next fun thing that would catch their eyes.

Admittedly, there was some basis for such fears. One of museum practitioners' greatest frustrations with participatory exhibits has had to do with their so-called "pinball effect." Particularly in science museums, where there is now a preponderance of hands-on exhibits, visitors have been observed moving around haphazardly, pushing buttons and pulling levers, enjoying the effects but making no effort to understand them.[3]

The museum, in essence, is thus reduced to a giant playground. As visitor researcher Chandler Screven observed:

> The three-dimensionality of exhibits and their novelty, gadgetry, and manipulatory aspects can have intrinsic interest and generate attention but distract viewers from the main ideas, distinctions, or story line. . . . [The apparent fun and involvement observed at popular exhibits] may simply reflect the excitement of free exploration, social interaction, manipulation, and unfocused attention to movement and random visual elements. The result: educational exhibitions sometimes serve not as conditions for learning but as backdrops for exploratory, social, and family activities unrelated to their educational purposes.[4]

While the educator's concerns had just cause, the designer, determined that the exhibit not become just another dry, didactic presentation, opposed her. For him, the exhibit's success depended first and foremost on its ability to attract and to hold attention. Therefore, the exhibit's design—not just its overall character but also the presentation of its individual parts—was crucial. To the designer, colorful geometric blocks spoke volumes more than did the plant specimens they represented.

Interestingly enough, the curator—whom one might have expected to side with the educator—supported the designer. The curator fully understood the principle of an exhibit's "attracting and holding power."[5] His fascination with the plant world ran deep, and he was receptive to methods that might spark a similar response in others. Unlike the designer, however, he saw nothing dry about plants and plant science. Nevertheless, after much discussion the educator prevailed. The result was a more literal demonstration based on actual plants from the vegetable kingdom.

An unfortunate consequence of this decision was that the use of complex plants instead of simple objects posed a design hurdle that threatened to restrict the effectiveness of the exhibit's message. Producing lifelike models and mounting them so that they could be grouped proved technically complex and financially prohibitive. Thus, the idea of using three-dimensional models was retracted in favor of flat photographs.[6] Visitors, as a result, would no longer manipulate objects themselves; the exhibit would present to them three possible groupings based on three different

criteria. Their participation would be limited to lifting the label under which the groupings were concealed. What had begun as an interactive, metaphorical game had become a static, literal demonstration.[7]

This was not the only part of the classification panel on which team members disagreed. The humorous tabloid's inclusion was also opposed by the educator, on the grounds that it did nothing to further visitors' understanding about Linnaeus's system. This was an arguable point—the quotes, after all, did drive home the message that the system was based essentially on sex. But the quotes also produced a chuckle: "Who would have thought that bluebells, lilies, and onions could be up to such immorality?" Indeed, who would have thought that plant morality could be an issue?

In fact, the methods of presentation criticized by the educator stood on sound pedagogical principles: self-exploration, games, humor, even play itself have long been recognized for their role in promoting learning.[8] At the same time, these activities carry associations that are by tradition at odds with "real" education: recreation, entertainment, fun. It was these associations that the educator could not fully accept. And no wonder: conflict between museums' education and entertainment functions are being widely discussed today. The last few years have seen museums under increasing fire for their adoption of "Disneyesque" techniques and goals. Critics chide museums for market-driven practices that put them in competition with the entertainment industry, while proponents cite the natural evolution of exhibition techniques that has resulted in more glossy, high-tech methods of display and interpretation. Educators, caught in the middle, have found themselves divided over their own goals and visitors' agendas, because ultimately it is the latter that define the market in which the former must be achieved.

Disagreements over museums' education and entertainment functions, however, are not new. Indeed, they have been at the heart of museums' evolution as public institutions. To clarify exactly what is at issue here, and set the stage for the chapters that follow, it is useful to take a closer look at the picture historians have painted for us and on which modern attitudes about education and entertainment largely have been based. These attitudes grew out of an earlier, related conflict from the last century over museums' popular and scholarly functions, and may be viewed as the latest manifestation of that conflict.

Today's conflict, however, differs from those preceding it in some rather significant ways. First, the earlier conflicts had to do with the very emergence and establishment of education as a central museum function, whereas today they are more concerned with the nature, ends, and means of that function. Second, the earlier battles were waged primarily by curators driven by institutional agendas, while today's disputes involve educators driven by visitors' agendas.

The differences between the two conflicts are important because they signify how thought about museum education has changed as it has become a valued and professional function. Educators' ideals emerged from movements to popularize the institution. Ironically, professionalization is now bringing them into the scholarly realm they once resisted. (Indeed, "curator of education" has become standard nomenclature.) Now "serious" education is pitted against "frivolous" entertainment, as educators struggle to protect their hard-won gains while remaining true to the interests of the visitors for whom those gains were fought. Although this struggle appears to be about defining the nature of museum education, it is also in effect about redefining quintessential features of the institution—from the power structure it upholds to the manner in which objects are interpreted and experienced.

Popularization versus Scholarship

Only a handful of historians have closely studied American museums. Nearly all of them were children of the post-1870s era, which witnessed great museum building and growth, and they tended to look back at the first century of museum development with a certain condescension. Their assessment, however, was largely derived from two opposing positions that sum up, somewhat exaggeratedly, the dual path museums have taken in their responsibility to both public and scholarly uses.[9]

The first position held that early museums were amateuristic sideshows devoted to popular entertainment. This view was first articulated in a highly influential paper now regarded as the first formal work in U.S. museum history: "Museum-History and Museums of History," delivered by George Brown Goode to the American Historical Association in 1888.[10] Goode spent the better part of his museum career at the Smithsonian Institution, eventually rising to assistant secretary of the

National Museum. Under the tutelage of Joseph Henry, the Smithsonian's first secretary, Goode was exposed to the heady struggles of professionalization that characterized the institution's formative years. Henry's view of the museum as a handmaiden to science heavily influenced Goode's indictment of early museums as trivial popular attractions.

Goode's pronouncement was repeated over the years by other critics bent on establishing more professional, scholarly uses of museum collections. For example, geologist Newton Horace Winchell, addressing the St. Paul Academy of Sciences, argued that one must look back to the ancient Grecian museum, with its commitment to pure study and contemplation, for the "true museum."[11] Later Benjamin Ives Gilman, renowned for his promotion of education and public interests at Boston's Museum of Fine Arts, actually opposed the provision of information about art objects, maintaining that "a museum of art is primarily an institution of culture and only secondarily a seat of learning."[12] Still later, Walter Pach, writing about art museums, defended Gilman and stated that:

> Our democratic period, if it is to equal the wisdom of Louis XIV and the other great patrons of the past, must do so by drawing on the resources of men who devote their lives to study of the museum and its contents. . . .[13]

The second critique of early museums was completely opposed to the first. It held that as museums catered to a more scholarly clientele, too little was done for the public. Ironically, this view was also first put forth by Goode, thus demonstrating his ultimate ambivalence on this issue. After Henry's death, Goode was influenced by the ideas of the new secretary Spencer Baird, who, in defiance of Henry's vision, championed greater public use of the collections. Thus, in accordance with Baird's crusade to bring museums back to the people, Goode began to blast early museums for catering to scholars and connoisseurs. Interestingly, both of these critiques—museums as vulgar sideshows and museums as elitist enclaves—appeared in the same 1888 speech.

Like the first view, the critique of museums as elitist institutions was also carried forward through the years, this time by museum officials eager to promote popular uses of museums and their collections. Beginning in 1917, for example, John Cotton Dana, the revolutionary director of New Jersey's Newark Museum, authored a series of booklets that promoted museums as instruments for popular education and recreation

and attributed their elitist orientation to the aristocratic European collections on which they were initially modeled.[14] Later, his disciple, Theodore Low, published a book on museums' social responsibilities in which he virtually ignored the first century of museum history even as he condemned the next half century for its emphasis on collections over education.[15] Metropolitan Museum of Art director Francis Henry Taylor continued the argument, attacking museums for "high-hatting" the man in the street and for calling their interpretations scholarship.[16]

Significantly, nearly all of these commentators were also practicing museum professionals who brought present institutional interests to bear on their versions of the past. They bequeathed us a black-and-white history that paints museums as either entertaining sideshows or stuffy professional enclaves. These enduring images continue to color thinking about museums' responsibilities and functions.

With little exception, the few contemporary historians who have looked comprehensively at museums have concentrated on the last one hundred years.[17] Early museum history is seldom given more than a few token pages. One important exception is the work of historian Joel Orosz, who has analyzed a ream of original material from eleven major museums that thrived during the late eighteenth and nineteenth centuries. Orosz challenges the longstanding views that lump early museums into elitist or popular camps. While his account has been criticized for its too-tidy periodization, his extensive investigation of primary sources represents a long overdue contribution to museum scholarship. Especially with regard to the issue of popularization, Orosz moves beyond what has been branded as vulgar entertainment and provides a clearer account of what such experiences might have meant to the users—proprietors and visitors alike.

By Orosz's account, the United States' earliest museums were founded out of the highest ideals for the new citizenry. Du Simitiere's American Museum, Charles Willson Peale's Philadelphia Museum, and the Tammany Society's American Museum were all established to promote intellectual and moral improvement. Early museum proprietors came from the wealthy, "respectable" classes; theirs was a didactic, moralizing conception of education that sought to inculcate "respectable" ideals. To Peale, the museum represented a world in miniature and, thus, a place where order reigned supreme. There people could study the perfection of the Creator, social order, and civic responsibility.

What came to be called entertainment in later years was born out of resistance to these early museums' ideals, which underscored class difference by privileging respectable values and ideals.[18] According to Orosz, museums' initial shift to more popular forms of education was preceded by changes in society that saw the collapse of the aristocratic social order and the rise of a middle class wielding political influence. In 1800, for example, the Federalist Party, then *the* symbol of respectability, was defeated by the Jeffersonian Republicans, who to many represented the vanguard of mob rule. Along with political influence came economic clout, and many museum proprietors found themselves at the mercy of a market economy that no longer favored them.

Change came with the recognition that in order to educate, museums must first survive. In order to survive, they had to cater to a public whose tastes were being shaped by a slew of imitators exhibiting the far more lurid freaks and oddities of nature and art. As one contemporary put it, "the truths of natural science were not as attractive . . . as the occasional errors of nature in her productions."[19] Nature was eminently more provocative as a horror show than as a didactic exercise.

Peale was the first to assert that museums must "amuse as well as instruct," though in the end few museums were able to maintain an even balance between the two. What began as innocent "amusements"— the addition of music recitals, costumed monkeys, a silhouette cutter— soon became increasingly tawdry, as museums competed to outdo one another. By the 1830s, Peale's museum (now under the management of his sons) featured one-man bands, trained dogs, ventriloquists, and the obligatory freaks of nature. The Tammany Society found it necessary to turn their American Museum over to the leadership of John Scudder, who transformed the entire museum into a gaudy, sensational spectacle because the institution was unable to survive with serious exhibits. Similarly, the Western Museum of Cincinnati stayed open only because of its waxworks, its special "Chamber of Horrors," and its notorious "Dante's Inferno" or "Regions," a smoke-and-mirrors exhibit that simulated Hell. It was here, much to museum audiences' delight, that the practice of sniffing nitrous oxide at the conclusion of lectures was introduced. A British visitor touring the United States aptly summed up the situation:

In America, Museums are almost always the property of some private individual, who gets together a mass of everything that is likely to be thought curious—good, bad and indifferent—the worthless generally prevailing over the valuable. The collections are then huddled together, without order or arrangement; wretched daubs of painting, miserable wax-work figures, and the most trifling and frivolous things are added; and there is generally a noisy band of musicians, and a juggler, belonging to the establishment, to attract visitors. . . . Mere amusement, and that of the lightest and most uninstructive kind, is the only object sought in visiting them.[20]

Not every museum succumbed to this fate, however. Some, like the New-York Historical Society, responded by withdrawing from the public altogether. In so doing, they ended up restoring the very elitist mentality against which the public had rebelled.

These examples represent the evidence on which early museum historians derived their two condemning and opposing positions. "Popularization versus scholarship": while the aims and means of the latter were fairly straightforward, Orosz suggests that those of the former may have been a bit more murky. Historians who have found it easy to dismiss them as "mere" entertainment have done early popular museums a disservice. The question must thus be asked, what was this entertainment really about? Were the exhibits indeed as "uninstructive" as the British visitor had branded them?

Orosz finds the beginning of an explanation from Peale himself, who became increasingly frustrated by the "rude and uncultivated" people who overran his Philadelphia Museum. Unlike some proprietors who simply excluded visitors, however, Peale's response was to shift his thinking about popular education. To Peale, instead of didactic moralizing, popular education should be concerned with

the presentation of supposedly objective facts to the people so that they could make their own decisions. For those who would not or could not learn, the museum would at least provide "rational amusement" that would reduce the need for frivolous pleasure or vices. The museum would thus be simultaneously a school in which the sovereign people could learn to make wise choices and a place of wholesome diversion for the thoughtless.[21]

Peale continued to cling to his faith in museums' potential to inspire and to shape good moral character. But he also recognized that diversion

could help to advance these goals by amusing in "a rational and informative fashion."[22] Furthermore, he recognized the importance of control, over not only what one views but also what one thinks about what one views. Today, such ideas are central to our understanding of the learning process; at the time, they demonstrated a remarkable acceptance of "common" thought, however unpalatable Peale might have found it.

These ideas found support and elaboration in another related quarter. In his biography of P. T. Barnum, the undisputed king of curiosity displays and showmanship, Neil Harris suggests that more was at work than simple amusement.[23] While history has remembered Barnum principally as a master entrepreneur, Harris argues that his success was tied directly to his satisfaction of a variety of social needs. Barnum's strategy involved a certain amount of deception, whether direct falsification of exhibits or their stories or indirect persuasion to stoke public interest in his product. Tolerance for these impostures, Harris argues, was based on a host of things that they came to represent.

Initially, Barnum's success was probably tied to the social climate of Jacksonian America and its rejection of Jefferson's intellectual ideals. While Jefferson may have been instrumental in his support of lower- and middle-class interests, he was still a landowner and a philosopher who never articulated commoners' experience in the way that Jackson could. Under Jackson, the climate shifted: learning and knowledge were considered valued endeavors—even amusements—but they were not to be monopolized by "experts." New forms of exhibition that featured prodigies, freaks of nature, and automata didn't just pander to public appetite for entertainment; rather, they reinforced onlookers' emerging sense of authority and control by challenging them to judge for themselves the truth of the "wonders" before them. The detection of fraud became an exercise and pastime, and Barnum's shows played splendidly into this sensibility.

At the same time, advancements in technology had led to widespread credulity, as science continued to reveal the boundlessness of nature. Curiosities and freaks contributed to this feeling, heightening the challenge of detecting fraudulent displays by stretching the limits of what was possible.

Finally, the existence of an untamed frontier, whose control might be simulated through the (physical or intellectual) manipulation of its elements, may have posed a threat to society. The fabrication and detec-

tion of fraudulent exhibits may have helped satisfy this need for control over nature.

In short, what critics called frivolous, uninstructive entertainment may have satisfied an unconscious but powerful need to experience a sense of personal control and power. It is true that Barnum came nearly a generation after museums had begun their decline. But his success and the transformation of museums find explanation in issues related to control. Recall that museums' initial shift from "respectable" to popular education was a response to visitors' needs (or perhaps desires). However, museums did not go far enough in fulfilling those needs. Sideshows and other related displays offered a more compelling way of encountering nature that satisfied the public's ulterior needs for feeling in control.

While museums may have satisfied the needs and interests of their immediate publics, many had completely neglected the community of users largely responsible for building their collections in the first place: the professional community of naturalists, scholars, and explorers. By the 1840s, changes on the scientific front—such as the launching of the United States Exploring Expedition, the increasing specialization of knowledge, and the subsequent rise in standards of training and skills—brought scientific interests back to the fore. Subsequently, the professional community began to reclaim and build upon the museum collections that an earlier generation of naturalists and explorers had assembled. This was the decade when James Smithson, Britain's outcast bastard son, vindictively left his bequest to the U.S. government to establish an institution dedicated to "the increase and diffusion of knowledge." That knowledge be increased was paramount to his intent, for nowhere at that time was original research receiving adequate support.

The result—the establishment of a museum that would become a national signature—is history. The founding of the Smithsonian Institution renewed the heated debate on the possibility of "serious" educational and scientific uses for museum collections. Joseph Henry, the Smithsonian's first secretary, was adamant that Smithson's will be carried out to the letter, which meant that the Institution's overriding commitment should be to the advancement of knowledge and not to popular education or entertainment.

In carrying out his mission, Henry did much to advance the cause of science and basic research. But the period was short-lived. Wary of

falling back into the same charges of elitism that caused the downfall of an earlier generation of museums, proprietors began working again to strike a balance between popular and professional uses of collections. Several reasons are given by Orosz to explain this change of heart, including scientists' fear of alienating religious opinion with controversial findings, a resurgence of popular education by antislavery forces, and the rise of international expositions, which helped repopularize the museum idea.[24] By the 1860s museums were well on their way to achieving a balance between the interests of both communities to which they catered.

Orosz's history stops here with what he has called "The American Compromise": the acceptance by museum officials of their institutions' dual (scholarly and popular) functions. There is indeed no question that, after the 1870s, museums had for the most part achieved an uneasy balance between their scientific and public responsibilities. Although museum officials were generally sincere in their acceptance of multiple uses for collections, however, many continued to favor one or another. Concern for, argument about, and decisions based on the two traditionally opposing views still persisted, perpetuating an enduring ambivalence.

The years around the turn of the twentieth century were not unlike those during the founding of the United States' first post-Revolutionary museums. A strong patriotic spirit prevailed, at least in the North, and a renewed sense of social righteousness followed in the wake of the Civil War. Once again, proprietors saw in museum collections the potential for moral and social improvement.

The 1870s are almost universally considered a turning point in museum history. Indeed, many historians mark this as the starting point of the American museum. The 1870s witnessed the first generation of philanthropists step forward to found America's great metropolitan museums, including the Metropolitan Museum of Art, the Boston Museum of Fine Arts, the American Museum of Natural History, and the Art Institute of Chicago. Interestingly enough, the bulk of these new establishments were devoted to the arts, no doubt a reflection of a climate that embraced the redemptive power of art.[25]

This climate fostered a notion of social reform that was based not on political change but on cultural uplift. Business leaders in the 1870s were faced with tremendous social and economic problems. Labor riots,

racial strife, and immigration all threatened to upset the social fabric. Art held the promise of spiritual uplift and social refinement without altering the economic structure that had served business leaders so well. Their sentiments were quite genuine; but like the respectable classes of 100 years before, they promoted the values and manners of their class by supporting only those forms of art and culture that they believed would strengthen people's spiritual nature: paintings, symphonies, museums. A fierce distinction was made between popular art, made to amuse, and Art proper. The value of true art lay in its representation of some "eternal ideal"; art should ennoble, not entertain. The parallel with the early museum founders could not be clearer.

During this time, natural history museums, most the legacy of pre-1870 collections, also continued to grow. In keeping with the spirit of the time, they too opened their doors to a public they believed would benefit from exposure to their collections. Initially, their intentions, while well-meaning, were thwarted by a cluttered, encyclopedic manner of display that managed to impress without making much sense to the untrained eye. Belief in the inherent power of the object to teach and uplift was strong, and it was widely assumed that visitors need only stand in front of museum collections to comprehend their antiquity, beauty, or rarity. Laudatory though such goals were, most of these museums suffered from an exhibition style that overwhelmed visitors by the sheer volume of objects on display. This was true not only of natural history museums but also of art museums. As Neil Harris notes:

> By the early twentieth century . . . [art museums] had turned into storehouses, paradise for the curator or researcher, but hell for the serious amateur and the ordinary visitor. The art museum, it appeared, had become a depository, a subtreasury of art and valuable artifacts, with only a peripheral influence on knowledgeability and public preference.[26]

While museums may have been ready for the public, it was not clear that the public was ready for them. History was repeating itself: museum officials found themselves once again faced with the problem of how to get the public in to see what they "needed." Once again, officials turned to the competition for new direction. Seventy-five years before, that challenge had pitted them against sideshows and hucksters. This time they were confronted with the great world's fair expositions.

Between 1880 and 1920, expositions became a regular feature of the American and European social landscape. Like museums, they professed an explicitly educational function: their exhibits followed a similar hierarchy of classification; their buildings reflected the neoclassical styles of museum architecture; and the objects they displayed represented the best in quality. Unlike museums, however, the expositions made no effort to mask their entertainment function; their well-designed, tremendously flattering exhibits boldly mixed pleasure with serious instruction. As one commentator described it, the expositions promoted "entertainment without lewdness, information without struggle."[27] Visitors flocked to them.[28]

The expositions may have outstripped museums in sheer novelty and technical wizardry and in time museums did borrow heavily from them; but they also revealed a discouraging lack of taste that only reaffirmed philanthropists' goals for their museums. In his comparative study of expositions, department stores, and museums, Neil Harris points to "an impoverished national taste, a struggling and depressed class of artists, and a debased and vulgar stock of consumer goods" that characterized the Centennial Exposition. "Americans looked crudely mercenary and badly educated. Museums were meant to redeem the fortunes spent creating them by raising the level of public taste."[29]

An earlier generation of museum officials had altered the very things put on display in order to compete, exhibiting "curiosities" such as trained dogs, ventriloquists, and mermaids. This generation, determined to maintain some integrity, altered the manner of presentation: not only exhibit style (by using dioramas, painted backdrops, thematic arrangements—although it would take well up to World War II before these were well integrated into museums) but also interpretation. It was George Brown Goode who, back in 1888, described an efficient educational museum as a collection of instructive labels, each illustrated by a well-selected specimen.[30] That prophetic description sums up the character of twentieth-century museum work. Well-conceived interpretation became the key to museums' success and the battleground for competing institutions. Lectures, tours, demonstrations, and even labels had been employed to varying degrees in the nation's early museums. In the early twentieth century, they became staples.[31]

These reforms were influenced not just by the great expositions.

Criticism of the burgeoning museums came from other fronts as well. Historian Helen Horowitz identified three groups whose critiques were instrumental in broadening philanthropists' visions.[32] All were loosely related to an early twentieth-century reform movement called Progressivism. Progressivism, generally regarded as a political movement concerned with protecting workers and consumers and arresting big business, was also a social movement. Quality of life was a key issue, and reformers endeavored to understand the nature of society and to derive an activist approach to social problems. Like the philanthropists, reformers saw culture as a powerful tool for reform, but they had quite different ideas about its employment.

The first group of critics Horowitz identifies were the settlement house reformers, the most prominent of whom was Jane Addams. To Addams, museums by their very nature alienated all but the higher classes who had built them. Physically, they stood far removed from poorer neighborhoods; and spiritually, they offered an experience so remote from lower-class life as to be unbridgeable. Addams worked to overcome the gap between cultural institutions and lower-class neighborhoods by establishing settlement houses like Hull House. Addams believed that art had little worth if it did not grow out of experience. Among other things, the settlement houses displayed local artists' work; offered art and music classes; and provided space for such activities as concerts, reading, and painting.

The second group of critics were artists themselves. While they shared the philanthropists' basic principles, they criticized their lack of patronage for contemporary artists. Museums might foster cultural uplift, but their collections neither reflected nor supported contemporary work by living artists.

The third group of critics, and for our purposes the most significant, were institutional administrators and curators, whose professional standards increasingly came into conflict with those of their philanthropist employers. For them, the scholarly expert's special skills and authority were paramount to the institution's proper governance. They began to introduce new criteria to their work, like a concern for utility and truthfulness in display. Thus an object might be displayed unrestored in its true state—even though it was less beautiful this way. In some cases, these concerns resulted in a renewed emphasis on scholarship and research— that museums existed primarily to increase, not to diffuse, knowledge.

In other cases, however, changes instituted by administrators and curators resulted in a strengthening of public service. Some museums began experimenting with extension programs, bringing their collections and programs outside their walls and into communities. The Art Institute of Chicago, for example, brought some of its paintings out of storage to exhibit them in the recreation buildings of city parks. Over time, the administrators developed a growing commitment to social service similar to that which had moved philanthropists to found their great institutions. The difference was that the administrators were willing to meet the public on their own turf, both literally and figuratively, while the philanthropists insisted on the primacy of the museum environment.

The turn of the century, then, saw the establishment of a variety of public-outreach mechanisms, including interpretive materials, exhibit techniques, and professional publications. Along with school group tours, loan programs, and printed materials (catalogs, brochures, and labels), most of today's standard interpretive vehicles were in place by World War I.

In addition to these supplementary materials, the exhibits themselves were subject to reforms in design and display techniques. The practice of displaying endless cases of specimens and hanging collections from floor to ceiling was gradually replaced by exhibit practices that used more focused displays combining related objects. Dioramas and period rooms recreated an object or specimen's environment; and advances in taxidermy enabled exhibitors to mold specimens to a story line by displaying, for example, a bird hanging from a predator's jaws.

Finally, a forum for professional exchange and critique developed with the establishment of the American Association of Museums (AAM) in 1906, the formal publication of association proceedings and papers in 1907, and the first exhibit research in the 1920s. Early studies about the arrangement of objects, the density of displays, and the behavior of visitors led to further improvements in interpretation and presentation. Visitors responded readily to these overtures: attendance began to rise, and museums were soon on their way to becoming the highly popular institutions they are today.

Interestingly, many of the concerns that we now associate so strongly with professional museum educators were first conceived, developed, and promoted by curators. An uneasy balance still remained between curators who were devoted to public service and those who were committed to

scientific enterprise; but the establishment of the new display and inter-
pretive techniques left an indelible mark upon museum practice. In the
next section, we will see just how indelible this mark has been, particularly
with the transformation of debates about museums' public and scientific
functions into debates about their role as educators and entertainers.

Education versus Entertainment

The legacy of early twentieth-century displays fostered greater under-
standing of the collections through more effective communication, and
it continues to describe current efforts to promote museums. However,
this legacy has been complicated by disagreements over not only what
constitutes "understanding" but also what the outcome of a museum
visit should be. The source of these disagreements lies in museum edu-
cation's establishment as an autonomous institutional activity.

During the interwar years interpretive materials and exhibitry con-
tinued to evolve. By 1932 15 percent of U.S. museums offered organized
educational programs.[33] A 1934 survey reported that thirty-eight different
"educational activities" were being conducted at the time of the survey by
forty-seven of the museums that responded. The median of educational
programs during that year for the individual museums was 15.5.[34] The pro-
fessional journal *Museum News,* formally launched in 1924, evidenced a
growing body of writings devoted to educational topics. A total of three
articles related to education were published in the 1920s; this figure
soared to thirty-nine in the following decade. The two events that had
the most profound effect on the course of museums' popular function,
however, were the professionalization of educational work and the estab-
lishment and use of scientifically grounded research on museum visitors.

The first staff "instructors" whose work was solely educational were
hired as early as World War I. Many of these early instructors were
schoolteachers—a fact that would later hinder museum educators bent on
differentiating themselves from the more formal education field. Never-
theless, they established educators' first professional niche in the institution,
which soon led to the formation of autonomous education departments.
Within twenty-seven of the forty-seven museums that responded to the
1934 survey, educational work was organized under a single department.
In a few, the work was divided among two or more departments; only

three had no staff member charged exclusively with educational affairs.

The effects of this division of labor were consequential. First, it isolated the educational function from the rest of the museum's functions, in effect detaching it, as one commentator put it, from the very fund of knowledge from which it is supposed to draw. While this split may have given museums' educational role a "home of its own," it segregated what many thought should rightly infuse all of a museum's functions. AAM director Laurence Vail Coleman spoke for many when he wrote in 1939 that

> interpretation cannot be effective as the work of a staff detachment, or even of a department, that is entirely separated in its ranks from the curatorial departments whose messages it is trying to present.[35]

Sensible though such sentiments may be, Coleman unwittingly made educators' own case for separation when in practically the same breath he observed that

> there is an opportunity also at the bottom of the scale of duties. Most museums have overlooked a chance to combine instruction with other simple work in order to give a larger part of the budget to effective purposes. [For example], most of what uniformed guards are hired to do now could be done much better by young women [instructors] in the course of staffing an exhibit hall.[36]

The second consequence of this new job category was that for the first time there was a group of workers in museums whose primary and usually sole preoccupation was education. These workers began to introduce educational methods and theories, heightening the professionalization of museums' educational services.[37] Specific undertakings ranged broadly. In her 1938 overview of educational activities in U.S. museums, Grace Fisher Ramsey devoted some two hundred pages to the description of museum lectures, talks for the blind and the deaf, teacher training, museum clubs, nature contests, field trips, extension work, and even radio programs. Her overall assessment, however, suggested that education had yet to take hold across the board:

> On the whole, there has been relatively little evidence of a realization on the part of the museum that one of its chief duties lay in the interpretation of its collections to adults for their enjoyment and for the enrichment of their lives.[38]

Ramsey made clear that "the pioneer period in museum educational work may now be considered as completed."[39] Educators had indeed established themselves in the institution. But if they were to continue to advance, the next stage of development required that they address their own training and promotion within the institution.

The third and for our purposes the most important consequence of the institutionalization of museum educators was its profound effect on the debate over scholarly versus popular uses of collections. For the first time the organizational structure of museums reflected and reinforced the categorical differences between their various functions. The result was the creation of two natural camps that almost by definition came to stand for the interests of the curators and scientists on one hand and the public on the other.

It would not be fair, however, to lump all curators within a single-issue scientific platform. While some curators voiced concern that museum collections not be trivialized by overelaborate presentation or oversimplified interpretation, many remained committed to the public interest that educators now represented. But as had happened in the past, argument about museums' responsibility to visitors polarized the institution's public and scholarly roles, forcing curators to defend museums' research arm against a position toward which many were in fact sympathetic.

In 1942, for example, the publication of Theodore Low's booklet on the social role of museums placed the curatorial profession squarely on the defensive. *The Museum as a Social Instrument* was commissioned by the Committee on Education of the American Association of Museums, one of several task forces that would be established over the next few decades to deal with educational issues. Low sought to reinstate museums' responsibility to their communities, charging that museums had been derailed by staff who were "hypnotized by the charms of collecting and scholarship" and lacked "social consciousness."[40] Language such as this set the terms for a debate that would persist for years to come.[41]

Of interest here, however, is not so much the course of this debate as how educators' defense and articulation of their position altered their conception of their field. As educators became more proficient in not only arguing their cause but also practicing their trade, a significant shift occurred: the debate over scholarly versus popular uses of collections was

carried in modified form into the educational arena proper. The source of this shift lay in the way educators regarded the public. While establishing the importance of public use of collections, educators began inquiring into what "public use" entailed. Such issues were no longer a matter of simple ideology, because science had entered the picture as well.

The first formal studies of visitors occurred in the 1920s and 1930s. Edward Robinson and Arthur Melton of Yale University were among a handful of early pioneers bent on establishing a scientific understanding of exhibit use and design. Their work tended to focus on the exhibit setting and how such variables as layout and density affected exhibit's educational effectiveness. While studies such as these did produce guidelines that positively influenced visitor behavior, they failed to inquire into the nature of the behaviors themselves. The learning outcome of exhibit viewing and its manifestation by particular behaviors thus remained a matter of authority, not hypothesis.

In the 1940s and 1950s formal studies like Robinson's and Melton's languished. Owing partly to educators' disillusionment over the studies' limitations and partly to resistance to the idea that museums be subjected to the winds of public opinion, exhibits and programs again were developed not by science but by fiat. Then, after a hiatus of over two decades, visitor research made a second and, as it turned out, lasting comeback.[42] New data, as a result, began to be factored into educators' thinking.

One of visitor research's earliest contributions was characterizing the profile of the museum public. No longer was it possible to speak about "the public" as though it were a single, homogenous body; surveys showed the public to consist of a variety of subgroups, each with different needs, interests, and expectations. While educators were accustomed to classifying visitors into such broad categories as schoolchildren and adults, visitor surveys revealed groupings that were drawn along more specific lines that reflected, for example, visitors' ethnic and class background, frequency of attendance, and reasons for visiting. It thus became clear that a motivated hobbyist had quite different interpretive and social needs from a family whiling away a Sunday afternoon. It is precisely this disparity that recast the debate about serious and popular uses of collections. While the original debate was far from dead—curators and educators would continue to differ even up to the present—a hybrid debate was taking root within educational circles.

Early inklings of this new hybrid appeared in a 1962 *Museum News* article, "Leisure Time and the Museum,"[43] which caused no small stir by comparing museum-going to leisure activities like baseball and bowling. While the author, sociologist Rudolph Morris, took care to distinguish the former, which is *used* for leisure, from the latter, which *is* leisure, he nevertheless linked museums solidly to pursuits whose ends might be no more fruitful than passing the time.

What made this idea controversial was not that it was new—for it was not—but that it was offered as legitimate. Coleman, after all, had used the word "leisure" in 1939, suggesting that educators look harder at that "empty" time instead of competing for hours already filled by organized pursuits.[44] Furthermore, although history is full of examples of "leisurely" uses of museums, those examples had been generally regarded as either straying from or leading to a higher path of education and enlightenment. To suggest that museums make leisure a legitimate pursuit was, in some eyes, to erode hard-fought ideals about what museums should rightly be.

In a rebuttal to the Morris article, museum educator Raymond Stites differentiated the museum viewer from the ballpark spectator by citing the "intellectual motivation" and "cerebral and spiritual significance" incurred by the former in contrast to the "relatively simple mental exercise" required of the latter.[45] This argument revealed a shift that was beginning to take place in the language and thought about education, for it accounted for not only the museum's mission but also visitors' inner experiences and motives. While based less on data than on the author's own hunches and assumptions, this approach anticipated later research that would focus exclusively on visitor experience.

It would be another several years before visitor researchers would begin to bring the formal study of leisure into their fold. In the meantime, however, researchers, still driven to uncover the basic rules of design and behavior behind what might one day form the basis for an "exhibit science," continued to study and to define the educational effectiveness of exhibits. While their work did contribute to understanding some of the factors that inhibit and enhance learning, it also produced evidence that in many cases neither visitors' experiences nor their expectations and interests were strictly educational. Visitors were coming to museums for social outings, simple pleasure, and even leisure.[46]

These findings, neither startling nor entirely unexpected, were backed by hard data for the first time. Curators' worst fears about trivializing collections were here realized right from the visitor's mouth. Educators, long accustomed to defending visitors' rights to educational and uplifting experiences, were forced to face the fact that, for a large part of the public, their lofty ideals about society's uplift just did not matter.

At issue was the very battle educators had fought with curators over how far to popularize the collections. This time, however, the threat was that not just the collections but also visitors' experience, and ultimately the whole museum endeavor, would be trivialized into inconsequence. Museum director Daniel Rich gave early voice to these fears when he observed:

> Francis Taylor once called the museum the "attics of civilization," but at the pace we are going and the varieties of museums we are inventing, they may soon become the cocktail lounges or drive-ins of our day. Where *once* museums sought to collect, then publish the results of their collecting in scholarly report, today we are often expending nine-tenths of our energies to see how much and how fast we can make the public fall in love with us.[47]

Furthermore, such fears were backed by history, which bore evidence of what could happen if museums catered indiscriminately to visitors' desires.

Yet museums had hardly stooped to the kind of tawdry, vaudevillian entertainments of bygone days. Indeed, they were more self-conscious than ever of their responsibilities to their visitors. However, in their zeal to provide new and creative ways of linking visitors to collections, they were stretching the boundaries of accepted educational methods. By the early 1970s, collections had begun to share the floor with slide and film presentations, audio systems, and the first computer terminals.[48] The first Omnimax theater in a museum opened in 1973 at the San Diego Hall of Science. Puppets, theater, music, and festivals were rapidly becoming regular features of the museum landscape. While such vehicles were instituted with clear pedagogical aims, their market value was not lost on business-savvy officials:

> We must give people more than Billy the Kid's spurs or the favorite mites of an acarologist as a competitive, marketable product. The day is at hand

when museums must improve their services or risk losing their audiences to such money-making amusement organizations as Six Flags and Disneyland, which are going into object interpretation for the first time.[49]

Backing this point were those who suggested that the use of showy display methods was necessitated by the fact that museums now catered to a generation that had been reared in an age of mass-communications media. A steady stream of image bombardment was said to have shortened viewers' attention and numbed their capacity to be engaged.[50] Not everyone was convinced, however. In the words of William Fagaly, "the curator should not prostitute his institution by transforming it into an amusement center full of 'fun house' gimmicks in an attempt to win the interest of all potential visitors."[51] Museum planner Joseph Shannon cut straight to the chase: "Museums . . . are going to hell on a psychedelic choo-choo."[52]

There was no longer any question that museums existed to serve popular ends. The question now facing educators had to do with the nature of those ends—in particular, the fine line between instructing and entertaining that echoed earlier debates. After all, it was only a few short years ago that educators were defending museums' popular use and appeal against pure curatorial science. Now many found themselves in their old adversaries' shoes as they fought for serious, knowledge-based instruction against what increasingly came to be viewed as frivolous, popular entertainment.[53] Argument about "popularization versus scholarship" had shifted into argument about "entertainment versus education."

Not only the terms but also the stakes were somewhat different. While the underlying fear of popularization had been that museums were simply "selling out," critics of entertainment faced the genuine threat that a sound defense could be made for museums as entertainers. Both educational theory and visitor data had entered the vocabulary of the field, offering new kinds of tools for debate. Those who defended what was being castigated as "entertainment" rested their case on two arguments: that entertaining methods can still lead to educational ends, and that entertainment is a perfectly legitimate end unto itself.

The first was not a new idea. Educators had long recognized that visitors must first attend to an object for learning to even occur.[54] The

first step in the learning process, then, was to grab the viewer's attention. For proponents of the more "entertaining" educational methods, this reasoning continued to hold strong favor:

> [By having multimedia productions in the planetarium], you introduce new kinds of people to the planetarium as an environment. When we put on jazz shows, we brought a new kind of person into this setting. These cats came in and said "yeah, this is a groovy place," and now they come back for the regular [planetarium] show.[55]

This argument was later embellished by the notion that entertainment was not simply a stepping-stone to education but the progenitor of the receptive state required for authentic learning to occur. In other words, its very nature—playful, enjoyable, and fun—evoked in people the optimum conditions for learning—openness, loss of self, and what Mihaly Csikszentmihalyi called "flow."[56] Museum educator Dolo Brooking put it this way:

> It is through playful attitudes that creativity is nourished, personal growth sustained and the mind's flexibility preserved. . . . Playfulness enlarges problem-solving capacities and spurs the imaginative thinking.[57]

Related to this idea was the second, more controversial rationale, which broadened the very definition of education to *include* such "entertaining" components as play, fun, recreation, and leisure. While museum educators have been slow to embrace it, a growing body of research on the psychology of play and on what has come to be called "leisure science" have given scientific grounding to the value of fun.

Although research on people's use of leisure time was being conducted as far back as the 1930s, the formal study of leisure did not become an established discipline until the 1960s.[58] Its development received a strong boost in such outdoor settings as national parks, where throughout the 1960s a number of national studies were being conducted by the Outdoor Recreation Resources Review Commission and other government agencies. Largely economic in nature (how much can one charge for some activity), these studies took a turn in 1966 with the publication of a book that related the economics of leisure to the experience one got from it.[59] Henceforth, the field has concerned itself with questions related to the social and experiential nature of leisure.

This work was first introduced to the museum field in 1980 by Marilyn Hood in her landmark study linking museum participation to leisure values.[60] The study identified six leisure interests that characterized frequent, occasional, and non-visitors to museums. Activities like socializing with the family or enjoying oneself were found to be important motivators in the way many people chose to spend their free time. They also provided descriptions of the kinds of experiences that people valued and gained from their visits to museums.

While acknowledged to hold a variety of intrinsic rewards, leisure activities have continued to be viewed as secondary to more productive, instrumental activities that are required for survival (such as working, learning, and so on). However, based on his work on intrinsic motivation and rewards, Csikszentmihalyi has asserted the ontological primacy of leisure activities. He argues that they provide the source of meaning and criteria for evaluating all other life activities:

> As a person matures, the most rewarding experiences still tend to occur in expressive leisure contexts such as games, sports, intimate interactions, artistic, and religious activities. These experiences provide a criterion for fulfillment that can and often does serve as a critical standard for the rest of life. . . . Thus it could be argued that the most basic meaning of work and other instrumental activities is naturally determined by reference to meanings developed in leisure settings rather than vice-versa.[61]

For some museum educators, such ideas have proven to be exceedingly liberating, particularly with regard to the more affective experiences that their visitors report and value and that the collections naturally induce. In art museums, for example, staff have long struggled with the mismatch between the emotional, affective nature of the collections and the more rational, didactic nature of their interpretations. The result has been exhibits that are developed around historical and technical themes but whose interpretation has been barred for fear of cluttering the "experience" with too much verbiage. It is no surprise that work such as Csikszentmihalyi's has been so eagerly embraced, for it adds new dimensions to the traditional information-based language of education.[62] In the words of art educator Danielle Rice,

> As children are socialized into adulthood, they absorb the value systems of their parents and the broader cultural context in which they are raised. In

America this often means an adoption of a fairly pragmatic approach to living, which places less emphasis on dreaming, imagining, creating, and loving than on owning, using, and controlling.

The goal of museum education, as I see it, is pleasure through enlightenment. For in revealing the rich, abundant world of ideas behind objects, we encourage people to rediscover the delight, curiosity, and wonder they lose in becoming adults.[63]

Such sentiments hold wide appeal. But still some museum educators have resisted the implications of opening their field too fully to what continue to be regarded as nonessential, nonproductive, simple amusements. The language of play and leisure still carries negative connotations that are deeply rooted in our social consciousness. Ever since the Industrial Revolution, leisure has been opposed to work; it was by dint of hard work that individuals would make it into the kingdom of heaven. The pursuit of leisure has therefore been tinged with indulgence, ease, and sloth. Such connotations have made some educators shrink at being associated with the less-than-noble pursuit of entertainment. As Elaine Gurian observes:

We have internalized certain cultural preferences for some modes of learning over others. For example, we have been taught that one mark of the civilized person is verbal ability, and so when explicating objects . . . we concentrate on producing textual labels. . . . As a result of these internalized preferences, then, exhibitions often become places in which we, the exhibition makers, use certain styles of exhibiting to demonstrate our own mastery of these modes of knowing.[64]

In other words, not just professional differences but also cultural bias stands behind these habits of thought. Gurian goes on to observe:

Nor do we want to appear friendly, because we believe that informality would reduce the importance of our work. If the audience is having fun, we may be accused of providing a circus and not behaving in a sufficiently reverential manner.[65]

This issue of credibility lies at the core of disagreements over the nature of museum education work. It was also the central issue in the disagreements over the classification game in the Chicago Botanic Garden's Lin-

naeus exhibit. The educator's opposition to the game was ostensibly based on her fear that visitors would miss the connection between the game pieces and the plant world. Yet the game was designed so that visitors would still apply basic skills of observation, comparison, and grouping that are central to the classification process.

Similarly, the educator's opposition to the humorous quotes was based on her contention that they did nothing to further understanding of Linnaeus's classification system. However, they did serve the dual purpose of attracting viewers by using a tabloid format and colorful language, and also dramatizing in the words of Linnaeus's own contemporaries what was really at issue with his new system. The museum educator also opposed the use of short, snappy label headings throughout the exhibit. While their function was to introduce the block of text that followed, they also had to serve as a stimulating eye-catcher, grabbing visitors' attention and encouraging them to read on. "From Printer's Ink to Electric Link," "A Pressing Matter," "Collector's Items"—jingles like these sent the educator to pen her own, ultimately rejected, alternatives: "A Second Knowledge Explosion," "Pressing Plants," "Collecting Plants in the Field." Clearly they were more informative, but just as clearly, they lacked luster.

In sum, every position the educator took stemmed from her ideals for the museum education profession. While those ideals ultimately concerned museums' responsibility to their visitors, her responses did not necessarily reflect visitors' interests. Rather, they reflected a wider professional interest in preserving the credibility of this young profession—an issue that has become increasingly troublesome with education's problematic association with entertainment. Her concerns, then, lay in the extent to which the educational process would be demeaned by allowing for play and fun. In a way, her position sums up perfectly the challenge facing educators who are straddling their responsibility to visitors on the one hand and their establishment of professional integrity on the other. The two, it would appear, do not always go hand in hand.

Still, educators have clearly made museum officials more sensitive to visitor interests and needs. Their influence has resulted in the development of interpretive vehicles, displays, and special events and programs that, at their best, speak to visitors in their own language and encourage further exploration of the collection and, at their worst, find museums

selling out to market demands. New configurations not only of exhibitry but also of museums themselves have appeared in the form of blockbusters, industrial displays, and heritage corridors.

The vote is still out, however, on whether these developments are for better or worse. But critics have warmed to the issue. The 1980s saw a preponderance of articles decrying museums' adaptation of such theme-park effects as high-tech and "immersion" exhibitry. Some of these critiques came from within the profession, particularly at annual-meeting sessions with colorful names like "The Limits of Program Propriety; or Are My Belly Dancers Shaking Up Your Sacred Grove?"[66] Others came from academic semioticians who had discovered in both museums and theme parks a rich web of signs about contemporary culture.[67] Even the mass media has noticed. One journalist observed:

> Feeding on blockbuster shows and ever-growing attendance figures, art museums are becoming far more than places in which important objects are preserved in frames or glass cases. They are being transformed into centers of increasingly broad-based cultural entertainment and architectural display. Spacious rendezvous with restaurants and shops and even self-sufficient complexes reminiscent of Disneyland. . . . Not just the form but the content of museums is broadening in the 1980s. They are becoming pleasure centers with a broad populist appeal where the things on view tend more and more to be theatrical and three-dimensional rather than scholarly and literary.[68]

While responses have ranged from mildly derisive on the part of academics to downright defensive among practitioners themselves, perhaps the most telling sign that change was afoot occurred in 1989, when that most venerable committee, the Museum Trustees Association, held their annual meeting at Disneyworld.

But it is no more helpful to dismiss today's so-called entertainments than yesterday's sideshow hucksters. History has shown mere entertainment to offer users more than may meet the eye. In the 1800s it was about seeking control, and museums followed in the steps of sideshows and hucksters by changing the very things they displayed. At the turn of the century, it was about communication and engagement—this time the lesson

learned from the world's great expositions—and museums altered their manner of exhibition.

What is entertainment today? How has museum practice and education been altered by it? What have museum visitors gained from today's popular influences? The answers to these questions are explored in the next two chapters and rest on two key changes that underlie the struggles just described. First, museums have seen a remarkable shift in authority. While that shift has manifested itself in political and territorial disputes among professional factions, in the end it holds quite serious implications for what museums are and do. Ideologies about the uses of collections, the rightful authors of those uses, and the appropriate methods for carrying them out rest on fundamental assumptions about the nature of knowledge and authority. The next chapter examines how these assumptions challenge not only the nature of museum objects—their meanings, their boundaries, and the manner in which they can be known —but also the nature of the institution in whose authority and care those objects have traditionally been invested.

The second key change, which is intimately related to the first, concerns new categories of experience for knowing objects and using museums that have been thus legitimized. Acknowledgment and, gradually, understanding of the sheer variety of goals, needs, interests, expectations, and meanings that visitors bring to their museum encounters has challenged long-standing and often lofty assumptions about the visitors' experience and the role museums can or do play in their lives.

Ultimately, the first change has to do with what we will call empowerment: the transfer of authority from the curator to the educator, and later even to the visitor, altering not only the source but also the nature of "legitimate" knowledge. The second change has to do with the nature of the museum experience as a consequence of shifts in authority. Together, these changes have to do with the meaning-making process itself. This, we will see, is the characteristic feature of our age. This is the underlying gratification—and also threat—that today's "entertainment" holds.

2

Education as Empowerment

After touring the portion of the exhibit devoted to Linnaeus's lessons, viewers encounter a stretch of panels and cabinets entitled "The Legacy Continues . . ." Here the narrative takes a decided shift. An introductory panel reads:

> The work of classifying and naming plants has remained fundamentally the same for the last two centuries:
>
>> Reproductive parts are still the primary structures by which botanists classify plants.
>>
>> Names are still determined according to a specified code of rules.
>>
>> Today, however, we see a different world than Linnaeus saw. Tools, theories, and methods of communication shape the way we and Linnaeus view the world. What we know cannot be separated from the way we know it.

The next panel reads:

> Over the years, new tools have enabled us to penetrate the visible structures that Linnaeus so diligently counted. Our eyes have moved successively deeper into plants: From visible surface structures, to internal tissues, to cells, to organelles, to even chemicals themselves.

> New ways of looking at plants continue to generate ever more refined ways of grouping. . . .
>
> [Copy draft 4]

This panel is followed by four cabinets containing eighteenth-century and modern tools "that shape how botanists past and present view the world." A final panel closes the exhibit with these words:

> Systems of classification do not exist "in nature"; people invent these systems to help them think and communicate about the world.
>
> In ancient times, plants were grouped into 3 categories: all plants were either **trees, shrubs,** or **herbs.**
>
> In the 18th century, Linnaeus grouped plants into 24 categories based on the number of their reproductive parts.
>
> Today taxonomists groups plants into over 350 categories!
>
> How do you think we will group plants 100 years from now?
>
> As new tools and discoveries make new things available to our eyes, our understanding of the world will continue to change. . . .
>
> The lessons of Linnaeus have helped bring us this far. It is his legacy that they will continue to carry us to new horizons of understanding.
>
> [Copy draft 4]

The importance of this closing message is that it represents an unmasking of science, which to most people remains a mysterious and inviolable business. Studies conducted in the last twenty years show that public perceptions of science remain stereotypical: white lab coats, sterile laboratories, and bespectacled men.[1] Furthermore, science, still our sacred cow, is believed to hold the promise of salvation from a host of environmental, medical, and technological problems; and scientists are viewed as the ministers of a knowledge that is objective and true.

Paradoxically, scientists themselves have moved farther away from the certainties their profession once claimed. Both practitioners and philosophers have shown how scientific observations are influenced by the manner in which they are made.[2] Not just tools but also the changing tides of thought and vision affect what scientists perceive.[3] It was but a matter of time before this idea would begin to trickle down into the larger so-

ciety's depictions of science represented in, for example, textbooks, news reports, and exhibitions.[4]

Hence, one message of the Linnaeus exhibit is that science is an ongoing process, shaped by what it is possible to see. This idea was given voice by the exhibit team's taxonomist who, in the early planning stages, spoke passionately about a favorite aphorism: "The questions never change; only the answers do." In other words, science changes. Its solutions are never final but are always subject to the fresh eye of a new age. This message received the team's full support. Working it into the exhibit, however, proved challenging, because it dealt only indirectly with the subject at hand. It was never an explicit goal but a philosophical position on science. Yet, of all the material being considered for the exhibit, this particular message was integral to the meaning of the whole. It described the conditions that enabled not only Linnaeus to assert the reliability of his system but also today's scientists to assert the same for their own. Although addressing the nature of science may not have been a primary goal of the exhibit, doing so provided a broader context for orienting visitors to the concepts they would encounter. It took several drafts of copy to arrive at an acceptable way of presenting that context.

The first draft tightly integrated the message "science changes" into the narrative. An introductory panel presented the historical climate of eighteenth-century Europe, thereby setting the stage for the environment in which Linnaeus lived and worked. The frontispiece from Linnaeus's *Hortus Cliffortianus*—a fabulously symbolic, baroque engraving that evoked eighteenth-century science and culture—was proposed as an accompanying graphic. The first-draft narrative read as follows:

> As you can imagine from the frontispiece, science was a very different discipline at the time Linnaeus lived. Its language and illustrations were works of art. The questions scientists investigated were closely tied to the peculiar events and culture of the time. It was a time of tremendous exploration—both conceptual and geographical:
>
>> Improvements in the science of navigation paved the way for numerous trade and exploratory expeditions. Hundreds of new and strange species of plants and animals were discovered and brought back to Europe.
>>
>> It was the Age of the Enlightenment as scientists, philosophers, and political thinkers wrote and invented in a burst of creative energy.

> It was the age of the encyclopedia as people sought to organize the enormous influx of new knowledge into a comprehensive system.
>
> New tools brought the world closer to Linnaeus's eyes, shaping what he was able to see.
>
> Botany was not yet an established science. Plants were of interest chiefly to physicians, and were mostly investigated for their medicinal properties.
>
> [Something about the state of printing and scientific illustration as a means of communication—how it both fostered and limited communication among scientists.]
>
> <div align="right">[Copy draft 1]</div>

The exhibit team intended that this approach would provide not only the historical context in which Linnaeus had lived and worked but also specific examples of factors that had shaped the era's dominant thought, including, of course, Linnaeus's. The next panel introduced classification in the following manner:

> Throughout history, people have organized plants into different categories based on different criteria.
>
> This oak has been classified many different ways throughout history.
>
>> In ancient times, plants were grouped by *how they looked*. There were only three categories of plants: trees, shrubs, and herbs. The oak belonged to the category "Tree."
>>
>> During the 1500s, plants were grouped by *how they were used*, in medicine and in agriculture. There were dozens of categories for describing plants. The oak belonged to the category "XXXXX."[5]
>>
>> Today we group plants by a variety of characteristics: structure, biochemistry, habitat, and more. We use thousands of specialized categories to describe millions of species of plants. Today the oak belongs to the category "Fagaceae."
>
> <div align="right">[Copy draft 1]</div>

This panel was to be followed by a simple activity in which visitors could group disparate objects according to shared properties.

Having thus introduced the idea of classification, the proposed exhibit text continued with a short section about how Linnaeus classified

plants. It examined the criteria and rationale behind Linnaeus's proposal to group plants according to their reproductive parts. It also addressed the language—at times poetic, anthropomorphic, and even erotic—he used to put his ideas forth as a way of illustrating the characteristics of eighteenth-century science. The section concluded:

> Eventually, as new tools for examining plants were invented and new theories for explaining what those tools showed were developed, Linnaeus's system of classification was replaced by others which better described the relationships that could be seen.
>
> Categories like "genus," "family," and "order" are still artificial abstractions. Systems of classification do not exist "in nature"; people invent these systems to help them think and communicate about the world. As we develop new tools and concepts for viewing the world, our understanding of that world will continue to change. How will we classify the plant world a hundred years from now?
>
> [Copy draft 1]

Staff review of this early copy revealed two conceptual differences. First, although both the taxonomist and the designer appreciated the historical context primarily for its evocation of the period's color and flavor, they believed that to draw out its role in shaping Linnaeus's thought and science was to magnify an abstract, obscure, and ultimately untenable point. Historical context might indeed relate to forms of thought; however, they thought it was far more interesting as background scenery.

To the educator, what was compelling about the taxonomist's aphorism that "only the answers change" were the factors that caused the change. This was the first hint that the taxonomist had a differing interpretation of what those factors might be. For him, the changing nature of science had less to do with the wider historical and social climate than with the field's internal variables: for example, new tools, theories, and paradigms.

The second difference concerned the close interweaving between classification as an ongoing and changing activity and Linnaeus's particular classification system. To the taxonomist, this seemed to create something of a disclaimer that undercut the exhibit's intended focus. Of utmost importance to him was the message that Linnaeus's system marked a tremendously creative solution to a problem that had previously stymied the

practice of eighteenth-century plant science. He felt that this message should take precedence over that about the changing nature of science.

In contrast, the educator valued the opportunity to use Linnaeus's system to teach a more general lesson about classification and the thought processes by which scientific solutions are derived: for example, comparing and contrasting, and judging similarities and differences. Her approach to scientific learning emphasized process over product and thinking skills over the principle they derived.[6] Behind this approach lay the recognition that to reach most visitors, basic skills of processing information would be more applicable and relevant than specific facts. Moreover, such an approach would help to demystify an activity that pervades most visitors' lives but, to them, remains largely unintelligible, a matter for experts.

A simple rearrangement of text sufficed for the moment to satisfy both the taxonomist and the educator. Instead of introducing classification as a historical topic ("Throughout history, people have organized plants into different categories based on different criteria"), it was introduced as a scientific activity ("We organize plants into different family groups that reflect their relationships"). By focusing at the outset on the nature of the activity, it was possible to keep the spotlight on the brilliance of Linnaeus's solution while still addressing broadly the process of classification.

The disagreement over the treatment of historical context was resolved by shifting the exhibit's point of reference. The sketch of the historical climate was greatly reduced, partially to conserve space; and the message that science's solutions are shaped by external conditions was moved to a later section of the exhibit that displayed the artifacts. The resulting text follows:

> Linnaeus developed his systems of classification and nomenclature according to what he was able to see. Many things shape the way Linnaeus viewed the world.
>
> TECHNOLOGY. New tools like the microscope brought the world closer to Linnaeus's eyes and allowed him to see what was once invisible.
>
> EXPLORATION. Hundreds of plants were discovered by explorers and sent to Europe for study. A classification scheme was desperately needed to accommodate the many strange new plants.

PHILOSOPHY. Philosophers argued that the world (in this case, a plant) should be viewed and classified according to its own characteristics, instead of its usefulness to humans.

[Copy draft 2]

The panel below followed the cabinets of artifacts:

Over the years new tools have permitted our eyes to penetrate successively deeper and deeper into plants, from the level of visible surface structures to the internal organs to the tissues and cells that make up those organs to genes to molecules.

Scientific knowledge is constantly evolving as new tools and new concepts make new things available to our eyes. *What* we know cannot be separated from *how* we know it.

[Copy draft 2]

While the message of scientific change was still there, it now lacked the context in which it had been previously presented. Six illustrations of historical climate had been reduced to three, whose sole purpose was now to demonstrate their impact on Linnaean science. Removed from what was emerging as the two primary sections of the exhibit (classification and nomenclature), the message now suffered from lack of clear reference. Team members expressed their discomfort unreservedly: it was too vague; it was too abstract; and it distracted from the main point, which was that Linnaeus's systems of classification and nomenclature had marked a creative and significant contribution to the plant sciences.

However, there was yet another main point to be made: the fifth and final exhibit goal called for visitors "to realize the application of Linnaeus's system to the organization of the plant world today." This goal gave new direction to resolving where messages about the nature of science properly belonged. As a forerunner of modern taxonomy, Linnaeus's system demonstrated that science is not static but changes and grows with each new generation of observers. For the educator, the lesson here lay in the present. In her mind, what was interesting about the idea that science changes was not so much that the Linnaean system has been replaced by improved systems of explanation, but that those improved systems, in which we place so much faith today will continue to be replaced by others tomorrow. Once again, the goal of this message was

to help make the exhibit more meaningful to visitors, by bringing the science up to the present and by addressing its basic nature.

The next round of copy revisions reflected this new shift in reference. The revised narrative compared science then and now: what did Linnaeus see, and what do we see; what did he use to see it, and what do we now use to see it? By shifting back and forth between the two perspectives, the lesson about changing views applied not just to the past but also to the present. The exhibit team therefore decided to replace the three general influences (technology, exploration, philosophy) with four specific examples, each to be illustrated by an artifact from the past and the present:

> Linnaeus's contribution was shaped by the problems, tools, and events that characterized his time. They are what determined what he could see:
>
> - the scientific PROBLEMS and questions that predominated
> - the scientific TOOLS that were available to him
> - the means of COMMUNICATION with which knowledge was shared
> - EVENTS of the day that influenced the practice of science
>
> Improvements on Linnaeus's system were also shaped by the prevailing problems, tools, and events which shaped what later scientists were able to see.
>
> [Copy draft 3]

The biggest problem at this point was how to demonstrate simply the impact of these various influences. Specifically, the exhibit team thought that sections dealing with prevailing "problems" and "events" were too abstract and complex to address in simplified form. Furthermore, neither could be easily illustrated by accompanying artifacts. The message was thus subject to one final reduction. Instead of focusing on multiple factors that influenced science, the exhibit would single out one: the tools with which scientists perceive and interact with the world (see Copy draft 4).

In summary, two things are revealed by the sequence of copy changes outlined above. First, the exhibit team consistently emphasized the principles of science (for example, the sexual system of classification and binomial nomenclature) over the broader conditions that shaped them (for example, cultural context and dominant paradigms of thought).

Second, they nevertheless retained the conditions, albeit modified by reference and location. The effect was to separate the scientific product from the conditions that influenced it. Arguably, the presence of the latter could distract attention from or add complexity to the central story. Ultimately, however, that is a problem of not content but composition.

While considerably toned down, then, the message remained: science changes. What we see changes. What we know changes. And, to the extent that these things continue to change, we can never be entirely certain of the "truth" of our explanatory systems. This is a remarkable message: for it has to do not just with Linnaeus's or our own system of classification, but with the conditions by which we are even able to know and to speak about them.

This message is the most significant story to be drawn from the exhibit copy cited above. More than just a particular depiction of science, it reflects a shift in the language museums use to discuss their collections. This shift finds its roots in a wider revolution of thought about the nature and the production of knowledge.

Scientists have not been alone in questioning the basis of their work. Our century has seen doubt cast over long-held assumptions in every major discipline. The notion that knowledge depicts a "true" and objective reality no longer holds the sway it once did. The idea has begun to take hold that knowledge is socially constructed, shaped by prevailing interests, values, and mores. No major academic domain has remained untouched by this idea. Yet museums—whose very business is the generation and the communication of knowledge—have been slow to consider its implications for exhibits and the exhibit-making process.

As practicing scientists and historians, curators have been deeply affected by current debates about knowledge. However, few have shared these uncertainties and disagreements with the museum audiences to whom they communicate. For the most part, it has been museum educators who have sounded the cry for exhibits that take into account the basis for the "knowledge" presented. It is educators whose sensitivity to visitors has brought them to question the comprehensibility, the significance, and the voice of exhibit messages. When educators represent the views of museum audiences, and when they argue for alternative messages that speak to diverse perspectives, they are bucking traditional ways of knowing and presenting objects.

Education thus regarded becomes an act of empowerment. In working to make museums responsive to the public, educators have instituted reforms in their interpretive activities that treat knowledge as not only a productive endeavor but also a shared venture: for example, they have involved the wider community in interpreting collections; legitimized a range of possible meanings and outcomes of a museum visit; and begun to expose the meaning-making activities performed by museums. Interpretation thus conceived is the business of not just those who possess *special* knowledge but also those who possess *any* knowledge and relation to the collections at hand.

How this shift has come about and how it will play out is bound up in the history of museum interpretation. That history is the subject of the next two sections of this chapter, which will look at, first, changing definitions of knowledge and, second, changing practices of interpretation within museums. The final section will consider the implications these shifts entail for the way we understand museums' interpretive role and task.

Changing Definitions of Knowledge

Few scientists would argue with a broad statement such as "Science changes," because the ongoing regeneration and refinement of explanations about the physical world is basic to their work. But they have traditionally operated under the premise that there exists an underlying order to nature that can be known. It is this premise that has been contested in recent years by new views that insist on the contingency of knowledge. By these accounts, the truth of a statement rests not on its correspondence to some objective "reality" but on the context in which it is derived—be it historical, cultural, or social.

In the sciences, this trend has been afoot since Werner Heisenberg's revolutionary uncertainty principle. In demonstrating the influence of physicists' tools on what they observe, Heisenberg linked scientific knowledge to the exterior conditions that shape it. While his work dealt primarily with the physical context of instrumentation and experimentation, later historians and philosophers of science began to consider the influence of the observer's historical and social context as well.[7] The result was heightened attention to the interpretive basis of scientific work.

This attention was not limited to the sciences. As the twentieth century unfolded, a growing awareness about the fundamentally interpretive nature of knowledge led scholars across the academic spectrum to rethink the assumptions of their disciplines. Historians, for example, became increasingly self-conscious of the extent to which their observations of and approaches to examining the past were shaped by their own particular historical moment. Anthropologists began scrutinizing the cultural biases in their work and found racist undercurrents in their own depictions of other cultures. Art historians and literary critics tested their boundaries by demonstrating how social forces ultimately shape definitions of art, beauty, and quality. The development of psychoanalytic theory turned attention within, toward the repressions and desires of individual human consciousness as the ultimate shapers of thought and perception.

History, culture, society, and personality; while each of these variables represents a distinct set of influences, all are united by one thing: they describe conditions that shape how we know what we know. All stem from the common assumption that knowledge is fundamentally interpretive. The significance of this fact lies not so much in its novelty. The integrity of knowledge claims has long rested on minimizing the factors that influence the process of knowing. Instead, its significance lies in the tendency to embrace rather than to downplay these factors and thus make them the centerpiece of all thought and knowledge. In other words, no method of knowing provides a clean escape from the conditions that shape thought, because those conditions are immanent in the very definition and pursuit of knowledge.

The theoretical underpinnings of this shift in perspective about knowledge have been most fully explored in the field of literary criticism. Literary critics have long wrestled with the subtleties of meaning embedded in works of fiction. The development of semiotic theory cast their task in a whole new light. Semiotics treated language as a system of signs and was concerned largely with the rules by which those signs functioned. Ferdinand de Saussure's dissection of the sign into *signifier* and *signified* set forth the fundamental problem that would preoccupy the next generation of theorists: how the two come to be joined.[8] How is it, in other words, that the word "girl" (or "woman" or "chick") could come to signify an adult female? By Saussure's account, the connection was arbitrary; the only thing that tied a word to its object was social convention,

which itself was far from arbitrary. Language, consequently, came to be viewed as being embedded with ulterior interests and values. The question of meaning thus shifted from the literal text to the conditions of its production: the social mores, interests, and existing knowledge that shaped what was possible for an author to say and, ultimately, defined the terms for meaning.

The central question of literary criticism then was no longer "What does a thing mean?" but "What makes a thing meaningful?" Movements like structuralism, deconstruction, and Lacanian psychoanalysis each had a different answer. Meaning was never so ambiguous, and literary critics were never so conscious of the sheer variety of factors that shaped thought and intention. Even the objects of criticism were transformed by the recognition that messages might be borne by any manner of media, nonverbal included. The term "text" came to refer to any signifying system, thus bringing message bearers throughout the social and cultural fabric—from advertising and architecture to film and fashion—into the fold of literary criticism.

Whatever the text, whatever the analytical method, meaning now existed in reference to a wider context of values and interests. Thus, to speak of a masterpiece of art or a literary classic is also to speak of the criteria of taste and value by which it is judged to be great. For this reason, it has no longer been tenable to speak of any work without reference to the social, cultural, and historical context in which it was produced; for it is that context that ultimately prescribes the standards of quality and criteria of truth according to which meanings are determined.

Even scientific discourse, whose very existence is devoted to the search for certainties, was subjected to this critique. Literary critic Jean-François Lyotard showed how the reliability of scientific statements depends on what he called "legitimating criteria" that exist outside of its normal domain of discourse: for example, consensus, efficiency, and performance.[9] He demonstrated that even supposedly objective knowledge like science, in which verification is a central activity, rests on judgments that express the values and the interests of the knowledge producers.

These shifts in thought about knowledge have not been smooth. Nor have they been restricted to the scholarly domain. Battles over new interpretations of history and culture have become a very public discourse.

Educators, as communicators of knowledge, have found themselves smack in the center of these debates. Since they are responsible for deciding what will be taught, which often determines what will be thought, it is not surprising that public schools and university classrooms throughout the country have become sites of fierce debate. While operating in this heated climate, educators have also been grappling with a related problem: making knowledge relevant and worthwhile to the learner.

In recent years, "reaching learners on their own turf" has become a watchword for teachers facing a generation of apathetic, maladjusted, and in the words of one now-famous commentator, "impoverished" students.[10] The incorporation of popular forms of literature and culture like science fiction, current events, film, and other mass media into mainstream curricula was one way of reaching students through the languages and cultural forms that were a part of their everyday experience. However, it also appeared to give equal footing to "inferior" cultural forms and knowledges.

Fueling these concerns was the appearance of special-interest departments and programs in universities throughout the country. With the genesis of women's studies, African American studies, and gay and lesbian studies, just about any disenfranchised group could make a case for their subspecialty. At issue was the retrieval of histories, literatures, and other art forms that had been excluded from the canon of "Great Books and Ideas" that formed the core of university studies.

It is no accident that the term "canon" came to be applied to this core curriculum. It encapsulated perfectly the reverence held for texts that were widely regarded as the pinnacles of Western thought. Critics of the new curricular and program revisions cast the issue in stark terms. They argued that there exists a body of superior books, ideas, and art that stands at the center of the Western tradition, and that it is possible to determine these works by absolute standards of judgment, value, and quality.

Canon opponents, however, challenged the very nature of the issue. It was not a matter of great books versus inferior books, high culture versus low culture. It was about the very existence of criteria by which judgments of "greatness" could even be passed. It was about the singling out and privileging of criteria that supported one group's tastes and values. And it was about the use (or abuse) of those criteria to keep nondominant groups at bay. In short, it was about politics—cultural politics.[11]

This debate has changed the way all cultural products are viewed. For example, teaching a popular-culture form such as science fiction or film was no longer considered simply a pedagogical strategy but an affirmation of that particular genre's value. This shift in perspective upheld the idea that knowledge is the product of a wider social and cultural context, and that popular forms potentially hold powerful messages and meanings to those who inhabit that context.

In the late 1970s and well into the 1980s discussions about meaning making became inscrutable, as theorists struggled to speak about that which they were inevitably doing. For the canon bashers, the simple connection that linked knowledge to context was enough; it gave philosophical grounding to what critics were trying to paint as a patently political agenda.[12] Politics, of course, were still at issue. However, it was the upholders of "Western tradition" who were using cultural works to protect a power structure that favored them. What had begun as a critical method of literary studies had grown into a potent tool of social analysis.

What does all of this have to do with museums? The debate about the canon closely parallels events in the museum world. By suggesting that they possessed "Great Objects" of "Great Value" that represent "Great Traditions," museums have traditionally presented their collections according to the Great Books prescription. In so doing, they have privileged a particular mode of knowledge, particular methods and criteria for acquiring it, and a particular class of (usually) professional curators and directors who author—and authorize—it. Admittedly, some curators, particularly during the first twenty or thirty years of this century, introduced some innovative approaches to the interpretive enterprise. However, it has been educators, through their efforts at making collections accessible, who have done far more radical work that has both exposed and undermined the structure of knowledge production in museums.

Changing Practices of Interpretation

The use of interpretation was inaugurated early in museum history by curators, particularly those devoted to the public welfare.[13] Employed sporadically throughout the nineteenth century, interpretive devices like labels, brochures, and lectures became a permanent fixture in museum

halls by World War I. Initially, their content was largely information-based: dates, places, and facts were the norm. Some curators, however, began experimenting with new ways of presenting collections that, they hoped, would more effectively reach visitors. The most innovative of these figures was John Cotton Dana, director of the Newark Museum. Contemptuous of what he called "gazing museums," Dana hesitated to call the Newark a "museum," preferring instead "institute of visual instruction."[14] His many special exhibitions stretched the boundaries of conventional display by featuring, for example, applied and industrial arts, textile and clay products manufactured by local firms, immigrants' handicrafts, and "inexpensive articles of good design." Dana hoped that these exhibits would draw new visitors like housewives, workers, immigrants, and others who might have a natural interest in the objects on display.

More important to Dana than what was displayed, however, was how it was used. He established many now common practices to increase the museum's usefulness: for example, loaning objects to school classrooms, shops, and hospitals; creating a teacher-training course at local colleges; opening a "junior museum" for children only; establishing branch museums in local libraries.

Dana was not the only such innovator. Others came, interestingly enough, from the art-museum establishment, which then even as now had a strong conservative strain. As discussed in Chapter 1, many art museum officials were moved by wider social failings that they hoped their institutions might help to redress. Others, concerned about America's weakness in design, felt that museums could have a hand in elevating patrons' taste, thereby educating not only the producers of fine and applied arts but also their consumers, thus creating a demand and model for quality work.

Not lost on museum officials was the more subtle character-building that exposure to good art could induce. Historian Terry Zeller has cited numerous examples of ways museums sought to refine citizens and to raise their standards of beauty and taste.[15] The Toledo Museum of Art, for example, was an early pioneer, engineering a number of civic improvement projects and preaching "the gospel of simplicity and truth." The museum exhibited model homes and landscaping scenes and mounted two period rooms, one "furnished inexpensively and in good taste," and "the other room exhibiting as many as possible of the most common offenses against

the laws of truth and beauty."[16] Other museums involved in the beautification movement included the Art Institute of Chicago, through the Better Homes Institute of its Extension Department; the Boston Museum of Fine Arts; and the Milwaukee Art Institute.

Other innovators included the Rochester Museum of Arts and Sciences' Arthur Parker, who labored to make museums active service centers in their communities. Like Dana, Parker mounted exhibits with broad popular appeal and initiated services intended to break down museums' psychological and intellectual barriers. To him, the measure of museums was not their wealth and collections but the values they disseminated. Activities like loaning materials to schools, sponsoring programs for the unemployed, and offering programs to promote patriotism during World War II were just a few of the ways Parker sought to expand museums' community-service role.

In sum, many genuine efforts were made to make collections accessible to viewers before the arrival of professional educators.[17] Most of those efforts, however, whatever their express motives, sought to inculcate the public with specific aesthetic values. Naturally, they were the values of the propertied class who chose and controlled the culture enshrined in museums. Ideology, then, was as much a part of the mission as cultural uplift. As T. J. Jackson Lears has observed,

> Many middle- and upper-class Americans felt that if only the proper educational balance could be struck, immigrants could be assimilated, angry workers calmed, and an incipient leisure class returned to productive life.[18]

Like the museum proprietors of the founding republic, then, many early twentieth-century curators saw in museums the possibility of achieving social and cultural uplift for their public. They, too, were guided by specific, usually middle- to upper-class, ideas of what was good and what was beautiful.

As innovative and successful as some of these early approaches to reaching visitors appeared to be, they were not the norm; most occurred in small pockets throughout the nation, usually in metropolitan museums. Many innovators still faced resistance from colleagues who had differing philosophies about museums' public role, and few were furthering their cause in a broader, professional sense. As Paul Rea noted in his study on the problems and needs of U.S. museums:

> [While] a great diversity of educational methods has been developed and a high order of results has been achieved . . . few methods of juvenile museum education have become universal. There seems to be more interest in devising new small-scale experiments than in the more prosaic work of extending to the whole field such methods as have been found most generally effective.[19]

Still, the foundation was clearly laid for museums' involvement in a variety of public activities. The next stage would be ushered in with the newly emerging museum educators.

As museum education evolved into an autonomous profession, what affect did educators have on the interpretation of collections? Insofar as educators have lobbied for visitors' interests in practically everything museums do, including—and especially—interpretation, their influence has been substantial. It has been most significant in three areas: first, in the mere presence of interpretation; second, in the language used to interpret; and third, in the content of the messages. Educators' impact in these three areas occurred roughly chronologically, although there was considerable overlap.

The first issue—advocating the presence of interpretation—has been an ongoing cause for educators. Providing interpretation was the single most important thing museums could do to engage visitors with their collections. Of course, by the time educators came onto the scene in the 1930s and 1940s, many museums had interpretive and educational programs in place. Many more, however, remained underdeveloped with respect to their public functions; and even those with established programs were subjected to the backlash of conflicting professional opinion.

Art museums, for example, may have been the seat of many innovative programs, but not everyone supported their innovations. Many curators opposed educational activities that appeared to interfere with the direct contemplation of the object. In their eyes, interpretation demeaned art by turning it from an aesthetic phenomenon into a social or historical construct. The following statement by John Walker of the National Gallery of Art exemplifies this position:

> A work of art is not a specimen, not primarily an historical document, but a source of pleasure, analogous to, say, a musical composition. The major

purpose of the National Gallery is to allow each painting, piece of sculpture, or other object of art to communicate to the spectator, with as little interference as possible, the enjoyment it was designed to give.[20]

While critiques such as this did not oppose the educational value of art collections, they did oppose the provision of aids to that education. It was precisely this sort of attitude that educators sought to change. In his study about the educational values to be derived from museums, T. R. Adam observed:

> To someone outside the world of art criticism, there must seem an element of almost mystic faith in this belief in the power of great paintings to communicate abstract ideas of beauty to the uninformed spectator. . . . When background is lacking—where there is no knowledge of what the artist is attempting to say in terms of time, place, or social meaning—the resulting impression is confused and is likely to be painful as pleasurable.[21]

Despite such views, many art museum staff have persisted to advocate unadulterated contemplation as the proper means to understanding. Anything else alters, simplifies, and trivializes not only the art on view but also the experience of looking. Such sentiments were given eloquent voice by Walter Pach. In *The American Art Museum,* he argued that museums could not (and therefore should not) reach the public without lowering their standards:

> In the confusion of values amid which the world is struggling, the man in the street may be so misled by the blare of loud-speakers and the dazzle of fierce lights that his chances of achieving good judgment and good taste are progressively endangered. Much of what he gets over the radio, at the movie house, and from posters, magazine covers, and the like is making his "street" always more unhealthy. In that case, the museum cannot go halfway in meeting him.[22]

In other museums, the issue of scholarship continued to be raised periodically as the proper and primary focus of museum activities. In his 1932 study, Paul Rea admitted that "except in a few more favored or braver museums, scholarship has probably suffered from the public museum movement."[23] Additionally, Herbert J. Spinden in a 1940 *Museum News* article, "The Curators in the New Public Museum," observed:

It seems that in some institutions curators have little to say about new spec-
imens and little opportunity to develop their scholarship. The great Amer-
ican enigma is why men who have achieved a reputation in some special
field are hired because of that reputation and then given no opportunity to
do the kind of work for which they are best fitted.[24]

Despite such opposition, educators continued to press forward. Grace
Fisher Ramsey's 1938 study of educational work in museums recorded
dozens of examples of educational activity in museums nationwide: gallery
talks, discussion groups, teacher training, school visits, museum clubs for
children, extension work, and programs for disabled people.[25] In 1942 the
AAM appointed a Committee on Education to review the social and ed-
ucational problems facing museums; the result was *The Museum as a Social
Instrument.*[26] While Ramsey's and the AAM's studies clearly supported mu-
seums' educational potential, they cautioned readers against jumping to
conclusions about the effectiveness of museum education.[27] A 1952 study
conducted at Chicago's Museum of Science and Industry echoed their
concerns: just because visitors look does not mean that they learn.[28]

Still, educational activity in museums proceeded unabated. By 1960
79 percent of museums were reportedly offering some kind of organized
educational program (up from 15 percent in 1932);[29] and from 1952 to
1962 the gross attendance to museums more than doubled.[30] While im-
possible to establish a direct association between the expansion of edu-
cational offerings and the growth in attendance owing to the former, it
is not a far stretch to suppose the two may be linked.

It would seem that museum education had finally taken root in the
institution. Yet, despite the widespread allocation of staff and budgets to
educational services, education remained a minor institutional mission.
Throughout the 1960s and well into the 1970s, educators worked with
minuscule budgets in substandard office space; they were rarely involved
in exhibit development, and they had little or no voice in museum af-
fairs. Curators still reigned supreme; they kept alive old concerns about
the treatment of collections, while educators continued to advocate the
inclusion of interpretation that was directed toward visitors, not scholars.
In the early 1960s, for example, curator Wilcomb Washburn of the
Smithsonian Institution lamented the changes wrought by

professional educationists, who consider education a professional skill too abstruse to be left in the hands of the scholars, and who, typically, substituted functions and techniques for purpose and content.[31]

Echoing his concerns, Daniel Catton Rich, director of the Worcester Art Museum, exhorted:

> Though from time to time we will be advised to arrange our collections by the latest department store techniques, we must resist. The Kress stores and the Kress collections are quite separate things. Never must we be persuaded to become the supermarkets of culture.[32]

Keeping the debate alive during his tenure at Cleveland's Museum of Art, the irascible director Sherman Lee declared in 1971: "I part company with the concept of a museum as an instrument of mass education."[33] Meanwhile director Thomas Leavitt of the Museum of American Textile History pushed for the placement of educators under curatorial supervision: "Left to its own devices, a museum education department is like a nervous system detached from the cerebrum, like the chicken's conduct after its head has been cut off."[34]

Fortunately for educators, the AAM did not share these views. In 1973 it approved the creation of a standing professional committee on education to serve as the profession's mouthpiece and advocate. By the end of the decade, educators finally began to achieve parity within the museum institution. Pressure was mounting on museums to address a variety of public issues, such as assisting ailing school systems, diversifying audiences, undertaking community outreach, and increasing attendance to generate revenue and to demonstrate public service. These factors, combined with the growing professionalization of museum-education practice, began to make educators more valuable to administrators. Consequently, many began participating on exhibit-development and marketing teams. A few managed to break the glass ceiling with appointments to senior administrative positions.

As educators became more involved in decision- and policy-making, different issues came to the fore. No longer was it the case that they had to push for the inclusion of interpretation. With the possible exception of art museums, where "unadulterated contemplation" remained in high favor, by the 1980s interpretation was an accepted institutional function.

However, the nature of that interpretation became a contested issue. Hence, the second area in which educators affected interpretation was language.

If interpretation was to be effective, it had to be expressed in a manner that was both comprehensible and engaging. More often than not, it was neither. Interpretive writing was typically the purview of curators who had the expertise to know what to say but whose ability to say it often left something to be desired. As a result, labels and other interpretive materials often bore a voice that was technical, verbose, and eminently curatorial. "Rules" for effective labels had been put forth ever since Goode's time.[35] But it was the rare curator who practiced what the rules preached. Not surprisingly, few visitors had the wherewithal to absorb label text.

It was not until visitor-studies procedures became a more regular museum practice and interpretation was subject to evaluation that it became clear just how ineffective exhibit labels had often been. Some suffered the pitfalls of poor writing or design; others failed on the grounds of being simply uninteresting.[36] It is probably no coincidence that the bulk of these studies began to appear when the climate in museums was becoming more friendly toward educators and their interests. Museum officials were finally beginning to get the message: interpretation was about communication; and effective communication required bridging the world of the expert and the world of the layperson with language that was intelligible to the latter without being a misrepresentation of the former.

Achieving this balance between accuracy and intelligibility resulted in the development of new writing styles, many of which were reinventions of old rules. Many museums, for example, began to adopt a prose style that was short, simple, and direct. Others, notably the Monterey Bay Aquarium, began experimenting with the organization of information, producing a label hierarchy that distinguished between general and specialized messages. Label writer Judy Rand set a new standard and form of speech at the aquarium through the use of humor, colloquialism, questions, and second-person voice.[37] While many museum professionals balked at the sacrifice or oversimplification of information, evaluations of these new labels showed visitors engaging in such behaviors as reading aloud, pointing to objects, and sharing information. More importantly, visitors understood and were able to reiterate exhibit messages.[38]

Elsewhere, visitor researchers studied various narrative strategies that contributed to label effectiveness. At the Brookfield Zoo, for example, Beverly Serrell found that labels which included explicit visual references to what was on display held attention longer than labels lacking such references.[39] Steve Bitgood, while working at the Anniston Museum of Natural History, found that dividing a single label's text into several discrete chunks of information increased reading time significantly.[40] Separate studies conducted by Bitgood and other researchers confirmed that the inclusion of questions and directives in labels helped to focus visitors' attention and to increase their time spent reading.[41]

Of course, communication extends beyond the words on the wall. Messages are equally borne by the visual presentation, from interpretive graphics to display elements. With the growing acceptance of educative ways of thinking, researchers were conducting more studies on how the design of interpretive devices could improve visitor learning. With the incorporation of interactive elements into labels, along with improvements in legibility and attractiveness, exhibit halls began to receive a long-needed facelift. Standards and guidelines were established regarding type size, placement, figure-to-background contrast, and other design issues. Consequently, interpretive graphics were employed more boldly—both to illustrate messages and to provide atmosphere. Artifacts increasingly shared the stage with elaborate set dressings designed to establish a broader interpretive context. Significantly, these activities marked the growing participation of education and design personnel in exhibit development decisions.

Not everyone welcomed these changes. Critics raised anew questions about the proper treatment and selection of artifacts. When the Field Museum appointed "exhibit developers" from outside the curatorial division to head its exhibit teams, anthropology curator John Terrell had this response:

> [B]ecause curators can't remember how little museum visitors know—and so expect much more from visitors than they reasonably should—from now on, museum educators are to be the "choosers," the lucky ones to decide what visitors may and may not see in museums.
>
> What? The powers-that-be honestly believe exhibitions can be mounted without curators? Preposterous. But, sadly, we have no ruby slippers in our collections at Field Museum to tap together to return to better times.[42]

Terrell is not alone in his views. As educators have become more involved in exhibit and interpretive functions, once the domain of curators, more curators have begun to speak out against what some have called the "Disney-fication" of museum halls.[43]

Educators, however, were to leave their most radical mark in their third area of influence—the content of messages. No matter how engaging the interpretation of, for example, a Cambrian fossil, the question remained: Do visitors even care that another set of creatures once roamed the earth? Indeed, why should they care? The issue of language in museum-exhibit text has to do with not just presentation but also context, which has as much to do with the visitors as with the object. In other words, visitors' interest and attention is determined not by an object's inherent appeal but its relevance to their own framework of knowledge and experience. It was but a small step from visitor-centered language to visitor-centered content, and label writers experimented accordingly.

The Denver Art Museum, for example, proposed for labels a new "experience-driven paradigm" in contrast to the traditional information-driven paradigm. Based on their research about how novices view art, the new labels focused on what the visitors wanted to derive from the art instead of what the museum wanted to impart to visitors.[44] Making a human connection, for example, was found to be important to art novices. "Human-connection labels" focused on people—artists, patrons, users, and viewers—and employed such strategies as relaying first-person testimony and referring to the viewers' cultural context.[45]

Other museums also began employing front-end evaluation as a part of exhibit planning to determine visitors' interests in and knowledge about a particular topic. For example, when Minda Borun was education director at the Franklin Institute of Science, she conducted extensive interviews with visitors about their notions of gravity. Visitors' input helped exhibit developers to frame the subject in a way that was sensitive to visitors' preconceptions.[46]

As the climate in museums warmed to visitor input and feedback, exhibit developers also began to seek advice on exhibit content from outside advisory groups that represented various communities—for example, cultural groups, neighborhood residents, and teachers. This cooperative spirit marked an important step in making the production of knowledge and exhibits a shared process, open to everyone who might have a stake.

Finally, a handful of curators who were sensitive to the changing academic tide began to incorporate overlooked perspectives into museum exhibitions. Historians, for example, changed the face of Colonial Williamsburg by bringing to public view interpretations that deal with slavery and the African American experience that had previously been excluded. More exhibits began to consider long-neglected versions of history and culture, thereby giving voice to the perspectives of laborers,[47] women,[48] and other underrepresented groups.[49]

Exhibit content would receive its greatest makeover, however, with the entry of other noncuratorial, nonscientific meanings into the interpretive domain. As studies continued to reveal the vast range of interests, expectations, and experiences that visitors brought to museums, the question of relevance took on new dimensions: for example, who was to say that what was significant about an object to a visitor was any less valid or significant than what was significant to a curator? If a visitor was moved by a crystal decanter that reminded her of a family heirloom, did it matter that she did not learn something further about the Waterford line that had produced it?[50] Museum educator Patterson Williams explained:

> I would argue that the essence of a museum's public function is to enable the visitor to use museum objects to his own greatest advantage. To call for museum literacy, therefore, is to call for a theory of instruction focused on teaching visitors how to have personally significant experiences with objects. . . . The goal [of such a theory of instruction] must be an experience on the part of the visitor which *the visitor values;* therefore the significance, if any, of the encounter will be determined by the visitor's value system, not by our own.[51] [emphasis mine]

It became clear that the task of interpretation was first and foremost a task of connection: getting visitors to connect to what they see, on whatever terms that might be. At issue was the legitimization of personal experience as a source of meaning *different from but no less valid than* curatorial knowledge. Advocates of this view began experimenting with interpretation that encouraged visitors to look inside themselves.

Characteristic of this approach was a shift in focus from the object to the process of looking at it. For some, the goal was to impart not facts, but tools—skills of perception and interpretation. At the Brooklyn Children's Museum, for example, an exhibit entitled "The Mystery of

Things" introduces children to the process by which identifications and meanings are assigned to objects. Based on Csikszentmihalyi's work on the meaning of things,[52] the exhibit presents dozens of unfamiliar objects from around the world; interpretation guides visitors to use their senses and make associations to identify the objects. Of special interest is the fact that the exhibit is self-reflective, so that its messages also apply to museums and how they look at and decipher objects.[53]

Other museums have experimented with ways of evoking and validating visitors' personal responses to museum pieces. The Denver Art Museum, for example, developed a two-columned label for some of their paintings that reads on one side, "If you like this painting, is it because . . . ", and on the other, "If you don't like this painting, is it because . . . " A series of statements on each side helped visitors sort out their reactions to the paintings.

Similarly, in one of the earliest of such examples, the "Game Room" at San Francisco's Fine Arts Museum made important use of the idea of visitor-centered meanings. Designed as the art world's answer to the participatory-learning stations so popular at science museums, the room actually achieved a far more radical result. Its four "games" elicited visitors' personal judgments and opinions by challenging one of curators' most sacred cows: the idea of the masterpiece. In "Guess the Masterpiece," for example, visitors chose their favorite painting and played a computer program that helped them to characterize what they found appealing about it. "The Masterpiece Comparison Game" allowed visitors to compare their assessments of various masterpieces with that of curators.[54]

Another example of museums' experimenting with visitors' responses can be found at the Art Gallery of Ontario, where Doug Worts has been experimenting with different ways of stimulating visitors' personal responses to paintings. For example, "Share Your Reaction" cards, dispensed in some two dozen locations throughout the museum, have encouraged visitors to reflect upon their experiences with the art through writing or drawing. "Explore a Painting in Depth" uses audio to model different ways of engaging with an artwork. Most unusual is a reflective imaging exercise that has guided visitors into a reverie with a particular painting and has helped them to explore the personal reactions, feelings, and memories that it evokes. Both of these methods have elicited some rather dramatic and moving responses.[55]

Again, the significance of these approaches does not lie exclusively in their novelty, because no one denies the power of art to trigger an emotional response. But explanations of art's meaning and significance have always rested on external historical and aesthetic standards. The significance of these experimental approaches for eliciting visitors' response lies precisely in their insistence on internal, personal standards of meaning that are legitimate and that can stand on equal footing with traditional external standards.

Over the course of a few years, educators' interpretive role has thus shifted dramatically from representing the curatorial view to experimenting with new languages and methods for representing that view, and finally to authorizing alternative views altogether. Educators' immediate goal may have been to develop innovative ways of making collections intelligible and interesting; but in so doing they found themselves challenging not only traditional ways of speaking about objects but also the very basis and authority for speaking about them at all. At stake was nothing less than the conditions for knowledge by which museums have traditionally abided. Exactly what that means—for museums, for exhibitions, and for the nature of the interpretive task—is the subject of the next section.

Implications for Museums' Interpretive Role

By promoting interpretations that reflect visitors' worlds and experiences, museum educators have brought the debate about canon into the institution. Questions about what collections represent and who controls their representation parallel closely wider disputes over how knowledge should be defined. As advocates for visitors and their perspectives, museum educators have served as the catalysts of the wider shift to a more context-based definition of knowledge. If museums today are more attentive to displayed objects' contexts, and if they employ advisory groups and other mechanisms to solicit input from those with a special relationship to or knowledge about their collections, then it is largely because educative modes of thinking have pervaded the way exhibits are conceived and developed.

Although educators did not generate the new scholarship and inter-

pretations that have allowed them to make exhibits more inclusive, they are to be credited with taking an activist role in insisting that such interpretations be considered. Their efforts, as a result, go beyond the educational task of imparting understanding, and have had far-reaching political and epistemological ramifications. Three of these ramifications are examined below.

First, the inclusion of alternative ways of interpreting museum collections is open acknowledgment that there is more than one way of knowing. What is so revolutionary, however, is not the fact itself but the legitimacy conferred on those new knowledges by their mere presence in the museum. Ironically, it is that very authority to legitimate that their presence stands to challenge. Museums have traditionally been tremendously authoritative institutions. The history of their development, the architecture of their presence, and the gravity of their responsibility as stewards over the nation's cultural heritage have all bestowed on the institution authority over matters of knowledge. Inherent to this authority is the long scholarly legacy out of which museums grew.

So to permit, even to encourage, the inclusion of alternative interpretations is to acknowledge other modes of knowledge besides that on which museums were built. While practices such as the use of popular linguistic forms and nonscholarly contexts of meaning were promoted as aids to understanding, in fact they achieved a far more radical result. As the literary critics have so ably demonstrated, meaning is intimately connected to both the context in which it arises and the language with which it is crafted. To refer to an object in a different manner is to present not just an alternative way of communicating about it but also an alternative way of conceiving its meaning. The difference may seem insignificant, but it can have tremendous impact. For example, compare these three ways of labeling a gorilla specimen, all of which—until a 1992 renovation—could be found in different exhibits at Chicago's Field Museum of Natural History: "Western Lowland Gorilla"; "Man-like Ape"; and "'Bushman' lived in Chicago most of his life." The first presents viewers with a biological specimen; the second, with an animal depicted in anthropocentric terms; and the third, with an individual who has not only a name but also a history.

Second, curators no longer wield the same authority over museums' interpretive function. Educators now have a hand in that function,

although their role is still often confined to presentation: making interpretation available and intelligible. Presentation, however, has turned out be more than mere window dressing. As the above example shows, the manner of presentation affects not just the effectiveness of the communication but also the particular meaning it bears. Furthermore, as educators have become more knowledgeable about visitors' interests and needs, they have campaigned more strongly for interpretations whose content is more reflective of visitors' worlds.

Although curators might hold authority over interpretations stemming from their technical and scholarly knowledge, that does not necessarily qualify them to speak to meanings that are based on nonscholarly criteria of knowing. As visitors' representatives, educators are better versed in the diversity of languages and backgrounds that define visitors' ways of knowing. As a result, they are also more sensitive to the multifaceted nature of the interpretive enterprise. After all, there is no one "visitor-centered" way of interpreting something because museums do not have a single, homogenous audience. One of educators' biggest challenges has been to deal with the fact that even visitor-friendly interpretations only reach those visitors to whom those interpretations are indeed friendly. One solution to reaching a diverse population has been to hand the interpretive process itself over to visitors, so that they may discover for themselves the meanings that speak to them. By providing guides to questioning and looking, visitors are empowered to look for themselves from their own particular vantage point.[56]

Just as the work of white, Euro-American men may not be representative of other Americans' experience, so too may the specialized perspectives of curators never hold meaning for many visitors. By acknowledging such disjunctions and promoting alternative interpretations, educators have begun to shift the balance of power. On the surface, this shift might appear to be primarily territorial: educators now share some of the same interpretive functions that were once the domain of the curators. But it runs far deeper, touching basic assumptions about what museums are and do by authorizing other criteria of knowing and legitimizing other knowledge producers. Not just educators but also visitors themselves may now have a hand in the meaning-making process.

Third, the very nature of museums' exhibit function has been altered. Once a seemingly straightforward matter of displaying collections,

exhibition can now be viewed as an eminently interpretive endeavor: not just that the information exhibits present is subject to multiple interpretations, but the very act of presentation is fundamentally interpretive.

As a practice, exhibits were first developed for the sole purpose of presenting collections to public view. Over time, they were embellished in ways that were thought to improve that view: draped fabrics, painted backdrops, illustrative props and graphics were incorporated into exhibits. Such elements served to frame an object, providing not only the intended ambience but also shaping the object's apparent meaning. Literary critics have shown how messages may be borne by nonverbal texts. The props surrounding an object may thus carry a message in their own right by creating a visual context that shapes the way an object is seen and thus comprehended.[57]

Exhibits then are not simply displays; exhibits are systems of signs in and of themselves. They express messages about objects and the worlds from which they came, as well as about the institutions from which those messages emanate. The interpretive act does not end with a decision about what an object shall say, because the arrival at that very decision entails a translation of particular objects and their contexts into language and hence meaning.

The very act of creating an exhibit is thus subject to the same conditions and limitations that apply to the production of knowledge. The function of exhibits is, therefore, no longer driven strictly by the collections they exist to showcase so much as by what is done with them. In other words, many exhibits are now driven by messages for which the collections, when they exist, serve as a vehicle, since an object's presented meaning is ultimately shaped by decisions about its interpretation and display. Once again, it is the literary critics who have demonstrated how signs shape that to which they point. Messages no longer emerge from an object's "inherent" meaning. Messages express meanings that people create.

The exhibition enterprise may be fundamentally interpretive; but museums have been slow to share that fact with the viewing public. Despite the gains that have been made in making collections more accessible, few museums share the decision-making process through which their interpretations are derived. Even though curators may acknowledge the interpretive basis of their work, they generally continue to present those

interpretations authoritatively and anonymously. Visitors, as a result, remain uninformed about even the most basic assumptions and rationales behind the messages they are given.

From an educational standpoint, this is the worst kind of teaching: spoon-feeding information without the learner's involvement. More seriously, it preserves the institution's authority to dictate "truth" by denying visitors access to the assumptions and logic on which their messages stand. What is problematic is not that those messages are invalid, but that without an awareness of either the factors or the fact of knowledge production, visitors lack the tools to engage in even the most rudimentary critique of what they are being told. Museums may present various views and knowledges; but their role in doing so remains invisible and thus protected.

A few art exhibits, however, have tackled the issue of how display is an eminently interpretive act. For art curators, exhibition is a primary medium of scholarship. Since debates about quality and value (the art "canon," as it were) are quite lively in the art world, it is to be expected that one should find exhibitions created to address them.[58] Some of the most provocative of such exhibitions have been mounted at the Center for African Art (now the Museum for African Art) in New York. "Art/artifact," for example, displayed a series of African artifacts in four different settings: a nineteenth-century curiosity cabinet, a "typical" art museum, a natural history diorama, and a contemporary gallery. This extraordinary exhibit thus sought to demonstrate how objects' meanings are linked to what we do with them, and thus to how we choose to see them.[59] "Perspectives: Angles on African Art" interpreted African ritual objects through labels written by a variety of individuals both inside and outside of the museum profession. Each person wrote about the feelings and thoughts that some piece evoked in him or her. This manner of interpretation introduced visitors not only to the variety of meanings these objects might hold but also to the idea that the "knowledge" presented about them consisted of an interpretation.[60] Other art exhibits designed to reflect upon themselves have appeared at such esteemed institutions as the Whitney Museum of American Art, Downtown, and the Parrish Art Museum.[61]

Since exhibition is an integral part of the history and nature of Western art, it is not surprising that art itself has also been created to

explore the nature of museums and exhibitions. Furthermore, artwork, unlike other museum objects, can and has expressed a relentless self-consciousness about what it is and how it is experienced. Much twentieth-century artwork, in particular, addresses its own institutionalization by dealers, historians, and curators. Some of this work deals specifically with what it means to be enclosed by a museum, by challenging either the museum's scripture (what artwork goes in), its audience (the elitist knowledge they require), or its edge (that there is an inner and an outer that are different).[62] A handful of artists have tackled the issue head-on by creating fictionalized museums and museum exhibits whose very fabrication points out the myriad ways that museums shape objects' meaning through the imposition of such elements as frame, story, and context.[63] Some artists have been so fortunate, and some museums so bold, as to curate an exhibition using an institution's permanent collection to critique conventional notions of interpretation and display.[64]

Outside the art world, however, there are few examples of exhibits that address the basis for their own messages.[65] Without good models of what such interpretations might even look like, it is not surprising that exhibit developers have been slow to incorporate messages that reflect upon themselves.

One of the few noteworthy non-art examples appeared in the late 1980s at Chicago's Field Museum of Natural History in response to protests about a particular interpretation. Tucked away in one of the Native American galleries, a diorama of the Pawnee Morning Star ceremony showed a young woman about to be sacrificed. Naked and bound, she was surrounded by men, one with arrow poised, ready to shoot. On a bulletin board next to the exhibit, a letter was posted from a visitor protesting the depiction of images of violence against women in a respectable, public institution. Also posted was a response from the Pawnee Tribal Council defending the museum's decision not to hide history from public view, however unpleasant it may be. Visitors were invited to comment, and they did—in profusion. The bulletin board was dotted with index cards on which people scribbled their thoughts about everything from women's rights to the historical enterprise to the nature of museums' responsibilities.[66]

Implicit in this approach was an effort to involve visitors in the decision-making process. As visitors learned basic information about how

the Pawnee practiced this ceremony, they were also given the means to consider the wider context in which this information is represented and to judge it for themselves. For art museum educator Danielle Rice, this is not just good pedagogy; it is an ethical responsibility:

> [The educator's task is] to bridge the gaps between the value systems of the scholars who collect and exhibit art and those of the individual visitors who come to the museum to look at, and perhaps to learn about art. . . . It is the educator's ethical responsibility to represent, from within the institution, the position that art is only valuable because of ideas conceived by human beings about what constitutes value. . . . In showing that it is people who structure and control institutions, rather than the other way around, and in helping people to analyze the decisions by which aesthetic and other value judgments are made, we empower people to act with greater awareness.[67]

Likewise, it is the educator's ethical responsibility to ensure that history, anthropology, and even science are presented in a manner that reflects people's ideas about what constitutes history, anthropology, and science.

Returning to the Linnaeus exhibit, the significance of the messages about the interpretive context of Linnaeus's work becomes clear. It is not simply that Linnaean taxonomy was a product of the tools with which Linnaeus perceived the world and the language by which he described it. Nor is it that science in general is subject to external forces of history and culture that give it shape. It is that the science and history presented reflect the views and contexts of their presenters—the Chicago Botanic Garden staff. In other words, the Garden itself, along with museums as a whole, shapes the knowledge it presents through interest-laden acts of selection, interpretation, and presentation.

Ostensibly an exhibit about a historical figure and the science he bequeathed us, "Linnaeus: Lessons and Legacy" presents a definite point of view about the nature of science. Arriving at that perspective was not just a content decision of inclusion or exclusion but an interpretive decision regarding the Garden's conception of science. The exhibit drafts were riddled with arguments about the museum's interpretation: Should it emphasize the genius of Linnaeus's system of classification? Is Linnaeus's system even an end unto itself, or should it be turned toward some ulterior lesson, like the scientific process? Does a message such as "sci-

ence changes" refer to the paradigms and instruments by which scientists operate, or does it refer more broadly to currents of thought and history that give shape to the paradigms?

The fact that these questions were even raised was evidence of an awareness that the "information" being presented reflected a broader arena of meaning. For the taxonomist, that arena had to do with the activity of science; for the educator, it had to do with the experience of the visitor. Where the former sought to characterize the practice of science, the latter sought to make those characteristics relevant to viewers by applying them to the present and focusing more generally on process instead of product.

Although in the end the museum remained silent as to its own reasons for deciding to present Linnaeus's science in the way that it did, it had engaged in a conscious process of making those decisions. Visitors are given to understand something about the interpretive nature of scientific knowledge, but they are left to make the leap for themselves from a statement like "What we know cannot be separated from the way we know it" to its possible application to the museum professionals who constructed the exhibition.

How do we really know what we know? The question is readily addressed by scholars. We would do well to apply it to museums, for museums present not just straight information, but information that is interpreted and communicated in a particular manner based on particular assumptions and decisions.

By omitting any mention about the decisions behind the determination of an object's meaning, museums exclude visitors not only from an awareness that knowledge is something that is produced but also from the possibility that they themselves may participate in its production. Inasmuch as museum educators represent visitors' perspectives, they have paved the way for interpretations that both address alternative contexts of meaning and reflect upon publicly—to visitors—the basis for and decisions behind selecting those contexts. Thus stated, the work of interpretation becomes an act of empowerment, because it provides visitors with both the knowledge and the consent to engage in critical dialogue about the messages museums present.

3

Education as Experience

More than halfway through the "Linnaeus: Lessons and Legacy" exhibit, at "Tools of the Trade," viewers first encounter display cases of things. Two scientific-looking instruments greet the eye. The first, an old, exquisitely crafted optical device, sits in a Plexiglas box. The exhibit label reads: "Linnaeus studied the parts of plants through a microscope *like the one you see here*" (my emphasis). In other words, the microscope displayed is not the one used by Linnaeus but one that serves as an adequate (by unstated terms) approximation. Glancing down, viewers see a second device—a plastic mounted lens that could have been found in any science class. Invited to peer through the lens, viewers are momentarily arrested by the image of a pollen grain rising up to them. "Three-dimensional perspectives like this help botanists [today] to see how the surface of pollen is sculptured," explains the label.

From historical artifact to special effects—what is one to make of this mix of exhibit styles? Ostensibly a message about science past to present, this peculiar juxtaposition holds another story: that of exhibition from past to present, as well as changing mores about the ways visitors encounter objects.

That story begins with an observation. Neither of the two artifacts came from the Chicago Botanic Garden's modest collection of "objects related to the floral arts"; both were purchased for use in the exhibit. Whereas exhibits have traditionally been developed to showcase collections, they

are increasingly being developed to tell a story for which illustrative collections may not exist. As a result, new kinds of criteria are being added to acquisition guidelines. The decision to acquire a "Linnaean microscope," for example, had more to do with the object's educational potential than with the Garden's collections policy. However, another consideration also came into play.

Both the designer, who had spent fifteen years working in a traditional natural history museum, and the taxonomist, who traced his life study back to Linnaeus, felt keenly the importance of displaying original Linnaean objects. The latter was moved by his passion for the subject; the former, by the ineffable fact of the objects' "reality." This was, after all, a museum; and what was more quintessentially "museum" than the display of real, original artifacts.

The panel was originally conceived to juxtapose Linnaeus's microscope with a modern microscope so that visitors could directly compare "What Linnaeus Saw" and "What We See."[1] However, market forces (the availability and the cost of the object) prohibited acquisition of a period microscope like the one Linnaeus had used. Consequently, a series of alternative objects were proposed and considered over the next several months.

Reproduction of Linnaeus's Microscope

A reproduction was not the real thing but, at least, it could be made to *look* like the real thing. No one on the team disagreed that a well-reproduced model would provide the most satisfactory substitution for the original artifact. Furthermore, a model had the added advantage that it could be handled by visitors. As the educator observed: What better way was there of representing "What Linnaeus Saw" than allowing visitors to peer through "his" microscope with their own eyes?

Photograph of Linnaeus's Microscope

Months slipped by, and no steps were taken to secure a model. With an installation deadline looming, the designer, whose responsibility was to research both the design of the model and to locate a competent fabri-

cator, suddenly began proposing the use of photographs. He may have thought that, having already compromised the original by deciding to use a reproduction, photographs were no more serious a concession. More important, he argued, a photograph could depict the original microscope—Linnaeus's own. The educator, however, was unhappy at the prospect of displaying a flat, hands-off picture in place of a three-dimensional, hands-on object.

Stereoscope

To placate the educator, the taxonomist came up with an idea for the accompanying "modern" microscope. This microscope could also be replaced by a photograph (even though durable and potentially expendable school microscopes were readily available)—but it would be a photograph that involved visitors in both how and what they viewed. Visitors would peer through a stereoscopic lens and focus their eyes; the lens would then produce not only magnification but also dimensionality as the image rose up off the page. In effect, what the taxonomist was proposing were 3-D glasses. Interestingly, this solution effectively dispensed with the artifact altogether, focusing exclusively on the image seen through its eyepiece. It thus achieved the ultimate goal: to depict "What Linnaeus Saw" and "What We See."

The suggestion that the image in the lens be a pollen grain was accepted without discussion. This decision later turned out to be based solely on maximizing the visual effect; there were no scientific or historical subtleties here. Indeed the pollen's surface did produce a momentarily startling effect. To the taxonomist, it could be (modestly) compared to the experience of scientific discovery—seeing something new and surprising. To the educator, it represented an example of technical wizardry that would, if nothing else, grab visitors' attention.

What the stereoscope did not do, however, was illustrate the copy and original point. Having stated that Linnaeus's microscope enlarged his world only a few hundred times, the panel reads:

> Plant scientists today have access to equipment which enlarges the world over a million times! By making invisible structures visible to the eye, tools

like the powerful electron microscope help us make distinctions which were not available to Linnaeus.

The stereoscope might make a point about changing vision; but it had little to do with the microscope that made that change possible.

Photograph of a Pollen Grain Seen through Linnaeus's Microscope

For comparison, a photograph of a grain of pollen as it would appear through Linnaeus's microscope was also proposed. It was never suggested, however, that this photograph be presented any way other than two-dimensional. Perhaps the third dimension had too much of a special-effects feel to belong to the eighteenth century. More to the point, Linnaeus would not have *seen* three dimensions through his microscope.

Mounted Lens of the Same Strength as Linnaeus's Microscope

In considering the idea of displaying a photograph of a pollen grain, exhibit team members also proposed mounting a lens with the same magnification as Linnaeus's. This would provide an interactive component while conveying the fundamental message, "This Is What Linnaeus Saw"—something that a photograph of the microscope itself could not do. Discussion of this idea did not go far. Perhaps it went one step too many from the original artifact. At least both reproductions and photographs contained the likeness of the original. While depicting "What Linnaeus Saw" and "What We See" exceedingly literally (except for the detail that Linnaeus did not look at pollen grains but reproductive structures), the last two proposals (photographs of pollen grains) dispensed with the artifact altogether. And the mounted lens, though participatory, lacked romance. The taxonomist missed the sense of history that only the artifact could evoke, while the designer, ever the museum traditionalist, lamented the uniqueness and originality that are the hallmark of museum objects. The educator, mindful of the educational value of direct experience, remained unconvinced that photographs, even stereoscopic ones, could ever be as engaging as a three-dimensional object. Although diverse in their reasoning, the team was in agreement on this one point: that an *object* be somehow included in the display.

Period Microscope

Well into the project and having resigned themselves to some combination of photographs and stereoscopes standing in for the two microscopes of the original plan, the exhibit team received an unexpected prospect. The taxonomist, determined to pursue every possible alternative, had been quietly scouring the local collectors' scene. He encountered Robert McCormick—a private collector of scientific instruments who was willing to loan the Garden an eighteenth-century microscope for use in the exhibit. It was not quite like Linnaeus's microscope, but it was close enough; and it provided the exhibit team with an original, historical artifact. Several months after the exhibit had opened, McCormick made his loan available for purchase, and donor money was secured to this end.

In the final display, two objects stood as the centerpiece: the period microscope and the stereoscopic viewer. Photographs of Linnaeus's microscope and a modern electron microscope, as well as pollen grains magnified by each, provided supporting materials.

What had begun as a pragmatic question about what to substitute for Linnaeus's microscope became a test of the team's beliefs about basic principles and purposes of exhibition. Two themes recurred throughout the course of most discussions: the importance of the "real" and the value of participatory learning experiences. As museum professionals, most of the team members' knee-jerk reaction was to defend the "real," particularly since one of museums' most sacred cows is their possession of original and uncommon objects. The designer in particular enjoyed reciting a popular bit of museum lore: that a fundamental, albeit intangible, difference exists between an original object such as Linnaeus's microscope and its picture-perfect reproduction.

Complicating the issue, however, was a view that has itself come into the fold of museum lore: that direct, participatory experience was essential to the learning process and should be incorporated into exhibits whenever possible.[2] In other words, the "reality" of the object was less important to the learning experience than the opportunity to interact with something. These sentiments stood behind the original idea of exhibiting two microscopes with which visitors could interact. The irony is that displaying a real, period microscope required that it be sealed

behind glass to prevent damage from curious hands. While practitioners may embrace ideals that value "participatory experiences" and "real objects," the two ideals appeared in this case to stand in fundamental opposition to one another. Discussion of these issues, while never terribly analytical, did skirt around some of their complexities. For example, although real things can not be handled, can they not be otherwise "experienced"? What exactly constitutes a "participatory" experience? How does the nature of an object affect the outcome of the experience? How important a factor is "reality" to that outcome? Interestingly, questions about the nature of an object's reality were transformed into questions about modes of experience: specifically, how the user's experience of Linnaeus's own microscope might differ from each of several, successively more remote representations of it. Thus, the problem was not simply a matter of privileging reality versus privileging experience. The problem was what was really "real" in the first place, and what did it mean to experience it.

Academic though such questions may be, decisions about how people experience both original and substitute objects are dividing museum staff everywhere over exhibit methods, policies, and purposes. While devices like interactive communications media, evocative display settings, and high-tech gadgetry were developed to supplement and interpret collections and to extend visitors' experience, many have now become so sophisticated and interesting as to overshadow the objects they were designed to set off.[3] Not only do these innovations compete for attention, they compete for space: every new device represents a reduction in display area. Many curators believe that collections are getting short shrift in the very institutions created for their care.[4]

Nowhere have these issues been more publicly played out than at Chicago's Field Museum of Natural History (notably, one of the museums credited with popularizing a team approach to exhibit design). Museums nationwide have been closely following efforts to shake up the Field Museum and bring color and life into what by many accounts had lapsed into a grim, dusty attic.[5] Spearheading these efforts was Michael Spock—the boy wonder of interactive exhibit design and mastermind of the famed Boston Children's Museum.

Spock began his sojourn at the Field Museum in 1985 by creating a series of fun, colorful, eminently interactive exhibits that would eventually ring the huge main hall. Controversy was raised over everything from

content (the "Rearing Young" exhibit's treatment of parenting was construed by some to be more social service than natural history[6]) to method (the acquisition of such attention-getting objects as the shoes of basketball great Michael Jordan and the shoulder pads of football player William Perry for the "Sizes" exhibit) to aesthetics (design elements such as bright yellow pillars appeared to some to blaspheme the stately marble columns of the hallowed Stanley Field Hall). These exhibits were designed with the express purpose of attracting visitors' attention and nudging them to venture down the more serious thematic galleries that extended out from the main hall.

It was not until Spock tackled the redesign of two of these "serious" exhibits, which featured two of the most important collections, that the full impact of the museum's facelift began to be felt. "Inside Ancient Egypt" featured a reconstructed tomb, marketplace, and "Nile," complete with flowing water; "Traveling the Pacific" recreated a lava flow, an atoll, and a Polynesian market. The former opened to positive reviews and eager crowds; the latter, while heralded by many, caused an outcry among others. "Traveling the Pacific" marked the final treason against everything that curators have held dear: only 400[7] of the 36,000 objects from a world-class collection were put on display (down from 5,000 previously on permanent display); at least as much space was given over to the demonstration of principles like the formation of atolls and the migration of peoples as to the display of artifacts; interpretive decisions were made that highlighted not the collections' strengths but the Pacific region's culture, history, and geography; and, the ultimate rebuff, final executive authority rested not with subject matter experts but with design experts—specifically, an "exhibit developer" appointed from the museum's Department of Exhibits and Design to oversee all aspects of the display—from planning to installation.

The net effect of these changes was that interpretive decisions were made with the visitor—and not exclusively the object—in mind. Where once artifacts might have been pedestaled, interpretation, scenery, and interactives were installed. Proponents argued that the new exhibit elements would only enhance visitors' experiences with the collections—a claim that was not unfounded. Studies have borne witness to the success of new approaches to exhibit development: not only do visitors appear to be learning more but also their experiences are reportedly quite positive.[8]

Underscoring these results is the fact that museums have never before been more popular. Attendance at museums throughout the nation has reached an all-time high. It has been estimated that more people now visit museums every year than attend basketball, football, and baseball games combined.

Results such as these suggest that *something* is working; but for the most part they do not delve deeply enough into what that is. It is not clear that changes in technique and design fully explain the surge of popularity now enjoyed by museums. What does it *mean* that visitors are having a "positive" experience? What are they getting out of their visits? Are museums giving visitors something now that they were not in the past? If so, is that because museums have changed or visitors have changed? What is the role of the institution in people's lives? Since the answers to such questions have varied throughout history, perhaps it is to history we should turn for clues to clarify the changing nature of the "museum experience."

Museum history is dominated by the perspectives of "insiders." It tells of the varied motives that have moved collectors, naturalists, civic leaders, and philanthropists to establish their institutions.[9] It reveals that collecting has satisfied any of a number of needs, from personal distinction to a quest for immortality.[10] It tells, for example, how America's first museums were founded on moderate enlightenment ideals to promote rational instruction, civic responsibility, and cultural nationalism.[11] By the 1830s and 1840s proprietors sought wider public appeal through the establishment of hugely popular, sensationalist exhibits.[12] Following the Civil War many civic leaders stepped forward to found cultural institutions that would redress the tremendous social problems left in the war's wake.[13] Museum history also includes reports about what museums looked like and how they organized their collections.[14] But what is missing from all of this history is the visitors' account. Just because history reveals that museums founded in the three decades following the Civil War were born out of philanthropists' belief in their power to ennoble and uplift, one cannot help but wonder: did visitors indeed come away ennobled and uplifted? What sort of draw did museums hold for the average late nineteenth-century visitor?

Such questions can be approached at several different levels, the most

obvious being strictly archival. Accounts of museum experiences un-
doubtedly exist in diaries and autobiographies. Generalizing the experi-
ences of the population at large from such accounts, however, is a slip-
pery business. It may be that the question of what people got from
museums is better considered in reference to not the specificity of indi-
vidual experience but the general social climate of which those individ-
uals were a part.

A second approach, therefore, is to examine the societal conditions
that shaped broad collective interests and needs: what role did museums
play in late nineteenth-century society, how successful or unsuccessful
were they, and what distinguished them from other related social institu-
tions? The answers to such questions provide clues to the sorts of broad,
collective interests and needs that motivated people's choice of activities
and that made them attend or avoid museums and other related social in-
stitutions. Evidence of these interests and needs is sprinkled throughout
the cultural fabric in art, leisure, industry, and popular thought. To the
extent that museums are, in the first instance, concerned with objects, we
may best narrow our search of this evidence by studying people's rela-
tions with objects.

Objects surround us at every turn. What they signify, how they are
used, and the values they bear—these issues help point to the role that
museums, as well as other object-based institutions, have played in peo-
ple's lives. These issues also stand at the heart of a comprehensive study,
The Real Thing, undertaken by Miles Orvell.[15] The book is concerned
first and foremost with a concept—the "real"—and America's shifting
sense of that concept; but it draws on the evidence of hundreds of ob-
jects, all artifacts of American material culture from the Civil War to
World War II. Orvell's study is particularly apropos because his overrid-
ing concern is the nature of these objects' reality; and one of the central
questions surrounding the display of Linnaeus's microscope was just how
"real" it had to be.

Orvell's work provides a way to begin shaping an answer, because it
deals with the historical roots of the question of how people conceive
and experience the real. Furthermore, it employs a set of terms that are
useful for articulating what is meant by language like the "real." Such
terms stand at the core of his thesis: that "the tension between *imitation*
and *authenticity* is a primary category in American civilization, pervading

layers of our culture that are usually thought to be separate" (emphasis mine).[16] The bulk of Orvell's work cuts through those layers, uncovering the common qualities held by artifacts as disparate as consumer goods, literary and artistic productions, and forms of entertainment. Maneuvering skillfully through hundreds of objects that encompass daily life and culture, Orvell first demonstrates how nineteenth-century America's pursuit of something called the "real" took its meaning from its newfound powers of reproduction and imitation ("it was a culture inspired by faith in the power of the machine to manufacture a credible simulacrum").[17] He then picks his way through the flotsam of twentieth-century material culture and shows how the pursuit for what had come to be viewed as deceptive, illusory imitations gave way to an aesthetic that sought the real in "authentic" things made of natural materials and forms. His analysis holds important clues about the role that museums, as well as other object-based institutions, played in people's lives.

The Culture of Imitation

By Orvell's account, the nineteenth century was a "culture of imitation," producing imitations and illusions of every sort: furniture modeled after European aristocratic styles; linoleum recreations of marble, wood, and carpet; photographs that reported, literally and exactly, places and events; amusement rides that simulated famous disasters; chromolithographs that reproduced great paintings; the literature of mimesis; great cylindrical panoramas that recreated illustrious landscapes and historic events; and wax fruit and paper flowers, the magnificent artifice of the synthetic. Delving beneath all these imitated forms to the meanings they held for people, Orvell reveals a society basking in the dawn of the Industrial Revolution.

First, the near-perfect recreation of various goods is given as both proof and celebration of society's burgeoning technological powers. The new forces of mechanization were greeted enthusiastically in the United States, for they were identified closely with a spirit of national progress. From steam and electricity to the railroad and telegraph, the new technologies promised to bolster the nation's economy, social conditions, and, especially, the quality of everyday life. The large-scale production of styl-

ish furniture and other consumer goods also gave America a chance to do some cultural catch-up:

> Underlying middle-class Victorian taste lay an imitation of American upper-class taste; and underlying American upper-class taste lay an imitation of European traditions. . . . Despite our growing mastery in things industrial and technological, the dominant assumption was that we were still vassals to Europe in the arts.[18]

Second, the new technologies of reproduction not only affirmed America's sense of technical competence but also helped elevate the status of ordinary citizens by making upper-class goods, high culture, and world travel available to all. Not only were the styles and forms of goods imitated, their materials were as well. The use of cheap materials assured that at least the appearance of luxury would be more widely available, regardless of class. Some critics decried what they perceived to be a cultural debasement, as increasingly crass imitations of everything from art to floor coverings sprang into being. But many others championed the inevitable inspiration that exposure to "good culture" would bring.

Third, these newfound powers of replication represented a hitherto unknown control over the forces of nature through not only the activity of reproduction but also its subsequent detection. According to Orvell, "learning to tell the true from the false, the lie from the truth . . . was part of an acculturation process that shows up again and again in nineteenth-century culture."[19] Thus, Victorian interiors sported fanciful juxtapositions that mixed paper flowers with real ones, and wax and marble fruit with fresh fruit. Furniture was not always as it appeared, as wardrobes turned into bedsteads, and bedsteads into tables and chairs. Such deceptions found enormous popular appeal. People delighted in both the experience of confusing their senses and the challenge of unmasking the confusion. The former affirmed the genius of their artifice; the latter, of their own powers of detection. Both represented different means of controlling nature, through their own creative powers on the one hand and analytical prowess on the other. At a time when science and technology were revealing boundless new worlds and possibilities, imitations gave people access to an increasingly bewildering "real" on manageable terms.[20]

This was the climate in which many of the nation's major museums first came into being. Having languished through several decades of P. T. Barnum and social unrest, museums began to rebound. The last three decades of the nineteenth century saw the establishment of several of today's leading art museums by philanthropists eager to redress a variety of social ills. At the same time, a renewed sensitivity to museums' public responsibility was evidenced by efforts to make natural- and cultural-history collections more available. Yet, it would be several years before museums fully re-established their role. Their early failure to find immediate appeal may be attributed to their ineffectiveness in fulfilling the dominant needs that Orvell identifies.

For one thing, museums at the turn of the century were largely giant storehouses of "treasures," arranged in a cluttered and often haphazard manner. (As one observer cautioned, "There is such a state of mind as picture drunkenness or Museum drunkenness, and this should be carefully guarded against."[21]) This was not the kind of high culture that Victorians sought. Art museums in particular suffered from their failure to reach a lay audience. They set their sights instead on more specific art "consumers," such as artists, designers, and researchers. Natural history museums met with resistance in their efforts to distance themselves from the hokum that Barnum had brought into their halls and that continued to hold popular appeal. Historical museums were even worse off, their collections largely the product of chance accumulations of incongruous things. That the objects displayed in museums were authentic held little value to a society steeped in the power of artifice. That these objects were displayed in a manner that made viewing them difficult only sealed the public indifference to them.

Far more successful were two other popular settings devoted to the display of objects: department stores and world's fairs. Neil Harris has described at length how department store merchants courted their customers with settings that played upon fantasies of luxury. The creation of palatial displays, elegant tableaux, and lavish restrooms made the experience of shopping "high drama." Marshall Field's, for example, boasted

> an enormous glass done by Tiffany, rare Circassian walnut paneling and blue Wilton carpets for the tearooms, a Louis Quatorze Salon for gowns, an Elizabethan Room for fine linens, an Oak Room for antiques, a French Room for lingerie, and an American Colonial Room.[22]

While the things themselves were not necessarily imitations, their resurrection inside an American department store was. In their classy evocation of the aristocratic life of luxury, department stores appealed to the Victorian sentiment for high culture that was brought about by the magic of reproduction. Not only did the stores represent what that world might be like, they brought it to life through the activity of shopping and the possibility of acquisition. Mass-produced goods, technological ingenuity, and the wealth of abundance were used to tempt and awe the nineteenth-century consumer of imitated forms.

Fairs, where a similar lure was at work, appealed to people's fantasies about culture—both their own as well as that of others. A now widely accepted interpretation of world's fairs holds that they represented idealized consumer cities.[23] Both the goods themselves and the manner of their display promulgated a sanitized, middle-class, capitalist view of life. Everything boasted of human domination over nature; the evidence lay in the products themselves: for example, innovative appliances, new technologies of food production, first-class specimens of consumer and agricultural goods, a giant bottle of olive oil, and a 22,000-pound cheese. Such items were displayed in grandiose settings that were themselves representations of earlier architectural styles. Replicas of everything from the Liberty Bell to African villages seemingly brought the world to people's fingertips.

Unlike the newly burgeoning museums, department stores and fairs embraced values about objects that corresponded to public sentiment. Both celebrated progress and human achievement. Both displayed objects to which anyone, regardless of class, could make easy and strong connections: manufactured goods for daily living. And both raised their display techniques to a high art, resurrecting fashions, life-styles, goods, and cultures, all from other places and times.

If imitated forms flourished up until the late nineteenth century, it was because they embodied a host of ideals valued by nineteenth-century society. As Orvell notes, the heart of the matter lay in the central importance of *things* as signs—signs of progress, status, and cultural egalitarianism. So important were these signs that at least one retailer was moved to promise: "Every article sold in this establishment is guaranteed to be what is represented."[24]

All this interest and sentiment for imitation, however, would even-

tually take its toll, finally giving way to what Orvell has called the "culture of authenticity."

The Culture of Authenticity

By the early twentieth century, Orvell explains, changes in the nature and design of goods suggest a reconsidered stance toward the imitations so enamored by nineteenth-century society. Once symbols of progress and control, what were increasingly shoddy, cheap imitations came gradually to represent people's enslavement to the machine. Furthermore, assembly lines had begun producing an altogether new sort of manufactured good: other machines, such as telephones, automobiles, and household appliances. These goods did not just replace some original model; they also replaced entire arenas of experience. Basic life activities such as food preparation, transportation, hygiene, and communication were now mediated by machines that effectively distanced the body from the physicality of the "real world."

This sense of alienation was felt in other domains of life as well. New discoveries on the scientific front had exposed dimensions of the physical world that no one had dreamed existed—atomic forces and particles—which themselves raised new uncertainties about the reliability of perception.[25] Mass media like movies and newspapers became more widespread and thus more influential mediators of experience. Circumstances such as these provided the groundwork for America's shift from a culture of imitation to a culture of authenticity.

If imitated forms were the signs of certain social ideals, then "authentic" forms were the signs of a "reality" from which imitations had removed human experience. Retrieving that reality and returning it to American life became the watchword for a generation of new designers. The use of natural materials and more intimate, immediate processes of production by such figures as Louis Sullivan and Gustav Stickley represent attempts to restore concrete reality to human experience. Other designers, like Frank Lloyd Wright and Walter Teague, sought the reality of pure, abstract form through designs that attempted to recapture the essence of a thing, be it a blender or an office building.

Twentieth-century culture may have been grounded in an authentic ideal; but it also embodied new complexities surrounding what it

means to be real, a question no longer limited to the design of objects. For the first time we begin to hear language about *experience*. Authenticity was valued because it brought people back into direct contact with the real. However, what did it mean to experience the real? Did it entail purity of form? Was it a matter of direct, physical contact? These questions show glimmers of the issues that would later confound the Linnaeus exhibit developers.

If a desire for authenticity is indeed a dominant feature of the modern mind, it would follow that museums would enjoy a resurgence of popularity, since their very existence is devoted to the care and display of authentic objects. Many museums, however, continued to suffer in the early decades of the twentieth century from their own poorly presented displays, which were often dark, cluttered, and unappealing.

Despite this general tendency, a few notable attempts were made to improve museum displays. The Metropolitan Museum of Art, for example, created the first period rooms, exhibiting decorative arts in their original household settings. John Cotton Dana went a step further by displaying ordinary household objects, which placed the practical and the fine arts on equal footing. Collector and taxidermist Carl Akeley made natural history dioramas into an art form by recreating in exacting detail the original environments from which specimens came. The practice of displaying casts of ancient sculptures, instituted in Boston's Museum of Fine Arts in the late nineteenth century, was abandoned after the turn of the century on the grounds that the casts lacked the "emotional force" of the originals.[26] Authenticity had clearly become a valued quality. Yet, despite their own embrace of authenticity, museums and their collections were slow to find broad popular appeal. Reflecting on this period, T. R. Adam observed:

> During the last decade the museum has rallied all its powers to overcome the lethargy of the public toward firsthand knowledge of art and science. . . . The task of the museum has been to arouse once more public appreciation of firsthand material, to create understanding of the original sources of learning. To do this, exhibits have had to be made dramatic and colorful in their own rights.[27]

Perhaps it is not surprising that what did find popular appeal was an exhibit setting that had yet to enter the museum fold: living historic

settlements. Catering to (as well as creating) American sentiment for things authentic, John D. Rockefeller Jr. and Henry Ford resurrected what was undeniably an idealized past: the former at Colonial Williamsburg and the latter at Greenfield Village. Ironically, the public, swept away by the living reality these settings offered—grazing sheep, costumed inhabitants, fully functioning smithies, mills, and general stores—failed to grasp the fact that these settings were recreations from top to bottom. Certainly, visitors knew this was not 1690; but the life appeared to be so perfectly "realized" that it did not matter. What could be more authentic than watching a seamstress use an actual spinning wheel to spin wool freshly shorn from the sheep outside?

In a similar vein, Akeley's dioramas began to be widely imitated by exhibit designers trying to recreate "real-life" habitats in which to display museum specimens. Well-crafted dioramas had the power to whisk viewers to the earth's farthest corners, from the highest mountain tops to the deepest woods. "Reality" in natural history museums was becoming a reality.

However authentic these settings may have appeared, living settlements and dioramas are nevertheless reproductions of another original place and time. What, then, are we to make of Orvell's thesis that authenticity is a fundamental value of modern consciousness? The key to this apparent contradiction rests in what now counts as authentic.

The Culture of Simulation

Orvell defined authenticity primarily in contrast to "imitation" or "fake," even though he found evidence that in the twentieth century what was considered "real" was by no means clear-cut. While Orvell failed to probe deeply into the significance of this fact, it deserves our attention, for it bears significant relation to the question faced by the Linnaeus exhibit team: what does it mean to experience the real?

In order to push the question a bit further, it is helpful to turn to the work of another student of "authenticity": Dean MacCannell.[28] Interestingly, both MacCannell and Orvell begin with the same pivotal event—the Industrial Revolution—and both arrive at the same conclusion—that "authenticity" is a fundamental value in twentieth-century society. However, each examines different sets of data and arguments.

Where Orvell studies the products themselves, MacCannell takes a more classically Marxist point of view, studying changing work relations and the spiritual split caused by alienating workers from the products of their labor. The result is an analysis that penetrates beyond the physical objects to the nature of people's experience of authenticity—wherever it might occur.

MacCannell's study is an ambitious one: he not only sets out to explore the nature of authenticity in modern life but also tries to construct the grounds for an ethnography of modern society as well as create a set of categories for the study of tourism. These three projects are closely intertwined: MacCannell's basic argument is that the essence of modernity has to do with the split between authentic and inauthentic elements of human life, and that it is this split that heralded the rise of institutionalized forms of experience that culminated in tourism. For MacCannell, tourists—people in search of native, typical, original (or *authentic*) peoples, practices, artifacts, and places—are expressively paradigmatic of modern wants and needs. His approach is largely ethnographic, his data, colorfully broad: from turn-of-the-century Paris morgues to dude ranches to Elvis Presley's mansion.

"Modernity," for MacCannell, refers to a time and a condition that exists in contrast to pre-industrial life. It is characterized most importantly by the alienation of workers from the products and processes of their labor, which was brought about by the Industrial Revolution and the rise of mechanized forms of production. The fallout from these events has been vast. For example, the workplace no longer served as a source of identity formation, valuation, and social life, making it necessary for people to turn to alternative sources of orientation and value. With work effectively split from leisure, new kinds of activities began to be developed to overcome the discontinuities of life and the workplace.

Interestingly enough, these activities were a product of the very market system that had created their need in the first place. Experience itself became a commodity to be produced, promoted, and consumed. The creation of work displays (for example, behind-the-scenes tours of banks, industrial plants, and courts), spectacles (parades, inaugurations, and fairs), and attractions (Old Faithful, the Grand Canyon, and historic houses) are held up by MacCannell for their delivery of an *experience* that promises to fill the spiritual void of the modern world through some kind of

authentic encounter with it. But what makes these experiences authentic? For one thing, their separation and differentiation from that which is irrefutably inauthentic: modern society. For MacCannell, the very definition of authenticity arises from contrasting it to that which it is not:

> The differentiations *are* the attractions. Modern battleships are berthed near *Old Ironsides;* highrise apartments stand next to restored eighteenth-century townhouses; "Old Faithful" geyser is surrounded by bleacher seats. . . . Modern society institutionalizes these authentic attractions and modern life takes on qualities of reality thereby.[29]

So the process of integrating authenticity into modern life is not simply a matter of purification, as with Orvell's goods. For MacCannell, authenticity exists in contrast to the inauthenticity that dominates modern social life and experience. Like Orvell, he believes the value of authenticity to reside in the inadequacy of either fake or inauthentic versions of some authentic original. But where Orvell finds out-and-out rejection of inauthenticity in the manufacture of goods that are expressly "authentic" in materials, production, or design, MacCannell finds the opposite: that the condition of inauthenticity, far from being something to be eradicated, forms a kind of unifying consciousness that defines the modern spirit. In other words, the search for authenticity, indeed the very definition of the word, depends on the sense of instability and inauthenticity that characterizes the modern mind. The irony—and the complexity—of MacCannell's analysis lies here: in his refusal to dismiss or even denigrate inauthenticity.

An example demonstrating the inescapability of this approach is Old Ironsides. The act of roping off Old Ironsides has a dual effect, at once establishing its authenticity (by virtue of differentiating it from other ships) and occasioning its inauthenticity (by virtue of separating it from its original context and function—the context and function in which it really *is* a battleship). The brilliance of MacCannell's analysis and its relevance to our problem with the microscope is that he shifts the criteria for authenticity from the nature of the object to the manner in which it is experienced. In other words, in order to have an "authentic" experience, it is just as important that the artifact be presented properly (through acts like differentiating) as it is that it carry the correct pedigree.

If experience is the operative factor, the determination of authen-

ticity becomes less clear-cut. It is no longer simply a matter of contrasting imitation to actual, fake to real. The truth now lies somewhere in between—in a related phenomenon called simulation. According to critic Jean Baudrillard:

> To simulate is not simply to feign: "Someone who feigns an illness can simply go to bed and make believe he is ill. Someone who simulates an illness produces in himself some of the symptoms" (Littre) [sic]. Thus, feigning or dissimulating leaves the reality principle intact . . . whereas simulation threatens the difference between "true" and "false," between "real" and "imaginary." Since the simulator produces "true" symptoms, is he ill or not?[30]

This confusion is manifest in the proliferation of cultural facsimiles whose apparent appeal is based on their "authentic" simulation of some place or time, yet whose fabrication fails to undermine their appeal. Orvell recognizes this inconsistency when he observes:

> If the later nineteenth century can be described as a culture of imitation, and the first part of the twentieth century as a culture of authenticity, then our own time might be called a culture of the factitious. We have a hunger for something like authenticity, but we are easily satisfied by an ersatz facsimile.[31]

He goes on to list the variety of simulations surrounding us with which we unhesitatingly engage (many of which stand at the core of MacCannell's database): theme restaurants designed to evoke the ambience of the Wild West; docudramas like "Roots," where fiction seems truer than fact; and Disney's automated Indians pounding corn along a real but fabricated river. These observations have been echoed by a number of cultural critics, from Umberto Eco to Jean Baudrillard. Theme parks, Omnimax theaters, discotheques, Nike Town, TV verité ("Crimestoppers," "America's Funniest Home Videos," and Geraldo Rivera specials), and even the Field Museum's Pacific atoll—all create a fantasy out of what Baudrillard calls "the ideology of the lived experience."[32] In other words, the appeal behind these settings may be understood to lie in the *experience* to be had by imbuing oneself with properly evocative props. And if the experience is properly simulated—in other words, if the correct effects are reproduced in the lived body—does it matter that the props are "faked"?[33] The desire to experience the real would appear to have shifted to a desire for realistic experience.

So how did this shift occur? How does it work? The answer appears to have something to do with indicators. As MacCannell explains, the power of tourist attractions resides in a mark that indicates (and delineates and guarantees) what one is seeing. In other words, without some marker to assure us that a pile of black lumpy rocks indeed came from the moon, these rocks become indistinguishable from those that came from the quarry out back. The indicator of authenticity thus resides in a mark that states: this is authentic; these are really moon rocks.

These ideas follow directly from developments in the field of semiotics.[34] Ferdinand de Saussure's radical surgery on the notion of "sign," which up until then had been regarded as a single, symbolizing entity, split it into two separate organs: a signifier (MacCannell's mark) and a signified (MacCannell's sight).[35] As a result, signs were no longer equivalent to the reality they represented; instead a *signifier* represented a *signified* to which it is linked not by nature but by culture. In other words, there is no "natural" correlation between a sign and that to which it points; the two are joined by social consensus. Ulterior interests and assumptions are therefore embedded in the meanings signs take; they guide the once common consensus that, for example, the word "girl" can signify a grown woman.

As a result, it is no longer possible to represent reality except in a mediated fashion. Nor is it possible to speak of having direct experience with reality. Reality is now shaped by languages of representation: the map not only precedes the territory, it engenders it. For example, Euro-Americans' experience of people from Africa is mediated by how they have been represented in language and culture: as "savage," "colonized," "black," "African American," "Negro," and "indigenous." Consequently, if one can neither "accurately" represent what one experiences or knows nor experience or know in any unadulterated way, signs become more important than that which they represent. Ultimately, signs are what shape not only one's encounters with the world but also the meanings one makes of those encounters. If moon rocks are experienced as real and authentic, it is because there is a sign to assure us that they are indeed so.

Still, one cannot help but wonder: would the moon rocks be any less authentic without the marker? Certainly not from the standpoint of the rocks. From the standpoint of the viewer, however, there may be some question. For the assurance of the rocks' authenticity derives not from some innate "aura" but from the indication—the sign—that they indeed

came from the moon. The experience of authenticity, in other words, is based less on an inherent quality than on a sign imposed from without.

It is for precisely this reason that it is possible to continue to value and to seek authenticity. Although the proliferation of and mass participation in cultural facsimiles would appear to have undermined it altogether, they instead manifest perfectly the change in its meaning. Only now the locus of authenticity has shifted: from object to sign, from rock to representation, from artifact to setting. It is thus possible to search for and even to satisfy a quest for the "real," because it continues to exist as signs and markers. In other words, the very meaning of the "real" has changed, and with it, the conditions for encountering it. No longer is reality some immutable, transcendent thing; it is subject to the conditions of its representation, so that encountering "reality" becomes a matter of encountering the signs that define what it is.

These circumstances explain the success of such cultural phenomena as theme restaurants and Frontierland. What else are these artifacts but signs of some now inaccessible "real" (or rather, some outdated concept of "real")? The question of how well these signs correspond to that which they represent is thus no longer even an issue. The signs themselves now shape the reality they purport to represent. In "Travels in Hyperreality," Umberto Eco suggests that we have become so adept at manufacturing signs of the "real" that they have become an acceptable, even desirable, substitute for the "real" we can no longer have:

> Disneyland not only produces illusion, but—in confessing it—stimulates the desire for it. . . . When, in the space of twenty-four hours, you go . . . from the wild river of Adventureland to a trip on the Mississippi, where the captain of the paddle-wheel steamer says it is possible to see alligators on the banks of the river, and then you don't see any, you risk feeling homesick for Disneyland, where the wild animals don't have to be coaxed. Disneyland tells us that technology can give us more reality than nature can.[36]

But is it really simply a matter of signs being better, more "authentic," than the reality they have displaced? Perhaps not. If meaning is imposed rather than inherent, then authenticity is less a matter of origin as it is indication. It follows that the significance of signs lies not in their substitution of an alternative, more satisfying "reality" but in their indication, and consequent substantiation, of a reality that constantly eludes us. Ad-

ventureland may indeed provide a more satisfying version of reality than nature; but it still professes to represent a place that exists. We may not care to seek out that place, particularly if it fails to rise to the expectations engendered by our signs. But we may rest assured that it exists, and that it might even resemble the version at Adventureland.

What is the significance of these semiotics for museums? After all, museums would appear to be one of the few places that really do contain fragments of the "real"—at least in Orvell's sense of the word. Indeed, one way of interpreting current controversies between educators and curators is that the former appear to represent an assault on the real. Educators' crusade for interpretation has resulted in the development of devices and settings that, to some, have begun to substitute for the original collections. However, the issue is not simply a matter of devaluing the real but a far deeper matter of shifting definitions, as one idea of the real is displaced by another. Although this shift is being played out in museum corridors, its deeper implications are only beginning to be articulated.

First, the "reality" of an object is as much a feature of presentation and experience as it is provenance. If meaning is not inherent to objects but resides in the signs by which we indicate them, then it is impossible to speak of unmediated experience. Experience is mediated by signs that indicate what a thing is—even a thing like reality. To speak of experiencing the "real," then, is to speak of experiencing not some innate quality contained in objects but rather a wider context of signs that give meaning to that reality. Viewed in this light, the drive to provide interpretation for museum collections represents an attempt to restore the missing contexts out of which their original meanings arose and within which they "really" existed.

Thus, museum visitors can seek out and be satisfied by simulations that seem to offer as genuine an experience as a "real" object. For many, the experience of strolling through a simulated Polynesian village is far more visceral and evocative than that of gazing at an authentic, unadorned artifact behind glass. Place the latter in the context of the former, however, and it comes alive: the village not only embodies the context in which the artifact really is "real" (that is, where it was actually made, used, and stored); as a simulation it also stands in sharp contrast to—and thus substantiates—that which is truly authentic. As MacCannell

observes, authenticity derives its meaning and value in contrast to that which it is not. Far from undermining the real, interpretive contexts in fact help to "realize" it.

Second, the representative function of museums has consequently shifted. Throughout history, museums have been likened to a microcosm of the world: fragments of nature and culture that condense and order and represent the world outside their walls. Today, however, we may understand those fragments to shape the world they represent. The museum no longer follows from a world that is fixed; the world follows from signs that continually shape what it is. Of course, museums still purport to represent the world outside their walls. However, in so doing, they may be understood to serve an ulterior representative function unto itself, exhibiting a manner of representation that no longer "naturally" occurs.

To the viewing public, this function plays a critical role. In a world where authentic, unmediated experience is considered no longer possible, and where signs and markers are more important than the "reality" to which they point, the museum restores the possibility that there is some reality to which we have direct access. It does so by providing the now necessary sign that marks and thereby guarantees a manner of representing and experiencing that has been lost outside its walls. What is paramount is not the "reality" enshrined in museums but the possibility and the hope that there is something that can be so enshrined.

The fact that museums represent this hope, the ultimate act of representation, forecloses the possibility that viewers are somehow closer to experiencing the "real." The illusion is that there is some reality that museums give access to; but the only reality museums give access to is a representation. Again, the museum no longer represents a world which is given; instead, the world follows from signs that shape what it is. The museum exemplifies this fact and this relation—that a sign is required to "authenticate" reality. Thus, it is really no different from that which falls outside of its walls, but as pure sign it stands as the ultimate authority to authenticate experience. For those in search of an authentic experience, as MacCannell and Orvell would have us believe, museums deliver.

The particular compromises made in the Linnaeus exhibit splendidly exemplify the tension between old and new "realities" that dominate this moment in history—on the one hand, an eighteenth-century microscope

enclosed in glass; and on the other, a stereoscopic image requiring interaction. Each represents a different solution to the problem of what to substitute for Linnaeus's microscope and to the question of what was really "real" in the first place and what it means to experience it. The microscope embodies the more traditional notion whereby the real is located in the thing itself—in its history, its provenance, its very matter. To know of this reality and to be in its presence is to experience the real.

However, we just saw that to experience the real is to experience signs of the real—the label that assures visitors that the microscope dates back to 1760 and the Plexiglas barrier that signifies value and safekeeping. What matters is not the thing itself but the manner in which it is experienced. The stereoscope fully exemplifies this change in meaning, for why else is it displayed but to evoke a very particular experience? That experience—a stereoscopic vision—is not just as an "object" or an end unto itself; it also serves as a sign and a context for understanding the microscope.

Such complexities were embedded in the discussions at the Chicago Botanic Garden about the suitability of various ways of presenting Linnaeus's microscope. The two issues on which discussions continually touched—the reality of the artifact and the manner in which it could be experienced—are on many exhibiters' minds as exhibits become more participatory and interpretation becomes increasingly multifarious.[37]

What we have learned, however, is that the two are not quite at such odds as they would appear, that the former is in fact largely shaped by the latter. While viewers may indeed have been greeted by the sight of an old, optical instrument encased in a Plexiglas cube, at least this time their view was stirred by an additional experience with vision. The presence of the stereoscopic viewer may thus be understood to serve several functions. It helps to define visitors' stance toward an unfamiliar object—so that the lesson of Linnaeus's microscope becomes a lesson about sight; it shows what it is "really" like to peer through a lens and see something new and surprising. In these ways, the stereoscopic viewer provides an experience that extends the meaning of the microscope—an experience that is affirmed by its location within the walls of that arbiter of experience: a museum. The locus of authenticity and meaning resides not in the object but in the mark, not in the microscope but in the stereoscope that shapes our stance; and not just in the stereoscope but in the museum that substantiates the experience of looking.

4

Education as Ethics

A fter visitors leave the microscope display in the Chicago Botanic Garden's Linnaeus exhibition, they encounter a series of objects and labels behind glass. "Tools of the Trade" continues the contrast of science's past to its present by juxtaposing examples of eighteenth- and twentieth-century tools and practices. Viewers see comparisons between a metal vasculum and a plastic bag (demonstrating the collection of specimens), a handwritten letter and computer printout (demonstrating the communication of information), and the book *Hortus Cliffortianus* and the journal *Systematic Botany* (demonstrating the nature of science). The two texts are propped open to reveal their contents; what else they reveal is the subject of this chapter.

Hortus Cliffortianus is a catalog of plants grown on the estate of Linnaeus's onetime patron, George Clifford. Published in 1737, it is one of Linnaeus's earliest works. As is customary when displaying original artifacts, a small identification label accompanies the book:

HORTUS CLIFFORTIANUS
This rare volume, published in Amsterdam, 1737, is one of Linnaeus'
earliest and most celebrated works. In it, he catalogued and described the
plants found in the garden of George Clifford. Courtesy of the Chicago
Botanic Garden Rena Hooper Buck Linnaeus Collection.

A larger interpretive label reads as follows:

THE NATURE OF THE SCIENCE OF NATURE

18th century science had a very different character than 20th century science. The flavor of the time is captured perfectly in its language and illustrations:

> [*Andromeda polifolia*] is anchored far out in the water, set always on a lit-
> tle tuft in the marsh and fast tied as if on a rock in the midst of the sea.
> The water comes up to her knees, above her roots; and she is always sur-
> rounded by poisonous dragons and beasts—i.e., evil toads and frogs . . .

> Carl Linnaeus

The book itself presents an affecting, if impenetrable, visage; a lavish full-page illustration of gods, cherubs, people, and plants faces a Latin text rendered in calligraphic script.

Contrasting the book is a 1988 issue of the journal *Systematic Botany.* The accompanying exhibit copy reads:

> Whereas Linnaeus was able to study the whole plant kingdom, a botanist
> today might spend an entire lifetime studying a single plant group. The
> language in this journal reveals how extraordinarily specialized and tech-
> nical the field of botany has become.

This point is underscored by the open pages of the journal, where the eye scans text so highly technical as to be incomprehensible.

Two points are worth noting. First, the traditional function of identification labels has been to provide factual, succinct information about an object's name, creator, material, and/or provenance. The above identification label departs from this tradition in two ways: format and content. It presents information in complete sentences rather than line items; and it includes interpretive and descriptive information that are normally outside identification labels' purview: for example, "one of Linnaeus's earliest and most celebrated works"; and "he catalogued and described the plants." While presenting only the most basic information, the label nevertheless serves an interpretive function because it describes what the book is.

The second point is that the interpretive label focuses not, as one might expect, on information about the book's creation and use but on its characterization of the nature of science. In other words, the artifact is presented not as something of inherent interest but as an exemplum

of eighteenth-century science, language, and communication. The book's significance thus resides in its incarnation of a historical period.

What is interesting about this example is not so much the presence of multiple interpretations but rather the interests and rationales that stand behind their selection. Just because meanings are open to multiple possibilities does not mean they carry equal weight. Also, just because visitors play a role in interpreting their encounters with collections does not mean that museums no longer have a hand in shaping that encounter. Visitors' experiences and interpretations are still subject to stimuli that are provided by the museum. What, then, is the nature of museums' responsibility in determining how to interpret and to present an object? What, given multiple potential interpretations, goes into weighing and selecting particular ones?

Unlike the other objects in the exhibit, which were acquired with a specific use in mind, *Hortus Cliffortianus* was secured only with the intent to display an original work of Linnaeus's. Hence, it was necessary to determine what message the artifact best embodied. While historical and aesthetic criteria were key factors in selecting this particular work, its role in the exhibit narrative was not obvious. Introduced by a tremendously symbolic frontispiece and illustrated with intricately detailed copperplate engravings, the book promised many opportunities for dealing with Linnaeus's lessons and legacy. How was it that it came to represent eighteenth-century science?

Early conversations about the interpretation of *Hortus Cliffortianus* were driven largely by the exhibit team's taxonomist, whose familiarity with and affinity for the book were deep. To him, the work stood on its own aesthetic, reflecting a rich and romantic time when science was truly a vocation linked to the muses. He particularly admired the book's frontispiece, whose richly baroque renderings were embedded with symbols of events from Linnaeus's life.

Caught up in his elocutions, the exhibit team decided to use the images as a springboard to Linnaeus's life and personality. This would provide a broader context for understanding his work.

There was no shortage of stories to be told. The center of the frontispiece features the seated Mother Earth, holding a pair of keys indicating her right to the garden at any time. To her left steps the god Apollo, with the face of a young Linnaeus. With one hand he brings light; with

the other he casts aside the shroud of darkness around the garden. Underfoot he tramples the dragon of falsehood. This image is a reference to the counterfeit hydra at Hamburg, which was exposed as a fraud by Linnaeus. Apollo is shadowed by a banana tree—a reference to Linnaeus's success in its cultivation. In the foreground are a pot of *Cliffortia,* a plan of the garden, and two cherubs, one explaining Linnaeus's centigrade thermometer. Three women bring plants from the far reaches of the earth: an African carries *Aloe,* an Arabian, *Coffea arabica,* and an American Indian, *Hernandia.* On a pedestal in the back, a bust portrays the head of Clifford.

Clearly, these images provided ample fodder for treating the events of Linnaeus's life. However, as discussions progressed, two issues gave the group pause. The first concerned the nature of the frontispiece. The educator was concerned that however superb a rendering, and however evocative the images of Linnaeus's life, the frontispiece called forth an age that to the average person was ancient, maddeningly symbolic, and altogether alien. She was afraid that viewers would be put off by the images before they even had a chance to explore them.

The second issue had to do with how much space should be delegated to what was, in fact, a minor part of the exhibit. Referring back to the exhibit goals, team members were reminded that the central messages concerned Linnaeus's work in classification and nomenclature. Supporting historical material just provided context and color to develop and to enliven the (presumably) drier scientific messages.

Of course, neither context nor color were necessarily secondary issues: Chapter 2 demonstrates the significance of historical context in defining a subject; and Chapter 1 shows the importance of color and interest in drawing viewers' attention. But the link between the particular histories embodied in the frontispiece and Linnaeus's work on classification and nomenclature was tenuous, and while the stories themselves might provide suitably colorful anecdotes, the images on which they were based were still forbidding. The team thus decided to explore other options.

In the meantime, discussions about the exhibit narrative had progressed to the point where all of the artifacts to be used were kept together in one secure location. Plans called for organizing the artifacts around four key concepts that influenced the nature of both Linnaean

and modern science: tools, problems, methods of communication, and events of the day.[1] This organization shaped the next stage of thought about the use of *Hortus Cliffortianus,* because the question then raised was which of the four concepts did the book best exemplify?

Taking cue from the educator's concern about viewers' potential response to the frontispiece, the designer saw a perfect opportunity to address the issue of communication, which would allow the meanings of the book's images to be treated directly and explicitly. This point was made moot, however, by the fact that as an instrument of communication, the book's most important feature was not the frontispiece but the numerous floral engravings.

This shift in focus seemed an appropriate one. There was no question that illustrations of flowers and plants would be more accessible to novice viewers than the heavily symbolic frontispiece. Furthermore, the illustrations were historically significant in their own right. The fine copperplate engravings had set a standard of excellence in the field of botanical illustration. Prepared by Georg Dionysius Ehret and Jan Wandelaar, the engravings presented a level of detail that marked "the beginning of a new era in botanical illustration and foreshadow[ed] the golden century of great flower-book production."[2]

This interpretive shift effectively redefined the artifact by focusing attention not on its biographical but on its botanical features. However, as an example of eighteenth-century scientific communication, and particularly in comparison to that of the present day, the book's illustrations alone did not carry the contrast far enough. Botanical illustration remains largely unchanged today—at least in its attempts to convey detailed and accurate representations of plant parts. While new methods have evolved, illustrators still engage in the same basic process: observing carefully and recording their observations on paper.

Furthermore, the communication issue was better conveyed through comparisons of language. Linnaeus's work certainly held no dearth of examples. Both anthropomorphic and erotic imagery played heavily in his renderings of plant parts: "The nuptials are celebrated openly before the whole world" (in other words, the flower parts are visible); "males and females rejoice in the same bridal chamber" (stamens and pistils inhabit the same flower); and "seven husbands in the same marriage" (seven stamens in the same flower with one pistil).[3] The contrast to today's coldly

technical language could not be sharper. Unfortunately, since *Hortus Cliffortianus* was a catalog, its prose lacked the wonderful imagery of some of Linnaeus's other works.

The next interpretive revision came about when the educator raised a question that needed to be clarified: What did the team mean by "communication"? What specifically did it mean by "the nature of communication shapes the forms of thought"? Information delivery is affected by not only the character of the images and language but also the nature of the media—how changing methods of communication have sped up the transfer and, consequently, the generation of information. To the educator, the latter was a more important and concrete issue. Focusing on that issue would produce a different message, for it meant contrasting the "bookness" of *Hortus Cliffortianus* with modern electronic media.

The taxonomist, however, questioned whether *Hortus Cliffortianus* was the best means of conveying this message. He pointed out how each interpretive change—from the character of the book's illustrations to the character of its language to the character of the medium—had effectively shifted attention further away from the artifact's most interesting qualities. He believed that the point about communications media would be better made by another, less important book or perhaps a handwritten letter, an example of how scientists had once communicated with one another.

At about the same time that these deliberations were occurring, the narrative structure of the overall artifact panel was undergoing one final revision. While the "communications" and "tools" sections had lent themselves fairly easily to the selection and interpretation of supporting artifacts, the "problems" and "events" sections were proving to be not only problematic but also greatly contrived.[4] The team therefore decided to abandon the four categories in favor of a simpler "then-and-now" comparison. The artifact panel was thus reconfigured around the theme, "tools of the trade," with "tool" used in the broadest sense of the word.

Although "communications" was eliminated as an explicit topic, the group felt that the issue of changing media had sufficient bearing on the shape of science from past to present to warrant its inclusion in the panel. Thus, they decided to juxtapose a copy of a letter handwritten by Linnaeus with a computer printer and printout as one example of "tools, past and present."

As for *Hortus Cliffortianus,* the question remained: What did the artifact best exemplify? What manner of "tool" did it represent? Taken literally, the answer was that it represented a book: an instrument of communication. However, the team had already decided that *Hortus Cliffortianus* had too many other important and interesting qualities to serve simply as an example of print media. Consequently, the key to the question lay in what constituted "important and interesting qualities." The problem was assessing the qualities' relative significance.

It should be clear by now that features like "importance," "interest," and "significance" draw their meaning from criteria that are neither objective nor absolute. This point was amply demonstrated by the staff's different views of *Hortus Cliffortianus.* The three interpretations proposed thus far were based on three different criteria of significance. The first focused on historic and to a lesser extent aesthetic features, treating the book as a record of Linnaeus's exploits. The second focused solely on aesthetic qualities and the botanical account recorded therein. The third focused on the book's physical format as a medium for communicating information. From autobiographical record to botanical text to communications medium, each rendition presented a different artifact.

To answer the question of what constitutes the artifact's "most interesting qualities," the team kept returning to physical characteristics—in particular, the engravings. But again, what did the engravings best represent? After much discussion, the team decided to widen their gaze: rather than seek out the "tool" or activity that the book represented, they decided to treat the book broadly as an exemplum of the nature of eighteenth-century science. Physically, everything about it—its delicate engravings, elegant Latin script, and fine leather binding—was evocative of a time and a way of thinking, communicating, and knowing that each of the other interpretations under consideration had tried to capture. Furthermore, the book served as the perfect capstone to the rest of the panel. It was this historical flavor, captured in the form of the book's language and images, that the rest of the panel attempted to demonstrate took its shape from the tools and manner with which scientists observed the world.

There was one small problem with this solution. Part of what was characteristic about eighteenth-century science was the language in which it was conducted. But good examples of that language did not exist in the text of *Hortus Cliffortianus.* The taxonomist, therefore, proposed

including a quotation from another work of Linnaeus's in order to illustrate its colorfully poetic character. The quote, in essence, would function as a second artifact. Together with *Hortus Cliffortianus,* it would help illuminate the "nature of the science of nature."

This proposal was finally adopted, although both the designer and the educator held their reservations. At first, they seemed uneasy about the potential deception of using a quote that did not derive from the book with which it appeared. However, as discussions progressed, the problem appeared to stem more from the quote's content. The picture it painted of *Andromeda polifolia* called to mind a maiden in distress, "anchored far out in the water," "fast tied as if on a rock," and "surrounded by poisonous dragons and beasts."

While the dissenting staff failed to present their case in any depth, an explanation for their discomfort may be found in the educator's response to the use of similarly provocative quotations in the "tabloid" panel discussed earlier (see page 17). Recall that these quotes served to illustrate the various supportive and critical responses to Linnaeus's system. To underscore the character of that system, the responses were accompanied by a quotation from the master himself describing pollination:

> The actual petals of a flower contribute nothing to generation, serving only as the bridal bed which the great Creator has so gloriously prepared, adorned with such precious bedcurtains, and perfumed with so many sweet scents. . . . When the bed has thus been made ready, then is the time for the bridegroom to embrace his beloved bride and surrender himself to her.
>
> Linnaeus, 1729

While critics opposed the explicit sexuality of Linnaeus's system, for exhibit developers more than simple prudery was the issue. The educator thought that the inclusion of sexually suggestive quotations had the effect of calling attention to what in Linnaeus's work could be taken as amusing or perhaps naughty but in the long run unimportant. In effect, the quotes served to exploit the subject for the sake of attracting visitors' attention.

In a sense, this was exactly what was going on. The quote represented an attempt to grab visitors' attention in order to involve them with the exhibit; the fact that this time the attention-getter was sex rather than a catchy jingle or a hands-on activity was happenstance. Of greater sig-

nificance is the legitimate role that sex played in Linnaeus's system; sex is at the centerpiece of the system, and to avoid all mention of it would be negligent reporting.

Just as these quotes might appear to exploit Linnaeus and his work, so might the quote under consideration for "the nature of the science of nature." How funny and quaint it is to describe a plant as a helpless maiden at the mercy of evil monsters! Not to mention, of course, the image of women that is thus portrayed. Yet, just as with the Morningstar exhibit described in Chapter Two, to remove questionable images because they might offend viewers is to ignore the realities of history.[5] On the other hand, since exhibit developers have a choice about what they display, might a less provocative quote have made the same point about scientific language? The question was never even broached. Instead, the team decided to be as explicit as possible about the quote's purpose by showing that it demonstrated a way of perceiving plants that was not only colorfully descriptive but scientifically proper. The accompanying interpretation (see page 106) clarified this intention.[6]

There is a revealing footnote to this story. In what can only be described as an act of passive resistance, the designer "forgot" to silkscreen the quote. Furthermore, in preparing the artifacts' identification labels, he wrote and included without proper authorization his own more traditional interpretation for *Hortus Cliffortianus*. This explains the presence of two labels. The identification label was never intended to do anything more than specify the book's title, author, and date of publication. Whether this small act of defiance signaled an even deeper resistance to the selected interpretation than the designer had indicated is anyone's guess. If nothing else, it served as a reminder that the process of interpretation is tied as well to the more prosaic work of execution. Nearly two years passed before the designer corrected his "mistake."

Once again, the purpose of the example of *Hortus Cliffortianus* is to demonstrate not the existence of multiple interpretations but the role that different interests play—professional, personal, and social—in their selection and development. Even further, it serves to suggest that interpretation is an activity that is as ethical as it is rational. Out of a multiplicity of potential interpretations and meanings, museums are still the arbiters over which ones to present.

This point has been driven home recently, as museums come under growing fire for controversial exhibits, interpretations, and even collections practices. Both public and staff have become increasingly aware of the productive role museums play in crafting messages about what for years were assumed to be neutral, objective collections. This awareness has freed museum personnel to express a particular orientation or point of view in their messages. At the same time, it has opened those views to challenge, because fundamentally, differences over interpretation are differences over values and interests and cannot be resolved by appeal to traditional standards of truth. The discussions about how to interpret *Hortus Cliffortianus,* for example, had to do not with defining the artifact correctly but with determining what it best represented, and team members each brought different interests to bear on this determination. Out of a multiplicity of possible interpretations, one was selected.

The interpretive process, however, is not always so conciliatory (the designer's last-minute oversight notwithstanding). Nor is the outcome necessarily so benign. Growing public recognition that museums reflect social interests and values has given constituents a new way to critique and to debate institutional messages. Of interest to us here, however, is not so much the fact of debate (which marks a welcome opening of dialogue in an institution built on monologue) as the terms by which debate is being waged. It is ironic that while argument about interpretation was made possible by the acknowledgment that objects can be interpreted in multiple ways, the result has been a backlash attempt to censor and otherwise control opposing views.

This situation is the subject of the next section, which will examine several recent examples that aptly characterize the problem of presenting a single point of view in a world that admits multiple interpretations.

The Ethics of Interpretation: A Modern Dilemma

The introduction of new ways of interpreting museum objects began with a simple desire to make collections meaningful and intelligible to visitors. It has subsequently raised serious questions about the nature of our knowledge about objects. Insofar as these questions have affected museum practice, there has emerged a heightened awareness of bias in ex-

isting interpretations as well as a growing inclusion of alternative and even multiple interpretations in exhibits. What has not occurred, however, is a heightened awareness that efforts to reform the interpretive enterprise themselves express a bias that is rooted in systems of interests and values. What is also lacking is significant advancement in the way conflicting views are negotiated. Argument about interpretation tends to be waged in the old authoritative spirit that neither fosters nor acknowledges alternative perspectives.

Consider, for example, charges that many interpretations express a European, usually upper-class, and often male, perspective.[7] For the most part, bias such as this was acknowledged to be a natural and largely unconscious projection. Attempts to redress it have covered a broad range. Many exhibit developers, for example, have worked to eliminate bias altogether, making exhibit messages as neutral as possible. Some have singled out bias, making it in itself an object of interpretation.[8] Still others have concentrated on developing exhibits that put forth an explicitly female, ethnic, working-class, or other under-represented perspective.[9] These efforts may have reached their culmination in an exhibit entitled, "The West as America: Reinterpreting Images of the Frontier, 1820-1920."[10]

Mounted by the Smithsonian Institution's National Museum of American Art, this exhibit brought together 164 paintings depicting America's westward expansion by such artists as Frederic Remington and George Catlin. Together, the works emblemize the myths and legends of the American spirit that celebrate bravery, conquest, and progress. The purpose of the exhibit, however, was not to glorify this spirit; it was to point out the fact and the perpetuation of this glorification. Thus, where most viewers have found in these images courage and heroism, the curators found bigotry and greed. The submission of indigenous peoples and the intrusion of the railroad on the landscape—images such as these were held up as evidence of not a civilizing force but an oppressive conquering force.[11] This label describing Robert Weir's 1857 oil painting "Embarkation of the Pilgrims" is illustrative:

> "Chosen people" settled the colonies, according to this version of the departure of the Pilgrims from Delft in 1620. On the deck of the *Speedwell*

(later replaced by the *Mayflower*), passengers and friends offer prayers for safe passage, but other signs suggest God has already provided for the Pilgrims. The rainbow at left, the mighty cross formed by the mast and sails of the *Speedwell,* and the armor on the deck are evidence of a divinely sponsored crusade to the New World, whose success has been predetermined.

Such an analysis may be standard fare among art critics. But to the visitor who is unfamiliar with this approach and whose own past is under revision, such an interpretation borders on not only the offensive but the absurd. Exhibit organizers may have had a perfectly valid point to make; but their presentation demonstrated a lack of sensitivity to an audience unprepared to receive and respond to it. Just because museums can openly express a point of view does not negate their responsibility to help visitors to understand it.

Although the museum responded to criticism early in the exhibit's run by rewriting several labels to clarify their intent, it was too late. The public outrage could not be contained, and reactionary forces rallied to protect long-established and cherished views. It was no surprise when the next two host museums decided to cancel the exhibit (although they denied that the cancellation had anything to do with the exhibit's content).[12]

The issue here is not that the museum presented an offensive interpretation; the issue is that the museum failed to present its interpretation in a way that clarified its objective to uninformed viewers. Once again, visitors were left out of the "loop"; and once again, they encountered an anonymous, authoritative, scholarly voice. While the content may have changed, the delivery did not.

Three years later, history repeated itself when the National Air and Space Museum (NASM) began developing an exhibit about the *Enola Gay,* the plane that dropped the atomic bomb on Hiroshima at the end of World War II.[13] The draft exhibit script, which eventually underwent five publicly scrutinized revisions, not only questioned the wisdom of dropping the bomb but also it was patently sympathetic to the Japanese. Outraged veterans groups charged that the exhibit would not do justice to the events surrounding the decision, and they accused the museum of retrofitting the facts to support a politically correct agenda. Museum officials defended the historical enterprise and warned against allowing special-

interest groups to censor scholarship that was viewed as unpopular or unpatriotic. Even peace groups entered the fray, contending that the exhibit script did not go far enough in denouncing the bomb and the nuclear age that it had ushered in. The conflict generated considerable negative media coverage as well as congressional opposition at a time when the Smithsonian Institution was launching a fundraising campaign as part of its sesquicentennial. Perhaps it is no surprise that the museum finally bowed to the pressure and not only withdrew the exhibit and catalogue but also accepted the resignation of NASM director Martin Harwit.

These two exhibitions are not isolated examples. At the Royal Ontario Museum charges of racism were leveled at "Into the Heart of Africa," which depicted (in part) Canada's role in the colonization of Africa.[14] The fact that the exhibit attempted to critique that role was largely lost to enraged protesters, and four museums scheduled to host the exhibit subsequently canceled their engagements. An installation at the Art Institute of Chicago caused a similar public furor by its placement of that most revered of national symbols, the American flag, on the floor.[15] Veterans groups staged protests daily outside the museum, and the state of Illinois temporarily cut off funding to the museum. Natural history museums throughout the country have been confronted by various Native American groups for their failure to properly respect the sacred objects of native cultures. Repatriation of cultural patrimony as well as skeletal remains has, as a result, become the object of national legislation.[16]

Finally, the cause célèbre, an exhibition of photographs by the late Robert Mapplethorpe, stirred national debate over the nature of art, pornography, and the First Amendment right to free expression.[17] This exhibit of still lifes, portraits, and figure studies included a handful of photographs depicting what the press described as "homoerotic" and "sadomasochistic" images. Opening to little fanfare in Philadelphia and Chicago, the exhibit was branded before it reached the Corcoran Gallery in Washington, D.C., where Senate conservatives fueled a large-scale, emotionally charged protest.[18] The Corcoran subsequently canceled the show, a move that eventually cost the director her job. An alternative gallery, Washington Project for the Arts, displayed the photographs to record-breaking crowds whose curiosity had been piqued by the controversy. Later on the tour, Cincinnati police found grounds to close the

exhibit briefly, even going so far as to arrest the director of the Contemporary Arts Center on obscenity charges.[19] The offending photographs were subsequently secured in a separate room and branded with an X rating. This was a first in exhibit history.

Ostensibly protesting the use of federal (National Endowment for the Arts) funds to support the production and the display of obscene work, critics raised issues that struck at the heart of the museum enterprise: What is art? Who decides what will be displayed? What is the responsibility of museums to the concerns of viewers, private and government funders, and taxpayers? Finally, and most importantly, who resolves these issues?

Like "The West as America," the Mapplethorpe photographs controversy stemmed partially from organizers' lack of communication with their audiences. Where the former drew fire from the presence of (offensive) interpretation, the latter suffered from its complete lack of interpretation. To connoisseurs who know the art "code," the photographs could be approached as formal exercises whose aesthetic lay in their manipulation of form, shadow, and contrast. For most viewers, however, the images could only be read literally.[20] With no interpretive guidance or broader context about gay culture, the photographs served to reinforce negative stereotypes, fueling a wave of homophobia already galvanized by the AIDS crisis.[21]

The seriousness of these examples lies in the prospect that the interpretive enterprise is becoming politicized by debates that fail to distinguish between pluralism and authoritarianism and that cannot accept difference without hierarchy. Museums have not been forthcoming in clarifying these distinctions. Value-laden messages are being presented in the same authoritative voice that is museums' tradition. It is no wonder that public response has focused on the political and ideological interests that these interpretations appear to represent and/or threaten.

While it is one of this book's arguments book that interests and values infuse museum messages, the corollary is *not* that the interpretive enterprise become a battlefield for differing worldviews. Rather, it is the acknowledgment that a whole field of possible meanings has been opened. While this fact has strengthened museums' authority to speak as they will, at the same time it has exposed the terms of that authority, which places conflicting views on more equal footing.

Museums thus have a responsibility not only to clarify the basis and criteria for their messages but also to acknowledge the existence of other messages that they may not care to present. The "ethics of interpretation" refers not just to the presence of interests and values in message-making activities; it also refers to a museum's responsibility to acknowledge its role in and assumptions behind the messages it does present—in particular, to the fact that museums present *an* interpretation, not *the* interpretation.

Even as staff wrestle with ways of managing the development and consequences of exhibit and interpretive decisions, they are really doing nothing that is fundamentally new. As long as there have been exhibits, there have been developers who have assembled objects, props, and messages according to a specified set of interests and goals. What is new is our understanding of this activity and the impact it has had on the decision-making process. Interpretive activities are now grounded in a strong philosophical and critical framework; and they are managed through work structures that allow for a variety of perspectives—both professional and public. Exhibit-development teams, community-advisory groups, and evaluation practices all represent important channels for soliciting broad input into exhibit and interpretive material.

How museums came to be where they are and how much they have actually changed are the subjects of the next section. It will become clear that while the rhetoric is different, the issues are not; the ethics of interpretation has been a part of the museum enterprise since its inception.

The Ethics of Interpretation: An Eternal Issue

For the most part, museum personnel of the past did not reveal nearly the level of self-consciousness about their interpretive activities as do today's critics and exhibit developers. The reasons are in large part circumstantial; interpretation only developed into a full-fledged museum activity during this century, as did many of the developments that have shaped our thought about that function.

Those developments, however—visitor studies, the specialization of museum services, and the subjection of exhibit texts to literary analysis—may be seen as the continuation of an ongoing conversation in museums

about the institution's proper role. If the present age has trained its eye on the nature and implications of particular acts and activities within museums, it is because of past debates over larger institutional purpose. It is in that history of argument about the institution's responsibilities to society that we see the conversation shift from general to specific concerns.

It is worth revisiting that history one last time in the interests of clarifying the evolution of our understanding about precisely what museums do—in particular, as it relates to the values and the decisions underlying museum work through the ages. Each of the previous three chapters has presented different aspects of the same basic history: the first focused on the changing nature of museums' public dimension; the second, on the specific interpretive activities by which museums serve that dimension; and the third, on the changing nature of visitors' experience. This section takes a step back and looks at the nature of the commentary through which these changes have been observed. The manner in which commentators have treated the institution reveals much about the zeitgeist that defined current concerns. We have already examined many of the specific ideas that have been put forth over the years. What about the broad categories of ideas and process of thought evidenced in these accounts? What do they tell us about what was significant? How does that further our understanding about the profoundly, unalterably ethical nature of museum work?

Up until the great wave of museum building in the 1870s, and even a bit beyond, commentary about museums was produced mainly by the museum proprietors themselves in order to explicate and defend the purposes of their individual establishments. These early "museologies" shared two characteristics. First, they tended to deal broadly with museums' roles and responsibilities in society. Second, they expressed explicitly a set of goals that the individual proprietors sought to achieve.

Peale was among the first to articulate a specific vision that changed over time—from his earliest ideals to instill a sense of the perfection of the Creator, pride in the nation, and responsibility to fellow citizens, to his later concessions that simple "rational amusement" might have to serve as a means to that end. A later generation viewed museums' role as

pure and simple entertainment, although their success in this endeavor was tied to other more complex, though less obvious, factors. In time, Joseph Henry sought to restore the scientific responsibilities of museums, while George Brown Goode struggled to reconcile Henry's vision with his own growing commitment to popular education. By the end of the century, a growing number of philanthropists saw in museums the potential for massive social renewal, revitalizing cities and improving the lot of the lower classes.

All these views have been elaborated in earlier chapters. Together, they suggest something about the character of early thought about museums. The sense in which museums were believed to act upon, make decisions about, or otherwise play an explicit role in shaping visitors' thought and experience was very much a part of early museologies. Their actual influence, however, was assumed to operate at only the broadest level. The language used to describe these early establishments reveals clear, if sweeping, goals for visitors, and its style reflects a real optimism about museums' potential to affect people. One of the first art establishments, for example, the American Academy of Fine Arts in New York, was founded in 1802 "as a place of rational amusement to our citizens and strangers, and a delightful study to the Amateur," that would "give elevation to this city and reflect honor on our country."[22] Early proponents of the Charleston Academy of Art argued that the gallery would "prevent much time going to utter waste among the indolent" and excite "virtuous emotions and interesting thoughts."[23] Robert Dale Owen, the author of the congressional bill to establish the Smithsonian Institution, was quite passionate about the museum's potential benefits:

> Over the entire land must the rills from this sacred fountain freely flow. . . . We greatly mistake if we imagine that our constituents are indifferent to the privilege of drawing from these waters of knowledge; that they can not appreciate their fertilizing influence. . . . To effect permanent good in such a world, we must reach the minds and hearts of the masses; we must diffuse knowledge among men; we must not deal it out to scholars and students alone, but even to Tom, Dick, and Harry.[24]

Later, Smithsonian Secretary George Brown Goode found inspiration in these words by British museum founder Sir Henry Cole:

> If you wish your schools of science and art to be effective, your health, the
> air, and your food to be wholesome, your life to be long, your manufac-
> tures to improve, your trade to increase, and your people to be civilized,
> you must have museums of science and art, to illustrate the principles of
> life, health, nature, science, art, and beauty.[25]

In short, though the ends would differ among the various institutions,
the belief that museums were somehow good for people ran through all
accounts.

When it came to the actual operation of these early establishments,
however, few proprietors (the notable exception being Peale) employed
active interventions to carry out their goals. Strategies like advertising or
mounting special exhibits were used to enlist visitors' interest in their es-
tablishments, although the aim was less to achieve specific outcomes (such
as "exciting interesting thoughts") than to draw people inside in order to
reap the benefits—whatever they may be—of encountering the collec-
tions. Once there, the encounter itself tended to be passive exposure. It was
generally thought that if people had mere contact with museums' natural
and cultural wonders, any of various expressed outcomes would surely fol-
low: enlightenment, national pride, and social improvement. Early mu-
seums thus hardly conformed to the modern, perhaps nostalgic, ideal of
detached and objective exhibition. On the contrary, proprietors held
quite passionate visions about their institutions' transformative powers.

After the turn of the century, as the character of museum work be-
gan to change, so too did thought about the nature of the institution's
influence. Several events contributed to these changes by ushering a
broader spectrum of commentators into the museum fold.

First, acceptance of the idea that museums served multiple (scien-
tific and popular) functions was soon followed by the growing special-
ization of personnel. Along with the increased articulation of educational
and curatorial interests, there emerged spokespeople and professional or-
ganizations in such areas as exhibit design, conservation, collections man-
agement, fundraising, and public relations. Each of these domains has de-
veloped a broad knowledge base and sophisticated methods of practice.
As a result, many more perspectives have entered the discussion about the
proper role of museums. While such considerations as public relations

and donor interests are hardly new, they have come to play a far more central role in decisions about display, as exhibits like the Mapplethorpe photographs and "The West as America" attest.

Second, with specialization came the first undertaking of small-scale visitor studies. Growth in visitor evaluation and research activities not only clarified understanding about visitor behavior and exhibit design but also garnered important attention from the academic establishment. Beginning in the 1920s and 1930s with Arthur Melton and Edward Robinson's work, and growing in fits and starts, visitor studies has come to embrace the work of social scientists, psychologists, and education theorists.

Interest in research was also evidenced by the undertaking in the 1930s of several ambitious surveys designed to assess the establishment as a whole. The Carnegie Corporation, for example, commissioned a study, conducted by Paul Rea in 1930, to "appraise the problems and needs of American museums as social institutions." The study attempted to correlate variables such as attendance, exhibit size, and expenditures to community population.[26] A few years later, Grace Fisher Ramsey assessed the "development, methods, and trends" of educational work in U.S. museums, detailing the multiple ways that museums were defining and carrying out their educational mission.[27] In 1939 Laurence Vail Coleman, under the aegis of the American Association of Museums, completed his monumental three-volume study reviewing the "museum scene" according to such criteria as institutional types, purposes, incomes, buildings, and personnel.[28]

Characteristic of all of these studies was their attention to the broad spectrum of museum activities, as opposed to the work of a single establishment. While earlier museologies tended to generalize from the particular example, these tried to grasp the institution as a whole, drawing trends or patterns that could be applied in turn to the understanding and management of individual institutions.

During this time, other more specialized studies were still being carried out at individual sites by researchers such as Marguerite Bloomberg and Louis Powell.[29] Along with the continuing work of Melton and Robinson, these studies sought to establish the grounds for a science of museum management. Relying primarily on a methodology that

employed "unobtrusive observation," the studies consisted largely of inferences made from visitor behaviors about characteristics of exhibit design. Of interest is their evidence of a view that asserted a scientific foundation for museum work and that valued experimentation as a means to its discovery. At a time when scientific thinking was influencing heavily the practice of the "softer" social sciences, the application of systematic methods of analysis to museums lent credence to the belief that there were higher laws according to which museums operated, and that practitioners could maximize exhibit effectiveness through the discovery and the conscious application of those laws to their decisions. This view suggests the possibility of a far more active intervention for museum practitioners, in contrast to the more passive stance they had previously assumed by simply making objects available for view.

During the twentieth century museums became a solidly established social institution, prompting a third type of commentary from cultural critics. More concerned with larger social and cultural issues, this commentary reached its zenith in the last twenty years. Largely conducted outside the museum establishment, it is notable for its attention to some of the issues that have been addressed by the visitor-research field having to do with the effects (and effectiveness) of museum activities. Where the researchers used carefully designed studies, however, this new breed of critic used a more discursive mode of analysis — not unlike that employed by the early proprietors reasoning their goals and expectations for their institutions. These more contemporary commentators, however, were less directed toward professing the proper activity of museums than to analyzing its hidden effects. In this sense, they are closer to the researchers examining the underlying patterns of museum operation.

While some of the work of cultural critics appeared as early as World War I, it was not really until the 1950s that it fully assumed its more sharply critical character.[30] André Malraux was highly influential in this regard. His now classic treatise, "Museum without Walls," addresses some of the covert effects that the physical structure of the museum building exerts on its contents.[31] Malraux was one of the first to observe how museums, in severing objects from their original contexts and functions and enclosing them in a new space with its own logic of organization, endow objects with values and meanings that may have nothing to do with their existence in their original context. Malraux, whose particular interest was

art, demonstrated forcefully how paintings that were created for purposes of communion or remembrance were never considered "art" until they entered museums. In other words, art, along with beauty and significance, are categories imposed on objects by museums.

Over the following decades Malraux's ideas were elaborated upon by a variety of theorists, giving rise to two rather different critical approaches. The first was strictly political, emphasizing the social construction of values. Until recently, few examples existed of this approach's application to actual exhibits; however, those that did show its power to expose a range of biases and assumptions that are embedded in museum displays.

Donna Haraway's account of the African Hall in New York's American Museum of Natural History, for example, gives a convincing reading of the race, class, and sex relations that are embedded in the exhibit's architecture and design.[32] For Haraway, every step of the exhibit-development process—from hunting specimens in Africa to mounting them in suggestive postures—expresses organizers' hidden fears and desires: about Africa, nature, and themselves.

Helen Horowitz takes a more historical approach in her analysis of the New York Zoological Park, although she includes in her data the physical artifact of the zoo along with written records of its foundation. Her analysis focuses on founders' self-aggrandizing views toward wild animals, nature, and their relation to *Homo sapiens*.[33]

Science is the subject of Michael McMahon's critique. His review of the popular National Air and Space Museum finds a nation reveling in its own technical prowess. Progress, power, and military might—these are the messages that McMahon deciphers in what he views as a romantic presentation of aviation.[34]

Carol Duncan and Alan Wallach call their analysis iconographic: a look at New York's Museum of Modern Art as conveyed by the museum's architecture, layout, and themes. They find a monument riddled with contradictions as it exalts the very capitalist values from which it claims to provide a cultural refuge.[35]

Robert Hodge and Wilfred D'Souza's study of the Aboriginal Gallery of Perth's Western Australian Museum demonstrates the Eurocentrist prejudices and attitudes embedded in depictions of the minority aborigine culture.[36] More recently, James Clifford, reviewing a series of

exhibits featuring "tribal" art and artifacts, demonstrates the range of identities that we assign to these objects, identities that say as much about the namers as they do about the named.[37]

Together, these analyses represent an attempt to understand the more subtle effects and messages that exhibits can hold for visitors. Whether visitors are indeed affected, however, either directly or subliminally, is a question that remains to be answered. In any case, the view that museums and exhibitions are political arenas is one that has come under growing scrutiny by a whole range of commentators both inside and outside the institution.[38]

The second critical approach is more deconstructive, although it was being practiced well before deconstruction became a bona fide movement.[39] This approach is more concerned with the indeterminacy of meaning, and has tended to follow more closely Malraux's leanings. Its practitioners defy easy generalization and hold in common only their insistence that meaning may arise out of all sorts of unintended—as well as unattended—practices and utterances.

The resulting analyses have been diverse, each training its own peculiar spyglass on some hidden feature of the museum landscape. Many tend toward abstraction, and most display an inventive, if at times arcane, use of language. Robert Harbison, for example, devotes a chapter of his book, *Eccentric Spaces,* to a meandering contemplation of the transmutation of objects in museums through their "quarantine," "isolation," and eventual reduction to "index," "inventory," and "compaction."[40] Susan Stewart's abstruse essay on collections focuses on the representation of meaning through "dialectics of organization," "narratives of production and consumption," and "the metonymic displacement of part for whole."[41] James Clifford is more interested in the act of collecting (or "appropriating"). For him, museum displays represent less an unsatisfying attempt to restore some displaced meaning than a satisfying attempt to produce a new one that confirms the collector's identity.[42] The experience that these spaces and actions foster is the subject of Brian O'Doherty's reflections on the effect of "separation," "sanctification," and "indication."[43] Finally, in a highly entertaining essay, Umberto Eco describes the transmutation of objects into a state of "hyperreality" as we become more and more proficient at manufacturing credible reproductions.[44]

The examples of such commentary abound; but common to all is a

concern with the more subterranean levels of the museum enterprise: the unexpressed assumptions, motives, and effects that stand behind its many professed functions. "Knowledge," when the word is even used, is clearly a productive endeavor, a point underscored by the use of a style of prose that is less precise, reasoned, and technical than it is metaphorical, discursive, and imaginative. This characteristic is both a weakness and a strength; while it has led to some innovative and even radical interpretations, at times it appears to be based on nothing more than a critic's own creative imaginings and, in the end, has suffered from its clear lack of reference to real problems and actual practice. Few museum professionals have had either the interest or the patience (much less the guidance) to make the leap from "narratives of production" to, for example, novel ways of writing label copy.[45]

While work such as this has not penetrated deeply into museum practice, it has nevertheless begun to be felt through the more politically grounded critiques that have so shaken the institution. Public argument about issues ranging from the representation of non-Western cultures to definitions of art and pornography to the repatriation of skeletal remains have all heightened awareness about the highly complex nature of the institution's task and responsibilities.

In sum, this century has seen the development of a more focused perspective on museums in three general areas: in the museum professions themselves, in the empirical study of exhibits and visitors, and in social and literary criticism of the institution. The result has been a deeper understanding about the extent of the role played by museums in shaping conceptions of the world. What were once considered to be relatively simple acts of display are now understood to be highly judgmental, deeply consequential endeavors. This is not to suggest that museums have not always engaged in the making of choices and judgments. But in the past, those judgments were believed to relate only to the broad social functions and roles of the institution; today they are understood to affect every level of the operation, down to the lighting in the gallery.[46]

It is that understanding that compels thoughtful attention to the specific nature of the interpretive task. For years, museum professionals of various stripes have struggled to define that task, but they have tended to focus more on the content than the basis of interpretation. So too, as a result, have their presentations. To present controversial or nontraditional

interpretations without explanation of the rationale behind them has shifted argument from the scientific (is it true or not) to the political (is it oppressive or not). What is missing is what we have been calling the ethical dimension: the reasons and the basis for making a statement at all. Furthermore, it is insufficient to assert the sorts of altruistic goals that moved founders of bygone days; today's "museologists" have new tools and languages for addressing their aims and tasks. While many have been conscientious in their conduct of that task, their failure to share it fully with the visiting public remains a source of much misunderstanding.

Just as visitors bring their own experiences, beliefs, opinions, and interests to exhibits, so too do museum personnel. Presumably the opinions and interests of the latter reflect those of the professional community they represent; but, as we have seen, their goals may vary widely from the once-straightforward presentation of information. The community for whom exhibit developers speak is no longer limited to curators and scholars; it now includes the groups from whom artifacts originated and the visitors who will view them. Interpretive and display decisions may be based on such wide-ranging factors as visitor characteristics, community interests, artifacts' availability, design constraints, and ulterior educational messages. This point was demonstrated perfectly by the sequence of considerations behind the display of *Hortus Cliffortianus*. Historical background, aesthetic quality, visitor perspectives, educational goals, and design interests all affected the decision of how to interpret the book within the context of the exhibit. These considerations stand as testament to the fact that, in the end, interpretation is about choice; and choice will be governed by criteria that will express a message about what is important to the choosers.

Hortus Cliffortianus, for example, expresses several different messages by its representation of the nature of the science of nature. First, it serves as what critic Eugenio Donato calls a "metonymy" of eighteenth-century science. In effect, the book "sustains the fiction that a repeated metonymic displacement of fragment for totality, object to label, series of objects to series of labels, can still produce a representation which is somehow adequate to a nonlinguistic universe."[47] In the Linnaeus exhibit, however, the point of the representation is less the embodiment of eighteenth-century science as the demonstration that science was differ-

ent then. It is that message—that science changes—that defined the final conceptual organization of the artifact wall. It is thus possible to find in *Hortus Cliffortianus* a message about the changing nature of the scientific enterprise.

Second, both the interpretive label and the accompanying quote suggest the importance of language to thought and perception. Whatever viewers' immediate reactions to the quote—for example, charm, distaste, or indifference—in the end it serves as a demonstration of the message itself: that language shapes the way we perceive and interpret the world. In other words, what one says about a thing, be it a scientific observation or a judgment of value, shapes the meaning it comes to hold.

Hortus Cliffortianus, then, may be seen to express a message not just about eighteenth-century science or about the nature of scientific knowledge but about the process of knowledge derivation in general, including that engaged by museums. This final message, however, is lost in its delivery; it remains an implicit footnote to an ulterior message that is delivered in the very manner and voice of authority that it stands to challenge. Visitors continue to remain clueless as to the rationale or the goals behind what they are being told. Further, any sense of ambiguity or selectivity surrounding the artifact's interpretation is suggested only by the last-minute (and ironically, unauthorized) inclusion of the alternative identification label.

The lesson here is that while museums may willingly acknowledge the legitimacy of multiple interpretations, the process of weighing and selecting a single one tends to remain behind closed doors. While that process is a welcome step, it is not enough. To present an interpretation without providing some sense of the basis for it perpetuates the blind faith typically required of visitors. In the end, the criteria, beliefs, and assumptions on which a statement stands are as important a part of the interpretation as its manifest content, because they provide the basis for judging and evaluating it.

"Education as Ethics" thus carries a dual meaning. It refers to the system of values and beliefs that stand at the heart of interpretive decisions; and it suggests that museums have an ethical responsibility, both to themselves and to visitors, to clarify exactly what that system is. The acknowledgment that museums interpret opens the possibility for multiple

views. Without an eye toward judging those views, however, or an ethic guiding those judgments, the sky becomes the limit and anything can matter. Education, then, becomes truly inconsequential. The work of interpretation carries the attendant responsibility to reflect upon the values and criteria by which an institution conducts that task. It is only by sharing those criteria with the visiting public that viewers are able to absorb and to evaluate a museum's interpretations accordingly.

Conclusion
Education as a Narrative Endeavor

E ntertainment, empowerment, experience, and ethics: each of these
domains represents an aspect of current thinking about the mean-
ing of "education" in museums today.

"Entertainment" refers to museum practices and visitor experiences
that fall outside such traditional educational goals as cognitive engage-
ment and information transfer. Until recently, the term has generally (and
often demeaningly) been used in museums to refer to activities that have
no more redeeming outcome than pure and simple amusement. Both his-
torical evidence and visitor research, however, suggest that entertainment
may encompass far more than it connotes. As a vehicle to learning, for
example, "entertaining" methods of presentation may be viewed as at-
tempts to reach visitors through linguistic and cultural forms that are
comfortable to them. As a "learning" goal unto itself, entertainment may
be seen to represent a whole gamut of possible experiences and outcomes
that have nothing to do with the transfer of information.

"Empowerment" refers to the authorization of alternative modes of
knowing and speaking besides the information-based methods tradition-
ally employed in museums. Largely the result of both new critical theory
about the productive nature of knowledge and a heightened sense of ac-
countability, these changes have opened a whole field of possible mean-
ings, experiences, outcomes, and practices in museums. By defining

knowledge in relation to the larger social and historical context, visitors are being "empowered" to know and to speak in ways that are meaningful to them. They now share with museum personnel responsibility for and control over defining their experiences with the collections. Consequently, several long-standing tenets have been eroded, such as the authority of the curator, the sanctity of objects, and even the prestige of the institution itself as a source and distributor of "knowledge."

"Experience" refers to new ways of thinking about the basis for knowledge. With the legitimation of multiple ways of knowing and the acknowledgment of the role of context in shaping understanding, language about "knowledge" has shifted to language about "meaning." What we know, in other words, is based less on the nature of the object than on the manner and the context in which it is experienced. As a result, traditional criteria of "meaningfulness" based on measures like the "reality" of the object or the authority of the museum interpreter now include other considerations that take into account the context and character of visitors' responses.

"Ethics" refers to the value and belief systems that stand behind these different criteria for meaning. These systems describe the conditions according to which objects are selected, interpreted, and encountered. The museum enterprise is shaped by these systems, for they give rise not only to the meanings constructed by visitors but also to those that are given by the museum. In a world that allows for multiple perspectives, the conditions for meaning have become as important as the meanings themselves.

Clearly, "education," at least as it is practiced in museums, is evolving into a rather different animal from what it had been in years past. This last chapter attempts to characterize that animal by, first, demonstrating that museum education is essentially a narrative endeavor and, second, considering the implications for learning and teaching in museums.

Older models of education based on hierarchical, unidirectional modes of communication no longer adequately describe the learning that occurs when visitors encounter objects. Education is not just about museums teaching visitors; it is about visitors using museums in ways that are personally significant to them. It is about the mismatch that arises between a museum's culture and a visitor's culture; and it is about negoti-

ating that mismatch in a way that is respectful of both. The essence of the education enterprise is thus the making of meaning. Whether it involves visitors interpreting their experiences or museum personnel interpreting collections, meaning making is at the heart of the endeavors of both. Both engage in constructive activities that reflect the possible meanings of things.

Education, however, is about more than the making of meaning.[1] If it were not, we could stop right here and simply accept that there are multiple versions of the world and that each version, under its own terms, is as plausible as the next. In the real, lived world, however, different versions conflict and give rise to the sanction or the suppression of the norms, laws and behaviors according to which we are obliged to abide as members of a social community. Multiple worlds may work epistemologically; empirically, they create enormous tension, as people struggle to live and to think as they will.

It is out of that tension that the task of education arises. It is there that the task of constructing meaning—through observing, comparing, and evaluating possible versions of the world—really begins. Philosopher Nelson Goodman describes how the construction of world versions is always a *re*-construction of prior versions, necessitated when experience conflicts with expectation.[2] It is this moment of conflict that is the business of education, because out of conflict comes the need to consider the sense in which revised or alternative world versions may be valid.

This situation raises a question. Unable to appeal to higher standards of truth, how does one go about "evaluating" one world version against another? If different versions can exist on their own particular terms, on what grounds can one judge and react to them? Ultimately, the key to this question has to do with the object of evaluation. For what is at issue is not the truth of different versions but their truthfulness, and not the details of particular versions but the conditions according to which they may be true. Educator Jerome Bruner puts it this way:

> It is far more important, for appreciating the human condition, to understand the ways human beings construct their worlds . . . than it is to establish the ontological status of the products of these processes. For my central ontological conviction is that there is no "aboriginal" reality against

which one can compare a possible world in order to establish some form of correspondence between it and the real world.[3]

Bruner provides a much different approach to evaluation from that offered by long-dominant scientific modes of thinking. In essence, he replaces criteria that stress the accuracy of the product with criteria that take into account the context of production and reception.

These two approaches—the one product-based, the other context-based—describe two distinct ways that humans order experience. They also describe the two modes of knowing that are shifting in museums, as a single, curator-scientist-driven version of the world makes room for multiple, visitor-driven versions. The first, what Bruner calls *paradigm*,[4] specifies a manner of organizing thought that is "logico-scientific." Its modus operandi is reason and its goal is the establishment of consistent, verifiable descriptions of the world. The second, what Bruner calls *narrative,* deals with the creation of story. It aims to establish not truth but meaning; explanation is achieved not through argument and analysis but through metaphor and connection:

> Arguments convince one of their truth, stories of their lifelikeness. The one verifies by eventual appeal to procedures for establishing formal and empirical proof. The other establishes not truth but verisimilitude. . . .[5]

These models' crucial difference lies in the criteria each applies toward the verification of statements. Neither the language they employ nor the manner in which they construct their accounts has as much bearing on how they function as their criteria for what constitutes verification. Language and structure have to do with constructing a representation; but verification has to do with the plausibility of the construct.

In paradigmatic thought, verification has been defined by many different criteria over time. Thomas Kuhn, for example, defined it in terms of agreement—agreement with a larger class of scientific statements. For Karl Popper, it was about falsifying hypotheses. Other proposed criteria have included reliability, corroboration, and adequacy. However it is defined, in the end, the question it seeks to answer is whether a given statement is true or false.

By contrast, the question underlying narrative thought concerns the sense in which something is true. Verification involves assessing not cer-

tainties but possibilities; the world it represents exists in reference to not an external reality so much as a "psychic" (as Bruner puts it) reality. Its truthfulness concerns not its correspondence to an objective world but its ability to describe a possible world that one lives and experiences. According to Bruner:

> Science attempts to make a world that remains invariant across human intentions and human plights. . . . The humanist deals principally with the world as it changes with the position and stance of the viewer. Science creates a world that has an "existence" linked to the invariance of things and events across transformations in the life conditions of those who seek to understand—though modern physics has shown that this is true within very constrained limits. The humanities seek to understand the world as it reflects the requirements of living in it. In the jargon of linguistics, a work of literature or of literary criticism achieves universality through context sensitivity, a work of science through context independence.[6]

The role of context is crucial to understanding these differences. Although Bruner does not pursue this point and its significance, French philosopher Jean-François Lyotard does. Lyotard has studied in depth the procedures of what he calls "legitimation" (or verification)—which determine how truth or falsehood is established. For him, a primary difference between scientific and narrative thought lies in their appeal to "extra-contextual," in the case of the former, and "inter-contextual," in the case of the latter, criteria of truth.[7]

Scientific thought for Lyotard consists primarily of denotative—or descriptive—statements[8] that exist in relation to an outside, objective referent. By contrast, legitimation in science consists of a variety of statement types and relies on criteria of proof that originate from nonscientific—and, therefore, uncertain—modes of knowing. In other words, the criteria of legitimation are not immanent to science; rather, they arise out of narratives about what constitutes scientific truth: for example, falsification, reliability, and adequacy. Lyotard argues that "scientific knowledge cannot know and make known that it is the true knowledge without resorting to the other, narrative, kind of knowledge, which from its point of view is no knowledge at all."[9] This suggests a major chink in the scientific armor; and it is the sense in which verification relies on "extra-contextual" criteria of truth.

Narrative, on the other hand, has no such need for legitimation in the sense that science does. Narrative statements derive their acceptability not from truth but from custom. According to Lyotard:

> What is a "good" prescriptive or evaluative utterance, a "good" performance in denotative or technical matters? They are all judged to be "good" because they conform to the relevant criteria (of justice, beauty, truth, and efficiency . . .) accepted in the social circle of the "knower's" interlocutors.[10]

But from where do these "socially accepted" criteria come? From narratives about what constitutes beauty, ethical wisdom, and even criteria of truth. Examples abound in the myths and legends of traditional cultures, which dramatize positive and negative characters, moral dilemmas, and final resolutions. Contemporary culture finds its narratives in political and philosophical discourse, as well as fairy tales, literature, and song. Unlike science, then, the legitimating criteria for narrative are immanent in itself. This is the sense in which verification in narrative relies on "intercontextual" criteria of truth.

How do these observations relate to the problem of evaluating different world versions? As we noted earlier, evaluation has to do with not which version is more true but the sense in which each might be true. For Bruner, these "possible worlds," as he calls them, coexist because they appeal to distinct criteria of truth. They are different, complementary, and ultimately irreducible. For Lyotard, those criteria—while distinct in form—are in essence the same. Both scientific and narrative modes of knowing base their legitimating criteria on narrative forms of thought. The result is a common framework for thinking about the truthfulness of statements. Where Bruner gives us apples and oranges, Lyotard helps us to question what makes them fruit. In other words, to understand the sense in which either a scientific or a narrative version of the world might be true, one must finally engage in narrative about their respective criteria of truth.

The point of these observations is not to discredit scientific knowledge by making it dependent on narrative; rather, it is to demonstrate the utility of the narrative model for evaluating different world versions and, in particular, to establish the centrality of narrative modes of knowing to the educational enterprise. Narrative provides a useful "narrative," if you

will, for describing the nature of education in museums. It accommodates the various meaning-making activities engaged by curators and visitors as they interpret and order the world; it provides the terms under which different versions may be true; and it comprises the means for judging and evaluating those versions. If education is a process of assessing different possible worlds, narrative is the means by which this is accomplished. Consequently, our ideas about both "learning" and "teaching" must be reformulated. The next two sections examine exactly how, analyzing first the nature of visitor experience and then the nature of the museum enterprise.

Visitor Narratives: Rethinking "Learning" in Museums

In any given museum, visitors will probably encounter the same raw material: an entryway, exhibits, and perhaps a restaurant or gift shop. However, each will come away with an individually unique experience and interpretation because every visitor is engaged in constructing a narrative about what he or she sees. As literary critic Wolfgang Iser explains, "the reader 'receives' [a message] by composing it."[11]

How does a narrative view of education alter our understanding of the visitor's experience? How does it help us to move to a more penetrating understanding of how and what visitors "learn"? First, a narrative view of education suggests that visitors' experiences are shaped as much by who they are as by what museums are like. Second, it suggests that museums may have a far broader impact on people's lives and psyches than is typically acknowledged. At their most basic, museums communicate. In communicating, they ignite memories, activate emotions, and spark interchange. What visitors do with these possible responses is part of the narrative they craft. What they craft may or may not have anything to do with the messages institutions intend.

The unpredictability of visitor responses and narratives, however, does not excuse museums from carrying out the hard work of making their messages comprehensible. Instead, it introduces new considerations to the process by which museums convey those messages: for example, the significance of messages to viewers; the languages and modes by which viewers best receive them; and the prospect that messages can

be processed in unanticipated ways. It also suggests that museums should deepen their knowledge about visitors in order to better anticipate their responses and to refine working models of learning goals and outcomes.

At present, our understanding of learning in museums remains limited. The visitor-studies field continues to be dominated by exhibit and program evaluation and audience surveys; true educational research is only being conducted in scattered pockets. Interestingly, and indicative of the current tide of thought, much of the research undertaken in recent years has dealt with not learning per se but investigating the "visitor experience." Characteristically, these studies attempt to get inside visitors' heads to better understand the specific interests, motives, and rationales that shape their experiences and interpretations in museums. Results so far suggest that we are seeing only the tip of the iceberg when it comes to understanding what visitors make of museums.

It has become clear, for example, that visitors go to museums for a multitude of important purposes and experiences, many of which have now been repeatedly documented. Taken together, they constitute the beginning of a taxonomy, which includes social interaction, reminiscence, fantasy, personal involvement, and restoration.

Social interaction is high on many visitors' lists. From relationship building to seeking an emotional connection, interacting with companions while in a museum is an important goal for many visitors.[12] "Meaningfulness" for such visitors is measured as much by their experiences with one another as with the objects and exhibits around which they interact.

Reminiscence is a second important category of museum experience. For some visitors, objects and exhibits spark memories. Their museum visit thus provides an occasion for remembering, retelling, and re-experiencing significant moments and people in their lives.[13]

For other visitors, *fantasies* may be sparked by objects and exhibits. In such cases, the museum becomes a time machine, transporting visitors through history and allowing them to experience other periods and cultures. The significance of such experiences varies. The sense of "being there" is important to many visitors; the possibility of escape and respite is what matters to others.[14]

Personal involvement—making a personal or human connection, exploring self-identity, engaging in introspection—describes an aspect of

museum experience that, for some visitors, forms the basis and meaning of their visit.[15]

Finally, *restoration* has been identified as an important experience for visitors who go to museums to relax and recharge. Not surprisingly, most of the research on restoration has been conducted in art museums. Interestingly, the effectiveness of the restorative experience has been linked not to how much visitors know, learn, or like about the art but to factors that make the visit comfortable, such as accessibility and the visitor's general familiarity with museums.[16]

None of these findings discounts the other more familiar factors that bring visitors to museums and make their experiences meaningful. There is no question that some visitors come to get information and that intellectual curiosity can be an important motivator. But these factors, as the research shows, make up but one piece of a large puzzle.

Another piece of that puzzle comes from turning the question on its head and inquiring into the broader considerations that make museumgoing a part of people's lives. Leisure values, for example, have been found to play an important role in people's decisions about museum use. Frequent, occasional, and non–visitors can all be characterized by what they seek in their leisure-time experiences and by how well they imagine that museums will satisfy those interests.[17] Family history is another factor. People who go to museums often began their visitation patterns as children, usually with family but sometimes with friends.[18]

While the puzzle remains incomplete, enough research has been conducted to begin guessing what the whole might finally look like. A few models are beginning to appear that attempt to formalize the view that visitors' experiences are shaped by factors that go far beyond what museums suppose. John Falk and Lynn Dierking, for example, have proposed an "interactive experience model" consisting of three interacting spheres, each of which represents one of three contexts within which visitors experience museums: their own personal context; the social context of their companions; and the physical context provided by the museum. The site where they overlap represents the totality of factors that shape the visitor experience.[19]

Lois Silverman's work examines meaning making and proposes several key components that enter into the process. At its core is memory:

existing mental frameworks such as knowledge; expectations and norms; and life events and situations. Balancing memory is the present context—factors that shape the way visitors recall and connect to the past: for example, self-identity, companions, and leisure motivations. This mix of factors subsequently gives rise to the meanings visitors make, which, Silverman proposes, ultimately cluster around two basic human needs: the need for individuality and the need for community.[20]

This research provides evidence that supports a narrative view of visitor experience. It illustrates in visitors' own words the role that personal values and interests play in shaping why they visit, how they conduct the visit itself, and the narrative they create that describes what they experienced and that will live on in their memory. For the most part, however, attention to visitors' values, goals, and current knowledge has largely been driven by interest in improving the transmission of the museum narrative; the visitor's narrative, while acknowledged, continues to be regarded as something private, accidental, and therefore beyond the scope of museum attention and practice. For those visitors who either do not understand the museum narrative or who are so uncomfortable with the setting as to be unable to construct their own narrative, the museum becomes a place to be avoided, as Marilyn Hood so ably illustrated.

Studying visitors' narratives is problematic for another reason. Despite all appearances and activities to the contrary, handing the meaning-making process to the visitor is still a radical act that signifies a diminished role for the museum and calls into question the fundamental nature of museum work. It suggests that no matter how carefully crafted an exhibit, no matter how visitor friendly its design, the visitors who use it will still make their own sense of it according to their own terms. Of course, the opposite argument can also be made: if visitors' responses are shaped by a wider social and historical context, why can't exhibits—themselves social and historical entities—help shape the interests and values that make up that context?[21]

Either way, it is clear that more research on narrative construction can only help staff move beyond the apparent inaccessibility of visitors' meaning-making activities and determine the relation between what visitors bring and how museums can affect what they bring. Current research trends suggest some promising new directions for exploring this question.

Perhaps foremost among this research, in so far as it has been dis-

covered by museum personnel, is Howard Gardner's work on the different types of "intelligence" that dominate mental functioning.[22] According to Gardner, individuals naturally exhibit proficiency in any of several of several modes of thought: for example, linguistic, mathematical, and spatial thought. For the most part, Gardner's work has been applied to the problem of information delivery, particularly by proponents of learning-style theory who have found in Gardner's model a useful taxonomy that goes well beyond traditional visual, auditory, and kinesthetic categories. In relation to theories of narrative, this taxonomy provides a way of talking about the mental processes that are used to represent the world. Different world versions, in other words, may be understood to derive from the particular symbolic forms—for example, verbal and mathematical—in which one's mind is specialized to deal.

Gardner's is a more psychological perspective, and one that Bruner himself used to support of his discussion of world making.[23] However, social and cultural variables play a crucial role as well and have been the subject of work by a disparate body of researchers. Lev Vygotsky's work on the social components of learning, for example, has seen a resurgence of attention among museum personnel, who are interested in the social interactions that take place among visitors, particularly family members.[24] Blythe Clinchy's work on the processes by which women acquire knowledge holds promising application to visitor experiences with its emphasis on connected, internalized methods of knowing.[25] Even literary theorists like Umberto Eco or Jean Baudrillard, whose work is generally more descriptive than empirical, are relevant since the core of their work deals with the social construction of narrative.[26]

Beyond the specific examples, however, there is a need to extend the methodologies traditionally employed in the study of visitors and museums. Particularly with the expanded definitions of "education," it would be useful to consider alternative models of explanation, such as oral history, mythology, or family folklore—all of which have an established methodological tradition and are basically concerned with the telling of stories. Communications theory could offer another perspective on storytelling as it relates to the transmission and the reception of messages. Psychology has branched into areas that have direct application to the study of visitor experience: play theory, for example, could shed light on the process of play and fantasy in which visitors reportedly engage; en-

vironmental psychology could help illuminate the effects of museum and exhibit spaces on human perception; and human development theory remains an underutilized resource for linking visitors' expectations and attitudes toward museums with their stage in the life cycle.[27] Some of these areas have received more attention than others; but all hold great potential for furthering understanding about visitors, exhibits, and museums.

In sum, while some visitor research evidences a shift toward understanding the learning experience in more narrative terms, the issue begs further study through the careful development of questions and the creative application of models and methods. How do visitors' narratives change or set over time? What is their long-term influence on visitors' attitudes, decisions, memories? How aware are visitors that museum presentations are narrative constructions? The answers to questions like these have profound implications for museum practice. The next section will explore some of these implications as they relate to not only what museums do but also what they are.

Museum Narratives: Rethinking the "Teaching" Function

If we understand visitors to be engaged in a process of narrative construction, two questions arise. First, how does this fact alter what museums do for visitors? Second, how does it change what it means to be a museum?

The answer to the first question concerns educational goals. While museums have made enormous strides in fulfilling their educational function, exhibits and programs continue to be dominated by goals that privilege the museum narrative. For example, one objective of "Linnaeus: Lessons and Legacy" was that "visitors will recognize the contributions of Carl Linnaeus to the plant world." More attention should be paid to the development of goals that inspire visitors to discover and construct their own narratives. Clearly, this task is easier said than done. With few good models or precedents, the challenge becomes quite practical: how does one go about fostering narrative construction? What would such a thing even look like?

One approach to fostering narrative construction may be through the treatment of the interpretation. If readers indeed "receive a text by composing it," as Iser asserts, then one is led to wonder whether there are

particular factors that aid or encourage the activity of composition. Bruner asks this question of literary texts and proposes that certain kinds of linguistic devices help to open the "interpretability" of texts. For example, the use of "presupposition" (creating implicit rather than explicit meanings) and "subjectification" (depicting reality through the filter of the protagonists) has the effect of "subjunctivizing" the text with possibility, thus enlisting the reader in its interpretation. Evoking surprise is another method of involving readers, because what is surprise but the violation of expectation—followed, one hopes, by assessment and engagement. These techniques support what Bruner defines as the core task of literary narrative: to engage the reader to "'write' his own virtual text."[28] According to Bruner:

> The author's act of creating a narrative of a particular kind and in a particular form is not to evoke a standard reaction but to recruit whatever is most appropriate and emotionally lively in the reader's repertory. So "great" storytelling, inevitably, is about compelling human plights that are "accessible" to readers. But at the same time, the plights must be set forth with sufficient subjunctivity to allow them to be *rewritten* by the reader, rewritten so as to allow play for the reader's imagination.[29]

Just as literary texts can be written in a way that invites readers' participation in their composition, exhibits can be developed in a way that engages visitors in constructing narratives about what they see. Indeed, such practices as including the social and historical contexts of objects or presenting other cultural perspectives already offer ways of encouraging narrative construction—the first by suggesting that meaning is neither innate nor fixed but exists in reference to a wider set of conditions; and the second by acknowledging that there are multiple ways of interpreting an object.

An easy way to foster visitors' narratives, and one that is rarely practiced, is for museums to be upfront about their own process of construction—that the knowledge they present is incomplete and unfinished; that it is derived through a never-ending process of discovery and revision; and that its advancement is subject to ongoing debate. No one who is involved in the pursuit of knowledge would argue with this characterization, and yet museums persist in creating exhibitions that appear to present the single and final word on a subject. Were they to focus on the process of thought or the arguments surrounding their development,

visitors could more readily enter into dialogue and actively consider their own responses.

Several promising strategies have been employed at the Denver Art Museum to assist visitors in exploring their personal responses. The museum's two-columned "If you like/If you don't like this painting" label (described on page 71) goes to the heart of the matter by acknowledging a range of possible reactions to the artwork on view. Another label experiment encouraged visitors to follow their own interests and responses by presenting multiple interpretations of the same painting. Carefully worded headings direct visitors to those interpretations that interest them. Yet another example is a gallery activity that invites visitors to arrange a series of prints of women according to how "realistically" portrayed the subjects are. Obviously there are no right or wrong answers; but the activity serves to encourage observation, comparison, and thought about one's own perspectives about what is realistic. Characteristic of all of these methods is that they focus on the process of finding meaning; the product is of interest only to the extent that visitors are able to construct a narrative that works for them.[30]

At the Wichita Art Museum, visitors' interpretations have been formally collected and shared in handouts entitled "Visitors' Viewpoints." By publicizing visitors' views in this fashion, several outcomes are achieved including the presentation of multiple meanings and the affirmation of visitors' own meaning-making activities.

While interpretation is one way that museums can play a more active role in helping visitors to construct their own narratives, another method is to develop goals whose outcomes better approximate visitors' reported interests and needs. Some headway has already been made in this regard. Particularly for visitors on a primarily social outing, some museums have been attentive in developing interpretive guides or games that encourage interaction among visitors. "Discovery rooms," family programs, and interpretation that empowers parents to teach their children have consequently become more regular fixtures in museum halls.

Other visitor goals, such as entertainment or fun, have been a bit more difficult to fulfill for the reasons discussed in Chapter 1. While no one wants a museum visit *not* to be an enjoyable experience, concern for compromising traditional educational goals has inhibited (or at least challenged) the development of more entertaining methods of display. Nev-

ertheless, entertainment has wedged itself solidly into the range of museum offerings, although often in the service of other, more clearly "educational" ends.

These approaches encouraging visitors' narrative construction raise a rather serious issue. With the development of educational goals that accommodate and foster visitors' narratives, what happens to the museum narrative? How tied is it to the service of visitors? How far must its objectives be submerged by their stories and their voices? Actually, the very fact that museums even engage in narrative suggests that, like visitors, museums are engaged in the production of a story, and that they, too, may just as legitimately present a story that supports *their* particular interests and goals. Indeed, this is what museums have been doing all along under the guise of "objective," neutral presentation. Instead of presenting *the* version, however, they may now be understood to be presenting *a* version.

Narrative, then, describes the constructive activities not just of visitors but also of museums. It thus opens the door to a whole range of possible messages and has paved the way for some museums to take on an aggressive advocacy role. Exhibits that deal with social issues such as AIDS, technological growth, and medical ethics present messages that follow from *museums'* goals for their visitors, which are in turn an expression of the institution's stated interests and values. The narrative model, in other words, frees museums to take a stand and be explicit in their expression of issues in which they have a vested interest.

Although the narrative model may thus appear to support the preservation of old authoritative modes of expression, two key differences set the current situation apart. First, if a message is presented in a way that acknowledges its own nature—in other words, that is explicit about being not only a version but being the museum's version—then it does not exclude the possibility of alternative versions held by visitors. Second, if a message is presented in a way that allows for argument, complexity, or multiple perspectives, then it may begin to engage visitors in the process of evaluating it against their own perspectives. The result is a relation of shared authority, as both visitors and museums engage in constructive activities that give rise to the possible meanings of things. This is the essence of education.

More problematic is the question: What if visitors misinterpret the museum's narrative in such a way that completely changes its meaning?

For example, if an exhibit presents a model of the earth moving around the sun, and a visitor sees the sun moving around the earth, is the visitor simply "creating his or her own narrative"? The danger of the narrative model is that in opening the field of possible meaning, it can be used to rationalize any statement, however outrageous. More critical, it can easily become an excuse for not doing the hard work of making exhibits communicate clearly and effectively. Narrative, however, provides a useful tool for doing that work. By talking to visitors about their preconceptions of, interests in, and responses to exhibit elements that are under development, museum staff can anticipate viewer reaction and clarify exhibit messages accordingly.

So how does a narrative model of education alter what museums do? It requires that museums do what they have always done, which is present messages; but they must do it in a way that is respectful of the narratives constructed by visitors and that is conscious of and explicit about the constructive process engaged by museums themselves.

If we understand both visitors and museum personnel to be engaged in a narrative endeavor, how does this alter our understanding of the museum "genre"? How does it affect traditional definitions that emphasize collection, preservation, study, exhibition, interpretation? Once again, Bruner provides helpful direction. In discussing the implications of his work on meaning making for the conduct of education, he observes that

> a culture is constantly in process of being recreated as it is interpreted and renegotiated by its members. In this view, a culture is as much a *forum* for negotiating and renegotiating meaning and for explicating action as it is a set of rules or specifications for action. Indeed, every culture maintains specialized institutions or occasions for intensifying this "forum-like" feature. Storytelling, theater, science, even jurisprudence are all techniques for intensifying this function—ways of exploring possible worlds out of immediate need. Education is (or should be) one of the principal forums for performing this function.[31]

As stewards of culture, and as educational institutions, museums are perfectly positioned to carry out this negotiatory function. Indeed, if meaning making lies at the heart of the museum enterprise, then everything the institution does and represents must follow from that fact.

Museums have long been compared to universities or libraries, institutions whose devotion to the spread of knowledge has provided a powerful metaphor for museological activities. But shifts in emphasis from knowledge to meaning suggest that these models may have outlived their usefulness. Given the highly constructive activities in which visitors and museum personnel engage, objects—once the centerpiece of museum definitions—have taken on a diminished role. Once valued for qualities assumed to be innate, objects may now be understood to derive their meaning and value from narratives constructed and imposed from without. No longer are objects ends in and of themselves so much as vehicles for the expression of ideas. In the past, only those ideas that emanated from a scholarly tradition have been given voice. Now objects are being used to represent a host of meanings, from personal interpretations to social issues to reflection upon the exhibition function itself.

Objects have also become vehicles for experience. By opening the field of possible meanings that objects can hold, traditionally valued qualities such as rarity, provenance, or reality have taken their place next to experiential qualities that objects evoke, such as provocation, spectacle, or realism.

Clearly, museums are no longer object-based institutions in the traditional sense of the term—except insofar as objects serve as the conveyers of ulterior ideas and experiences. Rather, they are idea-, experience-, and *narrative*-based institutions—forums for the negotiation and the renegotiation of meaning. Indeed, this characterization is supported by the recent explosion in objects and spaces accorded for display. Nontraditional "objects" such as television and radio shows, movies, trains, sensoria, rock and roll, and folklife form the basis for a host of museums established in the last fifteen years or so. Children's and science museums often do not even maintain permanent collections, offering instead elaborate learning arcades of hands-on demonstrations and jungle-gym interactives. New museums are regularly built around themes just as much as collections: for example, the National Women's Museum, the Peace Museum, and the United States Holocaust Memorial Museum. Businesses now routinely exhibit company memorabilia and history, which are often professionally curated; corporations assemble collections of art; private homes and public neighborhoods declare themselves historic landmarks; and onetime "nostalgia shops" offer "collectibles" to the public eye.

All of these institutional manifestations evidence a shift in the field

itself away from traditional images and definitions.[32] They have also led to some unsavory comparisons, as museums adopt new and unconventional approaches. Once denounced as graveyards and attics, museums today are accused of being playgrounds and theme parks—which they are and more. New kinds of functions and goals are changing the institution in profound and fundamental ways; but further exploration of these changes will require moving beyond the traditional images connoted by terms like "museum"[33] and "education." Indeed, museums would do well to consider some of the metaphors that have recently been associated with them, because they provide an imaginative tool for thinking about what museums are and do.

Consider, for example, the marketplace, which has traditionally served as a place for social gathering. As museum director Roger Mandle recently observed:

> [Shopping malls] have become the community gathering places of today's society in the same way that the markets in Florence, or in Amsterdam, were in the 14th or 17th centuries. Museums have many of those same elements; it's just that we haven't learned how to exploit them.[34]

We live in a time and society in which traditional spaces for gathering and socializing—the marketplace, the plaza, and the general store—have all but disappeared. Even the extended family has been scattered by distance and social disruption. Museums hold the possibility of restoring public spaces for people to gather, to play, to tell stories, and to learn about their heritage. At a time when ethnic groups are seeking to renew their cultural ties, museums present a natural gathering place for them to revisit their history and culture.[35] It is not difficult to imagine museums in the future assuming such roles in community social life.

A second metaphor that is related to the first is something that might loosely be called "ritual." Some museums have assumed responsibility for presenting community rituals or ceremonies that for a variety of reasons are no longer commonly practiced: for example, Christmas caroling, Harvestfest, and Halloween. Special events are routinely developed for celebrating such "holidays" as Mother's Day, Earth Day, and even children's birthdays. Exhibits of cultural properties may be accompanied by ceremonies designed to protect or to honor the objects on display; in 1984, for example, Maori people came from New Zealand to the United States

to perform the "dawn ceremony" at museums hosting a traveling exhibit of cultural treasures.[36] In 1986 an exhibit of Japanese Buddhist art at the Art Institute of Chicago was opened every morning with chants and prayers performed by Buddhist monks.[37] Finally, ritual describes what for some visitors is the purpose and the nature of their museum visit. The United States Holocaust Memorial Museum, for example, has been called an "icon" for the contemplation of personal responsibility; its visitors have been likened to pilgrims on a journey of personal introspection.[38] Museums can provide an extraordinary, sanctified space for reliving or re-visiting the past.

Related to the idea of ritual is that of festival. The presence of na-tive peoples in museum halls is not limited to their artifacts. Members of various cultural groups increasingly participate with exhibitors in the in-terpretation of their culture through demonstrations of craftmaking, song, or dance.[39] They have thus helped turn exhibits into what might be more rightly described as festivals or fairs,[40] although the performance of ritual and the performance of culture raise serious ethical questions about what is in effect a "display" of native peoples.

Finally, a third and often disparaging metaphor is the museum as theme park, which in particular represents an assault on traditional museum values. Theme parks are built completely of fantasy and artifice, are un-abashedly commercial enterprises, and seek above all to entertain. Yet these qualities represent the very direction in which museums have been grudgingly moving. Theme parks have made no secret of the fact that they are creating an idea and a fantasy: Disney is quite upfront about pro-moting the image and the values of progress, fun, and small-town Amer-ica by means of "objects" that serve only as props. Disney thus takes full advantage of the medium's natural qualities; its presentations are com-pletely multisensory, three-dimensional, and symbolic. As popular cul-ture critic Margaret King observes, "Born of the animation process, film techniques, and the rapid procession of images, its lexicon consists of ideas-as-icons."[41] Theme parks offer a vision based not on literal or his-torical fact but on archetypes and community-consensus history. Muse-ums are moving in precisely this direction in both their exhibition tech-niques and "learning" outcomes, but many staff remain defensive at the comparison. Nevertheless, there is a need to clarify more precisely what is going on when visitors encounter these spaces. Museum director François

Barré, for example, makes the following observation of a particularly Disney-like exhibit at Paris's science center, Parc de la Villette:

> The visitors became active participants as they rediscovered their own memories, even fantasies. They were immersed in a universe where everything was at once true and false—false because it consisted only of backgrounds and illusion, but true because it existed in everyone's heart and dreams. It was not just an amusement park, but an environment stimulating new ideas.[42]

In sum, metaphors such as marketplace, ritual, and theme park provide models whose own characteristic properties can help to expand the way we think about and question museums. Together, they begin to encompass the gamut of experiences, goals, and outcomes that have come to characterize the museum "learning" experience. If education is about the negotiation of meaning and museums are a forum for that, then our definitions of the institution must begin to allow first for variation in meaning and second for interaction between presenters and participants. Both of these aspects are present in the models given above. Their descriptive power is clear; what new directions they indicate for advancing institutional practice is a question that warrants considered attention.

Summary

In the last twenty-five years education has taken its place next to research as a major, professional function in museums. Indeed, museums were officially designated educational institutions in 1969 by the Tax Reform Act. In 1973 a group of thirteen educators founded what would become the Standing Professional Committee on Museum Education, the first of a handful of special-interest committees within the American Association of Museums. The same year also saw the establishment of the first journal devoted solely to museum education, *Roundtable Reports*.[43] Heads of education departments began to be appointed assistant directors of museums in increasing numbers, taking their place next to their counterparts in the research, finance, and development divisions.

Perhaps the most telling sign of the field's coming-of-age is the recent adoption by the Council of the American Association of Museums of a report prepared by a special task force on museum education. *Excel-

lence and Equity presents an assessment of critical issues in museum education, recommends ten actions to strengthen the educational role, and outlines a plan for their implementation.[44] Most important, it places education squarely at the heart of the museum enterprise, although not every member of the profession has embraced this move. Resistance continues to be felt by curators concerned about the welfare of collections and research.[45] But education has become a central concern and function. Unless the pendulum swings away again, it will continue to shape the face of museum operations.

Of course, there will always be disagreements over the proper activities of the institution; indeed, it is out of such disputes that growth occurs. However, as the education field has matured, the disputes have changed. The institution's acceptance of education as a central mission, along with the evolution of educational thought and practice, has shifted educators' central task from advocacy to implementation, from asserting their role to determining the best way of carrying it out. This determination, however, has been complicated by the fact that even within their own ranks, educators embrace differing philosophies and goals. It is no longer a united front of educators standing against curators. Indeed, it is worth noting that educators and curators have been noticeably absent from this last chapter, replaced instead by "museum personnel" and "staff." In part, this change was intended to shift attention away from the content of disputes to the processes and to reflect the fact that every staff person, regardless of their professional, political, or philosophical orientation, is engaged in the production of narratives. In part, it was to suggest that, as a narrative endeavor, what we have been calling "education" in fact thoroughly infuses the museum.

While this is precisely the recognition that educators have struggled to realize, its meaning is slightly different from what they have advocated. While outwardly educators have occupied themselves with the content of museum presentations, their concerns have touched on questions about the process by which knowledge is even formulated. The work of bringing other voices and views to the museum floor has carried an implicit challenge to longstanding hierarchies of meaning and authority. Thus, the real impact of educators has been their demonstration that they, along with visitors, curators, and other museum personnel, are engaged in a common meaning-making endeavor, and that the museum institution

serves as a forum through which this endeavor is carried out. It is this sense in which education infuses the institution, and it is this sense in which disputes over mission or method may be seen as part of a larger process of negotiating meaning.

It is possible to argue that the events and shifts this book describes represent but the tip of the institutional iceberg. Indeed, it is probably the case that the bulk of the nation's over eight thousand museums, the majority of which are definitively small,[46] are more preoccupied with issues of financial stability and governance than with the sorts of vast transformations described in these pages.

This book then is both a document and a call to arms. It describes a moment of historic and philosophic import, and it offers a rally to museums to seize the day, to make museums people-centered, not just in intent but in definition. "Inclusion" is one of the great buzzwords of our day. It became so because it represents an idea of enormous significance. To acknowledge that meaning making lies at the heart of the museum enterprise and that narrative provides the means by which this activity is accomplished is to take the first step toward truly opening museums to multiple voices and views. No one wants to throw "traditional" museums to the wind but rather to guide them toward more inclusive currents. This alone will enable museums to continue to fulfill their role as social institutions, in the truest sense of the term, in service to their communities.

This book has attempted to demonstrate two things: first, that the emergence of educators as a forceful presence in museums has posed a challenge to longstanding values, structures, and practices that has transformed the institution; and second, that this transformation in turn holds serious implications for what it means to educate. It also has shown how the ordinary disputes and decisions in which museum staff regularly engage, and of which the Linnaeus exhibit is representative, reflect deeper assumptions about institutional purpose, responsibility, and authority. One could say that this book constructs a narrative of an exhibit team's narratives—after all, its conclusions apply to it as well. In arguing that education is fundamentally a narrative endeavor, this book takes its place next to a whole history of narratives about museums and visitors. But where other narratives have told stories of cultural uplift or rational amusement, this one tells a story about the telling itself.

Epilogue

There is an unfortunate ending to this story. "Linnaeus: Lessons and Legacy" opened as scheduled on Linnaeus's 282nd birthday. It was used for a time by visiting school groups, and a small part of the exhibit was revised following an evaluation. As is the case in so many museums, however, space was at a premium. Over time the room in which the exhibit is located increasingly came to be used for Botanic Garden business. The result was that the exhibit that now forms the basis for an entire book about education in museums has become virtually inaccessible to visitors. The irony could not be starker. If there is a message—or perhaps a moral—here it is that the story remains unfinished. Just because education is currently riding the crest does not mean that it will remain there. What new chapters unfold is now a matter of time and work.

Notes

Introduction

1. Although certification requirements may be lacking, a handful of academic institutions nevertheless offer specialized training programs. George Washington University in Washington, D.C., and Bank Street College in New York City have long offered degree programs in museum education. As the market for educators grows and the demand for specialized services increases, programs like these offer aspirants an important edge and underscore the need for formalized training opportunities.

2. Whether museum education has indeed attained the status of "profession" remains debatable. Strictly speaking, it lacks the certification requirements, scholarship, and standards that define a true profession. Yet many of the ingredients are there. For that reason, it is not unreasonable to speak of the *emergence* of this profession as practitioners continue to work to establish their expertise. For a critical discussion of professionalism as it relates to museums, see Wilcomb E. Washburn, "Professionalizing the Muses," *Museum News* 64, no. 2 (1985): 18–25, 70–71.

3. Of course, visitors will experience our collections as they will no matter what. The problem is how to responsibly direct that experience at a time when conventional guideposts of meaning have been overturned. For a provocative discussion of this dilemma as it relates to art museums, see Danielle Rice, "Museum Education Embracing Uncertainty," *Art Bulletin* 77, no. 1 (1995): 15–20.

4. Perhaps the most visible forum for museum educators to publish has been the *Journal of Museum Education* (formerly *Roundtable Reports*) first issued in 1973. Other examples of museum education literature include Barbara Y. Newsom and Adele Z. Silver, eds., *The Art Museum as Educator: A Collection of Studies as Guides to Practice and Policy* (Berkeley and Los Angeles: University of California Press, 1978); Bonnie Pitman-Gelles, *Museums, Magic, and Children: Youth Education in Museums* (Washington, D.C.: Association of Science-Technology Centers, 1981); Zipporah W. Collins, ed., *Museums, Adults, and the Humanities: A Guide for Educational Programming* (Washington, D.C.: American Association of Museums, 1981); R. S. Miles et al., *The Design of Educational Exhibits* (London: Unwin Hyman, 1982); Nancy Berry and Susan Mayer, eds., *Museum Education: History, Theory, and Practice* (Reston, Va.: National Art Education Association, 1989); Eileen Hooper-Greenhill, ed., *The Educational Role of the Museum* (New York: Routledge, 1994).

5. Analyses about the appropriation of culture, the production of meaning, and the power relations inherent in collecting and displaying have brought attention to the more hidden aspects of museum practice. This is a far cry from traditional museum historiography, which tends to be dominated by straightforward questions about institutions' roles and functions. See, for example, Douglas Crimp, *On the Museum's Ruins* (Cambridge, Mass.: MIT Press, 1993); Anthony Alan Shelton, "In the Lair of the Monkey: Notes toward a Post-Modernist Museography," in *Objects of Knowledge,* ed. Susan Pearce, New Research in Museum Studies: An International Series, vol. 1 (London: Athlone Press, 1990); Daniel J. Sherman and Irit Rogoff, eds., *Museum Culture: Histories, Discourses, Spectacles* (Minneapolis: University of Minnesota Press, 1994); George Stocking, ed., *Objects and Others: Essays on Museums and Material Culture* (Madison: University of Wisconsin Press, 1985).

6. A handful of practitioners have written eloquently about the politics of representation and display, but often from the framework of art history, anthropology, or other disciplines. See, for example, Michael Ames, *Cannibal Tours and Glass Boxes: The Anthropology of Museums* (Vancouver: University of British Columbia Press, 1992); Ivan Karp and Steven D. LaVine, eds., *Exhibiting Cultures: The Poetics and Politics of Museum Display* (Washington, D.C.: Smithsonian Institution Press, 1991); Sally Price, *Primitive Art in Civilized Places* (Chicago: University of Chicago Press, 1989); Richard Price and Sally Price, *Equatoria* (New York: Routledge, 1992).

This situation is beginning to change as "museology" continues to evolve as an autonomous discipline. The last few years have seen an important step forward in museum criticism with the publication of several books and essays,

largely British authored and many by current or past museum practitioners. Their marriage of theory and practice is laudable, but their work has been slow to reach U.S. museums. See, for example, Robert Lumley, ed., *The Museum Time Machine* (London and New York: Comedia/Routledge, 1988); Peter Vergo, ed., *The New Museology* (London: Reaktion Books, 1989); Eileen Hooper-Greenhill, *Museums and the Shaping of Knowledge* (New York: Routledge, 1992); Susan Pearce, ed., *Interpreting Objects and Collections* (New York: Routledge, 1994).

7. A. A. Bronson and Peggy Gale, eds., *Museums by Artists* (Toronto: Art Metropole, 1983); Brian O'Doherty, *Inside the White Cube: The Ideology of the Gallery Space* (San Francisco: Lapis Press, 1986).

8. This idea has by now become widely accepted. It was given voice early in Francis Henry Taylor, *Babel's Tower: The Dilemma of the Modern Museum* (New York: Columbia University Press, 1945), 18-24. For a more recent articulation, see Edward P. Alexander, "The American Museum Chooses Education," *Curator* 31, no. 1 (1988): 61-80; and Joel Orosz, *Curators and Culture: An Interpretive History of the Museum Movement in America, 1740–1870* (Tuscaloosa: University of Alabama Press, 1990).

9. Orosz, *Curators and Culture,* 51.

10. See, for example, the pioneering work by Edward Robinson and Arthur Melton. Edward S. Robinson, *The Behavior of the Museum Visitor,* American Association of Museums New Series, no. 5 (Washington, D.C.: American Association of Museums, 1928); Edward Robinson, "Psychological Problems of the Science Museum," *Museum News* 8, no. 5 (1930): 9-11; Edward Robinson, "Exit the Typical Visitor," *Journal of Adult Education* 3, no. 4 (1931): 418-23. Arthur W. Melton, "Studies of Installation at the Pennsylvania Museum of Art," *Museum News* 10, no. 14 (1933): 5-8; Arthur Melton, *Problems of Installation in Museums of Art,* American Association of Museums New Series, no. 14 (Washington, D.C.: American Association of Museums, 1935); and Arthur Melton, "Distribution of Attention in Galleries in a Museum of Science and Industry," *Museum News* 14, no. 3 (1936): 6-8.

11. By the 1960s and 1970s museums found themselves in a climate that made the study of the visitor not only a matter of science but also a social and economic imperative. The pressure to demonstrate service to and knowledge about museum constituencies was stepped up by recognition of the broad diversity of museum constituencies brought on by the civil rights movement, the need for aggressive new marketing strategies in the face of economic competition, and the growing availability of federal funds (National Endowment for the Arts, National Endowment for the Humanities).

12. Marilyn Hood, a strong proponent of this approach, introduced the term "psychographics" to the museum world in her work on leisure values. See "Adult Attitudes toward Leisure Choices in Relation to Museum Participation" (Ph.D. diss., Ohio State University, 1981).

13. The visitor studies field blossomed in the 1980s with the establishment of a journal (*ILVS Review*); an international clearinghouse and reference center for visitor studies (International Laboratory for Visitor Studies at University of Wisconsin-Milwaukee); an annual conference (Visitor Studies Conference); a standing professional committee in the American Association of Museums (Committee on Visitor Research and Evaluation, later changed to Committee on Audience Research and Evaluation); and a quarterly newsletter (*Visitor Behavior*). All of these were directed toward studying the behaviors, expectations, experiences, and perceptions of museum visitors. These activities culminated in 1991 with the formal incorporation of a Visitor Studies Association.

14. A major commission report issued in 1984 observed,

> The absence of consensus about learning in museums stems also from a paradox of significant proportions, a tension of values that is inherent in the very mission of museums. Stated quite simply, the concerns of preservation and the demands of public access are a contradiction lived out in every institution.

See *Museums for a New Century* (Washington, D.C.: American Association of Museums, 1984), 57–58.

15. Field Museum Hall Interpreters Program (an educational program to interpret exhibits), Chicago, 1987.

16. "Generations," an exhibition at the Smithsonian Institution, Washington, D.C., 1987.

17. Thomas Leavitt, "Can Research Find a Home in Museums?" *History News* 39, no. 9 (1984): 29.

18. Elliot W. Eisner and Stephen M. Dobbs, *The Uncertain Profession: Observations on the State of Museum Education in Twenty American Art Museums* (Los Angeles: J. Paul Getty Center for Education in the Arts, 1986). Based on interviews with educators and directors from twenty art museums, the report includes the following generalizations: museum educators lack consensus regarding their role; they lack adequate professional preparation in that which they take as their domain; they lack the recognition and credibility of the other museum professionals with whom they collaborate; and they lack the communications networks, resources, and even vision necessary for the exchange of ideas and the profession's advancement.

19. A lively debate occurred in the pages of *Museum News* throughout 1987. See the letters of Philip Yenawine and Patterson Williams, *Museum News* 65,

no. 3 (1987): 4–6; Terry Zeller, "The Uncertain Profession: A Review," *Museum News* 65, no. 3 (1987): 17–28; Elliot Eisner and Stephen Dobbs's response, *Museum News* 65, no. 5 (1987): 5–10; Danielle Rice, "On the Ethics of Museum Education," *Museum News* 65, no. 5 (1987): 13–19; letter from William Burback et al., *Museum News* 65, no. 4 (1987): 5; and Eisner and Dobbs's response, *Museum News* 66, no. 1 (1987): 5.

20. Mark Lilla, "The Great Museum Muddle," *The New Republic,* 8 April 1985, p. 26.

21. An early attempt to characterize the variety of museum experiences appeared in an unpublished paper, circulated extensively underground, by then graduate student Sheldon Annis. See Sheldon Annis, "The Museum as Symbolic Experience" (University of Chicago, Division of Social Sciences, Chicago, 1974). More formal studies have since confirmed his work. See, for example, Judy Diamond, "The Behavior of Family Groups in Science Museums," *Curator* 29, no. 2 (1986): 139–54; Marilyn Hood, "Adult Attitudes toward Leisure"; Stephen Kaplan, et al, "The Restorative Experience as a Museum Benefit," *Journal of Museum Education* 18, no. 3 (1993): 15–18; Britt Raphling and Beverly Serrell, "Capturing Affective Learning," *Current Trends in Audience Research and Evaluation* (Washington, D.C.: American Association of Museums Committee on Audience Research and Evaluation, 1993): 7:57–62; Lois Silverman, "Of Us and Other 'Things': The Content and Functions of Talk by Adult Visitor Pairs in an Art and a History Museum" (Ph.D. diss., Indiana University, 1991); and Amy Walsh, ed., *Insights: Museums, Visitors, Attitudes, Expectations—A Focus Group Experiment* (Los Angeles: J. Paul Getty Center for Education in the Arts, 1991).

22. The term, after all, has long been associated with an institutional setting and practice that is formal, classroom-based, teacher-directed, and information-driven. In the more informal, self-paced, voluntary setting of the museum, these connotations have persisted.

23. *Museums for a New Century,* 58.

24. Carolyn Blackmon, Teresa LaMaster, Lisa Roberts, and Beverly Serrell, *Open Conversations: Strategies for Professional Development in Museums* (Chicago: Field Museum of Natural History, 1988), 40; Randi Korn, "Redefining the Visitor Experience," *Journal of Museum Education* 17, no. 3 (1992): 17–19.

25. Lois Silverman, "Making Meaning Together: Lessons From the Field of American History," *Journal of Museum Education* 18, no. 3 (1993): 7–11 and "Visitor Meaning-Making in Museums for a New Age," *Curator: The Museum Journal* 38, no. 3 (1995): 161–70.

26. While a botanic garden might not appear to be adequately representative of the museum genre, the museum field has long included living collections in

its self-definition. Because aquaria, arboreta, zoos, and botanical gardens are called by specialized names, a false separation from museums has persisted in common thought. The Chicago Botanic Garden is accredited by the American Association of Museums.

27. For an excellent example of this use of ethnography, see Bruno Latour and Steve Woolgar, *Laboratory Life: The Construction of Scientific Facts* (1979; reprint, Princeton: Princeton University Press, 1986).

28. It also acknowledged that observers can never remain fully detached from their observations. As a result, the participant-observation model necessitates acute self-reflection through taking account of, instead of minimizing, the assumptions and the experiences that form the basis of the data.

29. Recent developments in historical scholarship situate it in a more participatory tradition by pointing out the historian's role in selecting, judging, and interpreting data. As with literary theorists, the logical consequence has been the recognition that all interpreters of texts speak from historical, social, and cultural traditions that inevitably shape their treatment of data.

Chapter 1. **Education as** Entertainment

1. It was surprising because educators are usually the ones who advocate interpretive approaches that attempt to reach visitors in new ways.

2. While these approaches may not be "modern" from the standpoint of classical educational theory, their application to the museum setting is a fairly recent phenomenon.

3. This effect was observed as early as 1956, when two researchers decried the way in which visitors "flit from one thing to another, stopping to press buttons or turn handles, and treating the Gallery more as an amusement arcade than as a source of scientific information." Joyce A. M. Brooks and Philip E. Vernon, "A Study of Children's Interests and Comprehension at a Science Museum," *British Journal of Psychology* 47 (1956): 179.

4. Chandler Screven, "Exhibitions and Information Centers: Some Principles and Approaches," *Curator* 29, no. 2 (1986): 113.

5. These terms were adapted from Arthur Melton by visitor researcher Harris Shettel to describe one way of measuring exhibit effectiveness. They have since become standard nomenclature in exhibit circles. See Harris Shettel et al., *Strategies for Determining Exhibit Effectiveness,* report no. AIR E95-4/68-FR (Washington, D.C.: American Institutes for Research, 1968).

6. Which of these two options better approximated the actual plants is another consideration altogether. It is more fully examined in Chapter 3.

7. It is worth noting that some presentation issues could have been effec-

tively resolved through a simple formative evaluation. Yet, no effort was made to seek visitors' direction for how best to explore the topic of classification. Despite museum professionals' general acceptance of evaluation procedures, their use still remains limited. While lack of knowledge is definitely a factor in deciding their use, it is also the case—as it was in this example—that the time required to carry them out often makes them more readily expendable. Particularly when educators are involved in the planning process, it is easier to dispense with the step of talking to visitors directly, since their interests are supposedly being represented by the educators. Of course, what the educator thinks is best for visitors may not coincide with what visitors think is best for themselves.

8. Research on play is not new. Discussions of its value exist as far back as the ancient Greeks. More recently, pioneers such as Karl Groos and Maria Montessori have made play an integral part of their educational philosophies.

9. These two positions are analyzed in detail by Joel Orosz, who argues that they do not fairly depict the pre-1870 American museum. See Joel Orosz, *Curators and Culture: An Interpretive History of the Museum Movement in America, 1740–1870* (Tuscaloosa: University of Alabama Press, 1990).

10. George Brown Goode, "Museum-History and Museums of History," *Papers of the American Historical Association,* ed. Herbert Baxter Adams (New York: G. P. Putnam's Sons, 1888), 3:497–520.

11. Newton Horace Winchell, *Museums and Their Purposes: A Lecture before the Saint Paul Academy of Sciences,* no. 1 (St. Paul: Brown, Treacy and Company, 1891), 6.

12. Benjamin Ives Gilman, *Museum Ideals of Purpose and Method* (Cambridge, Mass.: Harvard University Press, 1923), xi.

13. Walter Pach, *The American Art Museum* (New York: Pantheon Books, 1948), 226.

14. John Cotton Dana, *The New Museum,* vols. 1 and 2 (Woodstock, Vt.: Elm Tree Press, 1917).

15. Theodore Low, *The Museum as a Social Instrument: A Study Undertaken for the Committee on Education of the American Association of Museums* (New York: Metropolitan Museum of Art, 1942).

16. Francis Henry Taylor, *Babel's Tower: The Dilemma of the Modern Museum* (New York: Columbia University Press, 1945), 22.

Taylor was not one to mince words. In an address to the American Association of Museums, he said:

> If the term "museum" strikes terror to the heart of the average layman, it is as nothing compared with the sense of panic which its sound produces in the poor innocents who spend their lives rationalizing its very existence. . . .It has emerged

> through a metamorphic process lasting many centuries from the simple designation of the Muse to be the encompassing catch-basin for all those disparate elements of hereditary culture which are not yet woven into the general educational fabric of modern society. And, since education has been defined as "the art of casting artificial pearls before real swine," it is only natural that museum workers should have concerned themselves with the elaborate furnishing of the trough at the expense of the digestive capacity of the feeders.

See Francis Taylor, "Museums in a Changing World (Paper delivered at the American Association of Museums meeting, San Francisco, 26 June 1939, printed in *Atlantic Monthly* 164, no. 6 (1939): 785–92).

17. Alma Wittlin has probably been the most diligent, though her account is more descriptive than analytical. Like others, however, she is unconscionably brief. See Alma Wittlin, *In Search of a Usable Future* (Cambridge: MIT Press, 1970). See also Edward P. Alexander, *Museums in Motion: An Introduction to the History and Functions of Museums* (Nashville: American Association for State and Local History, 1979); Germain Bazin, *The Museum Age,* trans. Jane van Nuis Cahill (New York: Universe Books, 1967); Nathaniel Burt, *Palaces for the People: A Social History of the American Art Museum* (Boston: Little, Brown and Company, 1977); Herbert Katz and Marjorie Katz, *Museums U.S.A.: A History and Guide* (Garden City, N.Y.: Doubleday and Company, 1965); Dillon Ripley, *The Sacred Grove* (Washington, D.C.: Smithsonian Institution Press, 1969); and Taylor, *Babel's Tower.*

18. While language like "entertainment" was certainly applied to early museum activities, it was seldom used in contrast to "education" as it is today. Instead, the language was directed more generally to describe popular uses of collections.

19. *Genius of the West, An Original Magazine of Western Literature* 4 (1855): 195, quoted in Louis Leonard Tucker, "'Ohio Show-Shop': The Western Museum of Cincinnati, 1820–1867," in *A Cabinet of Curiosities: Five Episodes in the Evolution of American Museums,* ed. Walter Muir Whitehill (Charlottesville: University Press of Virginia, 1967), 84.

20. James S. Buckingham, *The Eastern and Western States of America,* (London and Paris, n.d.), 1:539, quoted in Charles Coleman Sellers, *Mr. Peale's Museum: Charles Willson Peale and the First Popular Museum of Natural Science and Art* (New York: W. W. Norton and Company, 1980), 276.

21. Orosz, *Curators and Culture,* 81.

22. Orosz, *Curators and Culture,* 85.

23. Neil Harris, *Humbug: The Art of P. T. Barnum* (Chicago: University of Chicago Press, 1973), 74–75, 77, 79–80.

24. Orosz, *Curators and Culture,* 180–87.

25. In her study of cultural philanthropy in Chicago during this period, historian Helen Lefkowitz Horowitz paints a detailed picture of this climate. See Helen Lefkowitz Horowitz, *Culture and the City: Cultural Philanthropy in Chicago from the 1880s to 1917* (Chicago: University of Chicago Press, 1976).

26. Neil Harris, "Museums, Merchandising, and Popular Taste: The Struggle for Influence," in *Material Culture and the Study of American Life*, ed. Ian Quimby (New York: W. W. Norton and Company, 1978), 142.

27. Paul Greenhalgh, "Education, Entertainment, and Politics: Lessons from the Great International Exhibitions," *The New Museology*, ed. Peter Vergo (London: Reaktion Books, 1989), 84.

28. Much has been written about these expositions' unabashedly commercial nature—in particular, the competition among exhibitors to portray their product or their nation in the best possible light. The development of attractive methods of display was no doubt tied closely to this competition for attention. See, for example, Robert Rydell's *All the World's a Fair: Visions of Empire at American International Expositions, 1876–1916* (Chicago: University of Chicago Press, 1984); and *World of Fairs: The Century-of-Progress Expositions* (Chicago: University of Chicago Press, 1993).

29. Harris, "Museums, Merchandising, and Popular Taste," 141.

30. Goode, "Museum-History," 262.

31. See A. B. Meyer, "Studies of the Museums and Kindred Institutions of New York City, Albany, Buffalo, and Chicago, with Notes on Some European Institutions," *Report of the United States National Museum for 1903*, no. 133 (Washington, D.C.: Government Printing Office, 1905), 324-28; Louise Connolly, *The Educational Value of Museums* (Newark, N.J.: Newark Museum Association, 1914).

32. Horowitz, *Culture and the City*, 126-93.

33. Joseph Allen Patterson, "Points of View," *Museum News* 40, no. 1 (1961): 3.

34. Seventy-five questionnaires were mailed out to art, science, history, children's, and general museums of varying sizes. Edmund Cooke, "A Survey of the Educational Activities of Forty-Seven American Museums," *Museum News* 12, no. 4 (1934): 4-8.

35. Laurence Vail Coleman, *The Museum in America: A Critical Study* (Washington, D.C.: American Association of Museums, 1939): 2:413.

36. Coleman, *Museum in America*, 2:414.

37. While slow to influence actual practice, discussions of learning styles, progressive education methods, and theorists like Rousseau, Pestalozzi, and Froebel appeared even in Coleman's work. See Coleman, *Museum in America*, 2:323, 343.

38. Grace Fisher Ramsey, *Educational Work in Museums of the United States:*

Development, Methods, and Trends (New York: H. W. Wilson Company, 1938), 43.

39. Ramsey, *Educational Work*, 252.

40. Low, *Museum as a Social Instrument*, 9.

41. Even twenty years after its publication, the booklet was used by curator Wilcomb Washburn as a launching pad for his call to a return to serious scholarship. Low responded with a more softened, if fundamentally unchanged, defense of museums' multiple functions and responsibilities. See Wilcomb Washburn, "Scholarship and the Museum," *Museum News* 40, no. 2 (1961): 16–19; and Theodore Low, "The Museum as a Social Instrument: Twenty Years After," *Museum News* 40, no. 5 (1962): 28–30.

42. A whole confluence of factors led to this reemergence, including the Civil Rights movement and increased public funding (both of which heightened museums' accountability to the various public sectors that supported them), as well as the natural evolution of educators' thinking about their audiences.

43. Rudolph Morris, "Leisure Time and the Museum," *Museum News* 41, no. 4 (1962): 17–21.

44. Coleman, *Museum in America*, 2:318.

45. Raymond Stites, "Leisure Time and the Museum: A Reply," *Museum News* 41, no. 6 (1963): 29–33.

46. Brian Dixon, Alice E. Courtney, and Robert H. Bailey, *The Museum and the Canadian Public* (Montreal: Culturcan Publications, 1974), 161–63; Ross Loomis, "Social Learning Potentials of Museums" (Paper presented at "The Museum as a Learning Environment," a symposium sponsored by the American Educational Research Association, Chicago, 1974); Marilyn Hood, "Adult Attitudes toward Leisure Choices in Relation to Museum Participation," (Ph.D. diss., Ohio State University, 1981); Nelson Graburn, "The Museum and the Visitor Experience," in *The Visitor and the Museum,* ed. Linda Draper (Berkeley: Lowie Museum of Anthropology, University of California at Berkeley, 1977); Sherman Rosenfeld, "The Context of Informal Learning in Zoos," *Roundtable Reports* 4, no. 2 (1979): 1–3, 15–16; Robert L. Wolf and Barbara L. Tymitz, *"Do Giraffes Ever Sit?": A Study of Visitor Perceptions at the National Zoological Park, Smithsonian Institution* (Washington, D.C., Smithsonian Institution, 1979).

47. Daniel Catton Rich, "Museums at the Crossroads," *Museum News* 39, no. 6 (1961): 36.

48. *Museum News* devoted its first 1974 issue entirely to the subject of audiovisual technology in museums. See *Museum News* 52, no. 5 (1974). The idea of marrying technology to museums had been promoted for a number of years. Descriptions of radio media in museum programming appear in Grace Fisher

Ramsey's 1938 survey (*Educational Work,* 194-207); the potential of radio and television were covered in Theodore Low's 1942 booklet, *The Museum as a Social Instrument,* 56-63. In the early 1950s *Museum News* published at least three articles on the same subject: Ernest T. Luhde, "Television and the Museum," *Museum News* 28, no. 15 (1951): 7-8; Ann V. Horton, "Radio Extends Children's Art Experience," *Museum News* 28, no. 15 (1951): 8; and Seymour N. Siegel, "Radio and Television in Museum Education," *Museum News* 29, no. 16 (1952): 6-8.

49. Helmuth J. Naumer, "A Marketable Product," *Museum News* 50, no. 2 (1971): 14.

50. For more on electronic media's effects on human perception, see Bryan Robertson, "The Museum and the Democratic Fallacy," in *Museums in Crisis,* ed. Brian O'Doherty (New York: George Braziller, 1972), 75-89; Marshall McLuhan, Harley Parker, and Jacques Barzun, "Exploration of the Ways, Means and Values of Museum Communication with the Viewing Public," transcript of a seminar held on 9 and 10 October 1967 at the Museum of the City of New York, sponsored by the New York State Council on the Arts, 1969, Museum of the City of New York, New York.

51. William Fagaly, Gilbert Wright, and Frederick Dockstader, "Thoughts on the Audio-Visual Revolution," *Museum News* 51, no. 5 (1973): 14.

52. Joseph Shannon, "The Icing Is Good, But the Cake Is Rotten," *Museum News* 52, no. 5 (1974): 29.

53. No doubt, many were motivated partially by the ongoing issue of establishing professional credibility. A 1974 survey of 728 museum directors revealed that while 92 percent considered education a "very important" purpose of their institution, only 17 percent felt the same about entertainment. National Endowment for the Arts, *Museums USA: Art, History, Science, and Others* (Washington, D.C.: Government Printing Office, 1974), 27.

54. In a remarkably prescient forerunner of this discussion, W. Douglas Burden of Florida's Marineland in 1943 presented to *Museum News* his vision of future museums:

> Those who plan new halls should recognize that in order to teach anything it is necessary to catch attention and hold it. The more a person is entertained the more certainly will his attention be held. It follows, then, that a primary museum objective should be to make teaching so entertaining that the visitor is barely aware of being taught. This can be achieved most effectively by the creation of favorable conditions, namely, comfort and dark as the environment for the visitor, and synchronized light, motion, and sound as the method of engaging and holding the visitor's attention.

Burden goes on to describe a hypothetical exhibit, "The Story of Mankind," which could just as easily be Epcot Center's "Futureworld." W. Douglas

Burden, "A New Vision of Learning," *Museum News* 21, no. 12 (1943): 9.

55. Ian McLennan, excerpts from American Association of Museums' annual meeting, *Museum News* 50, no. 1 (1971): 42. For a review of research on attracting viewer attention, see John J. Koran and Mary Lou Koran, "The Roles of Attention and Curiosity in Museum Learning," *Journal of Museum Education* 8, no. 2 (1983): 14–17, 24.

56. Mihaly Csikszentmihalyi, *Beyond Boredom and Anxiety* (San Francisco: Jossey-Bass Publishers, 1975).

57. Dolo Brooking, "Play, in All Seriousness," *Museum News* 56, no. 5 (1978): 22. See also Lesley van der Lee, "Playful Learning for All Ages: Participatory Exhibits," *Journal of the Washington Academy of Sciences* 76, no. 2 (1986): 115–21.

58. Leisure researchers mark the establishment of *The Journal of Leisure Research* in 1969 as their field's major founding event.

59. Marion Clawson and Jack L. Knetsch, *Economics of Outdoor Recreation* (Baltimore: Johns Hopkins University Press, 1966).

60. Hood, "Adult Attitudes toward Leisure."

61. Mihaly Csikszentmihalyi, "Leisure and Socialization," *Social Forces* 60, no. 2 (1981): 333.

62. His work on flow theory, in particular, has proven to be a rich resource for art educators eager to reproduce within their visitors the aesthetic experience that they imagine that curators have when they look at a work of art. See, for example, Melora McDermott-Lewis, Marlene Chambers, et al., *The Denver Art Museum Interpretive Project,* ed. Steve Grinstead and Margaret Ritchie (Denver: Denver Art Museum, 1990).

63. Danielle Rice, "On the Ethics of Museum Education," *Museum News* 65, no. 5 (1987): 19. Sentiments such as these prompted the development in 1979 of the "Museum of Fun," a Japanese traveling exhibit whose aim was "the rediscovery of the free spirit of play."

64. Elaine Gurian, "Noodling Around with Exhibition Opportunities," *Exhibiting Cultures: The Poetics and Politics of Museum Display,* ed. Ivan Karp and Steven D. Lavine (Washington, D.C.: Smithsonian Institution Press, 1991), 183.

65. Gurian, "Noodling Around," 183. Gurian explains:

> If we as exhibition producers begin to think that playfulness is a permissible part of learning, . . . different exhibition strategies may take over. For example, collections may be placed so that they are not immediately apparent, or objects may be installed in a way that reveals visual jokes. . . . Such an attitude may also make more apparent the humor of artists or cultures which is often omitted because humor is considered frivolous.

66. American Association of Museums annual meeting, Philadelphia, 1982.

67. Umberto Eco, "Travels in Hyperreality," *Travels in Hyperreality: Essays,* trans. William Weaver (New York: Harcourt Brace Jovanovich, 1986).

68. "American Art Museums: On the Road to Disneyworld," *St. Louis Post Dispatch,* 28 February 1982.

Chapter 2. **Education as** Empowerment

1. Philip Hills and Michael Shallis, "Scientists and Their Images," *New Scientist* 67, no. 964 (1975): 471–75; Georgine M. Pion and Mark W. Lipsey, "Public Attitudes toward Science and Technology: What Have the Surveys Told Us?" *Public Opinion Quarterly* 45, no. 3 (1981): 303–16; and Marcel C. LaFollette, *Making Science Our Own: Public Images of Science, 1910–1955* (Chicago: University of Chicago Press, 1990), 174–84.

2. Werner Heisenberg, who demonstrated how the behavior of particles is unavoidably changed by the instruments with which we observe them, was among first to find scientific proof of this fact. He argued that one cannot illuminate a particle without altering its speed and direction by the illuminating ray. Physics has never been the same since, and there has emerged a new generation of philosophers reflecting upon the implications of Heisenberg's research for scientific activity and knowledge. See, for example, Stephen Toulmin, *Foresight and Understanding: An Enquiry into the Aims of Science* (New York: Harper Torchbooks, 1961); Thomas S. Kuhn, *The Structure of Scientific Revolutions* (Chicago: University of Chicago Press, 1962); Barry Barnes, *Interests and the Growth of Knowledge* (London: Routledge & Kegan Paul, 1977); and Ian Hacking, ed., *Scientific Revolutions* (Oxford: Oxford University Press, 1981).

3. For example, in the early twentieth century, when immigration was felt to threaten the nation's moral and racial purity, scientists "found" evidence of racial inferiority, and eugenics became a serious branch of study.

4. In the museum world, Chicago's Museum of Science and Industry took one lead in 1981 by developing an entire exhibit about the nature and the processes of science. "Inquiry," Museum of Science and Industry, Chicago, 1981.

5. Oak proved to be a difficult example to implement, since it did not fit into the prevailing categories during the 1500s. This was one reason—not relevant to this chapter's objective—that this particular text was modified.

6. This approach has become more widespread in recent years through the efforts of science educators and educational reformers. Nearly all science curricula are now designed to include the teaching of process skills.

7. See note 2.

8. Ferdinand de Saussure, *Course in General Linguistics,* ed. Charles Bally et al., trans. Wade Baskin (New York: McGraw-Hill, 1966), 65–78.

9. Jean-François Lyotard, *The Postmodern Condition: A Report on Knowledge,* trans. Geoff Bennington and Brian Massumi (Minneapolis: University of Minnesota Press, 1984).

10. Allan Bloom, *The Closing of the American Mind: How Higher Education Has Failed Democracy and Impoverished the Souls of Today's Students* (New York: Simon and Schuster, 1987).

11. Conditions in the social and the political milieu were sympathetic to this interpretation. Cultural diversity, multiculturalism, whatever the term, it seemed to be on everyone's lips, including those of politicians, advertisers, and television producers. Suddenly, everyone recognized the power, the strength, and the numbers of ethnic minorities—the most rapidly growing segment of the American population—and everyone wanted to be on the ethnic bandwagon.

12. A 1988 report issued by the National Endowment for the Humanities made this point clear. Lamenting the view that "humanities texts are nothing more than elaborate political rationalizations," it argues that "what gives [the humanities] their abiding worth are truths that pass beyond time and circumstance; truths that, transcending accidents of class, race, and gender, speak to us all." Lynne V. Cheney, *Humanities in America: A Report to the President, the Congress, and the American People* (Washington, D.C.: National Endowment for the Humanities, 1988), 12, 14.

13. So short has been their existence that when museum educators looked back for evidence of museum education, they found that early efforts were carried out by the then dominant personnel: curators and directors. As a result, many of the profession's founding fathers such as Dana and Goode were, in fact, curators by profession.

14. John Cotton Dana, *The New Museum* (Woodstock, Vt.: Elm Tree Press, 1917), 1:19.

15. Terry Zeller, "The Historical and Philosophical Foundations of Art Museum Education in America," *Museum Education: History, Theory, and Practice,* ed. Nancy Berry and Susan Mayer (Reston, Va.: National Art Education Association, 1989), 10–89.

16. "The City Beautiful Campaign," *Museum News* 22 (October 1914), quoted in Zeller, "Art Museum Education," 21.

17. For a more complete sense of the scope and nature of these efforts, see John Cotton Dana's list of fifty-one "Helpful Museums" (for reference by those who may be starting a museum), many of which include educational activities. Dana, *New Museum,* 42–47.

18. T. J. Jackson Lears, *No Place of Grace: Antimodernism and the Transformation of American Culture, 1880–1920* (New York: Pantheon Books, 1981), 78.

19. Paul Marshall Rea, *The Museum and the Community with a Chapter on the Library and the Community: A Study of Social Laws and Consequences* (Lancaster, Pa.: Science Press, 1932), 31.

20. John Walker, "The Genesis of the National Gallery of Art," *Art in America* 32, no. 4 (1944): 167.

21. T. R. Adam, *The Civic Value of Museums* (New York: American Association for Adult Education, 1937), 26.

22. Walter Pach, *The American Art Museum* (New York: Pantheon Books, 1948), 229–30.

23. Rea, *The Museum and the Community,* 29–30.

24. Herbert J. Spinden, "The Curators in the New Public Museum," *Museum News* 18, no. 6 (1940): 7.

25. Grace Fisher Ramsey, *Educational Work in Museums of the United States: Development, Methods, and Trends* (New York: H. W. Wilson Company, 1938).

26. Theodore Low, *The Museum as a Social Instrument: A Study Undertaken for the Committee on Education of the American Association of Museums* (New York: Metropolitan Museum of Art, 1942).

27. Ramsey, *Educational Work in Museums of the United States,* 43, 217, 252–254; Low, *The Museum as a Social Instrument,* 30.

28. Lucy Nielsen Nedzel, "The Motivation and Education of the General Public through Museum Experiences" (Ph.D. diss., University of Chicago, 1952).

29. Joseph Allen Patterson, "Points of View," *Museum News* 40, no. 1 (1961):3.

30. American Association of Museums, *A Statistical Survey of Museums in the United States and Canada* (Washington, D.C.: American Association of Museums, 1965), 16.

31. Wilcomb Washburn, "Scholarship and the Museum," *Museum News* 40, no. 2 (1961): 17–18.

32. Daniel Catton Rich, "Museums at the Crossroads," *Museum News* 39, no. 6 (1961): 38.

33. Grace Glueck, "The Ivory Tower versus the Discotheque," *Art in America* 59 (1971): 81.

34. Thomas W. Leavitt and Dennis O'Toole, "Two Views on Museum Education," *Museum News* 64, no. 2 (1985): 27.

35. George Brown Goode, "Museum-History and Museums of History," *Papers of the American Historical Association,* ed. Herbert Baxter Adams (New York: G. P. Putnam's Sons, 1888), 3:262–64; Louise Connolly, *The Educational*

Value of Museums (Newark, N.J.: Newark Museum Association, 1914), 34-36; William L. Bryant, "Experiments with Museum Labels," *Museum Work* 6, no. 4 (1923): 114-20; Charles H. Blake, "Sizes of Type for Museum Labels," *Museum News* 22, no. 15 (1945): 8; George Weiner, "Why Johnny Can't Read Labels," *Curator* 6, no. 2 (1963): 143-56; Beverly Serrell, *Making Exhibit Labels: A Step-by-Step Guide* (Nashville: American Association for State and Local History, 1983); and Beverly Serrell, *Exhibit Labels: An Interpretive Approach* (Walnut Creek, Calif.: Alta Mira Press, 1996).

36. See, for example, Chandler Screven, "The Effectiveness of Guidance Devices on Visitor Learning," *Curator* 18, no. 3 (1975): 219-43; Minda Borun and Maryanne Miller, *What's in a Name? A Study of the Effectiveness of Explanatory Labels in a Science Museum* (Philadelphia: Franklin Institute, 1980); and Beverly Serrell, "Zoo Label Study at Brookfield Zoo," *International Zoo Yearbook* 21 (1981): 54-61. For a summary of the results of some two dozen studies on the effects of label length, placement, type size, and graphics, see *Visitor Behavior* 4, no. 3 (1989): 8-13.

37. Examples of her approach and a statement of the philosophy behind it can be found in Judy Rand, "Fish Stories That Hook Readers: Interpretive Graphics at the Monterey Bay Aquarium," in *American Association of Zoological Parks and Aquaria 1985 Annual Conference Proceedings* (Columbus, Ohio: American Association of Zoological Parks and Aquaria, 1985), 404-13.

38. Judy Rand, personal communication, 6 October 1995.

39. Beverly Serrell, "Zoo Label Study."

40. Stephen Bitgood et al., *Effect of Label Characteristics on Visitor Behavior,* technical report no. 86-55 (Jacksonville, Ala.: Center for Social Design, 1986).

41. Steve Bitgood et al., *The Effects of Instructional Signs on Museum Visitors,* technical report no. 86-70 (Jacksonville, Ala.: Center for Social Design, 1986); K. D. Hirschi and Chandler Screven, "Effects of Questions on Visitor Reading Behavior," *ILVS Review* 1 (1988): 50-61; Robert Farrington et al., "Tyrannosaurus Label Study," *Current Trends in Audience Research and Evaluation* (Washington, D.C.: American Association of Museums Evaluation and Research Committee, 1989): 6-12.

42. John Terrell, "Disneyland and the Future of Museum Anthropology," *American Anthropologist* 93, no. 1 (1991): 149.

43. Peter Cannon-Brookes and Caroline Cannon-Brookes, eds., "Editorial: False Gods," *International Journal of Museum Management and Curatorship* 8, no. 1 (1989): 5-9; Lynda Murdin, "'Director's Gone Disney' Claims South Kensington Union," *Museums Journal* 90, no. 6 (1990): 8-9; and "Editorial: A Major Museum Goes 'Populist,'" *Nature* 345 (1990): 1-2.

44. Marlene Chambers, "Improving the Esthetic Experience for Art Novices: A New Paradigm for Interpretive Labels," *Program Sourcebook* (Washington, D.C.: American Association of Museums, 1988), 213–27.

45. Patterson B. Williams, "Making the Human Connection: A Label Experiment," *The Sourcebook* (Washington, D.C.: American Association of Museums, 1989), 177–91.

46. Minda Borun, "Naive Notions and the Design of Science Museum Exhibits," *Proceedings of the 1989 Visitor Studies Conference,* ed. Stephen Bitgood et al. (Jacksonville, Ala.: Center for Social Design, 1989), 158–62. Results of the complete "Naive Knowledge" study appear in Borun et al., "Naive Knowledge and the Design of Science Museum Exhibits," *Curator* 36, no. 3 (1993): 201–19.

47. "The Way We Worked: Baltimore's People, Port, and Industries," Baltimore Museum of Industry, Baltimore, 1980; "Worker's World," Hagley Museum, Wilmington, Del., 1981; "Homestead," Historical Society of Western Pennsylvania, Pittsburgh, 1989; "By Hammer and Hand," South Street Seaport Museum, New York, 1990.

48. "Dress for Greater Freedom," Oakland Museum, Oakland, Calif., 1972; "Eleanor Roosevelt: First Person Singular," Smithsonian Institution Traveling Exhibition Service, Washington, D.C., 1984; and "Men and Women: A History of Costume, Gender, and Power," National Museum of American History, Washington, D.C., 1989.

49. "Pawnee Earth Lodge," Field Museum of Natural History, Chicago, 1977; "Essence of Indian Art," Asian Art Museum of San Francisco, San Francisco, 1984; "The Way to Independence: Memories of a Hidatsa Indian Family, 1840–1920," Minnesota Historical Society, St. Paul, 1987; "Field to Factory: Afro-American Migration, 1915–1940," National Museum of American History, Washington, D.C., 1989; and "Chiefly Feasts: The Enduring Kwakiutl Potlach," American Museum of Natural History, New York, 1991–1992.

50. In his study of visitors to the Steinhart Aquarium in San Francisco, Sam Taylor found that the exhibits were frequently used for discussion of past experiences and memories. In fact, reinforcement of previously held knowledge or experience was found to be a more frequent use of exhibits than the acquisition of new knowledge. Samuel M. Taylor, "Understanding Processes of Informal Education: A Naturalistic Study of Visitors to a Public Aquarium" (Ph.D. diss., University of California, Berkeley, 1986).

51. Patterson Williams, "Object Contemplation: Theory into Practice," *Journal of Museum Education* 9, no. 1 (1984): 10–14, 22.

52. Mihaly Csikszentmihalyi and Eugene Rochberg-Halton, *The Meaning*

of Things: Domestic Symbols and the Self (Cambridge, England: Cambridge University Press, 1981).

53. "The Mystery of Things," Brooklyn Children's Museum, 1988. For more on fostering looking skills, see Danielle Rice, "Making Sense of Art," *Journal of the Washington Academy of Science* 76, no. 2 (1986): 106–14.

54. For a more complete description of the Game Room, see Kathleen Berrin, "Activating the Art Museum Experience," *Museum News* 56, no. 4 (1978): 42–45.

55. Douglas Worts, "Extending the Frame: Forging a New Partnership with the Public," *Art in Museums,* New Research in Museum Studies, An International Series, ed. Susan Pearce (London and Atlantic Highlands, N.J.: Athlone, 1995), 5:164–91.

56. Of course, even guides to questioning carry an implicit perspective by attempting to elicit another perspective—that of the visitor.

57. It is not just the inclusion of props that makes an exhibit "interpretive." Their exclusion itself constitutes a statement and a context that shapes the way an object is seen. When the Art Institute of Chicago places a kachina doll on a bare white pedestal under a Plexiglas cube, the viewer's eye is drawn to formal characteristics like color and shape. This is a different sight from that at the Field Museum of Natural History, where kachina dolls are placed in a diorama that depicts a Hopi apartment. Hanging on either side of a hearth in which a woman is baking cornbread, the kachinas prompt viewers to consider their purpose and use.

58. It is worth remembering that the revolutionary director John Cotton Dana himself raised these questions about seventy years ago. Dana proposed displaying an ordinary drinking glass half filled with water and labeled thus:

> Is it a work of art? The glass surely is; the water is a natural product, like a landscape; look carefully at line and mass, at the gleams and reflections on the glass, on the water within, on the water's surface, on the color gathered from the textile—and perhaps what you are looking at will cease, for a moment, to be merely water in a cheap tumbler, and will come to be an exquisitely beautiful thing. If you thus see it, is it then a work of art?

John Cotton Dana, "In a Changing World Should Museums Change?" *Papers and Reports Read at the Twenty-first Annual Meeting of the American Association of Museums* (Washington, D.C.: American Association of Museums, 1926), 21.

59. "Art/artifact," Center for African Art, New York, 1988.

60. "Perspectives: Angles on African Art," Center for African Art, New York, 1987.

61. "The Desire of the Museum," Whitney Museum of American Art,

New York, 1989; "A Museum Looks at Itself: Mapping Past and Present at the Parish Art Museum, 1897-1992," Parrish Art Museum, Southampton, N.Y., 1992.

62. Examples include Marcel Duchamp, Claes Oldenburg, George Segal, Robert Smithson, and Andy Warhol. Forms such as earthworks, graffiti, and performance art seek to challenge traditional definitions of art and proper modes of viewing it.

63. Marcel Duchamp, "Boîte-en-valise," portable museum, 1936; Robert Fillliou, "La Galerie Légitime," gallery in a hat, Paris, 1961; Marcel Brood-thaers, "Musée d'Art Moderne," artist's home, Brussels, 1968, "Museum," Städtische Kunsthalle Düsseldorf, Düsseldorf, 1972, "Décors," several versions mounted in major European cities, 1974-75; Claes Oldenburg, "Mouse Museum," Neue Galerie, Kassel, 1972; Jean-François Lyotard, "Les Immatériaux," Beaubourg, Paris, 1985; David Wilson, "The Museum of Jurassic Technology," Los Angeles, 1988; various artists, "Theatergarden Bestiarium," Institute for Contemporary Art, P. S. 1 Museum, Long Island City, N.Y., 1989; Fred Wilson, "The Other Museum," White Columns, New York City, 1990; Danny Tisdale, "The Black Museum," INTAR Gallery, New York City, 1990; and Guillermo-Gómez Peña and Coco Fusco, "The Year of the White Bear," Mexican Fine Arts Center Museum, Field Museum of Natural History, Chicago, 1993.

64. Simon Grennan and Christopher Sperandio, "At Home with the Collection," Lakeview Museum of Art, Peoria, Ill., 1992; Joseph Kosuth, "The Brooklyn Museum Collection: The Play of the Unmentionable," Brooklyn Museum, Brooklyn, 1990; Fred Wilson, "Mining the Museum: An Installation by Fred Wilson," The Contemporary and the Maryland Historical Society, Baltimore, 1992-1993; and Wilson, "The Museum: Mixed Metaphors," Seattle Art Museum, Seattle, 1993.

65. Again, for every generalization, there exist exceptions. For a more complete overview of self-reflective exhibitions and artworks, see Lisa G. Corrin, "Mining the Museum: Artists Look at Museums, Museums Look at Themselves," in *Mining the Museum: An Installation by Fred Wilson,* ed. Lisa G. Corrin (New York: New Press; Baltimore: Contemporary, 1994).

66. At the end of 1990, the Field Museum renovated the exhibit, correcting some of its inaccuracies (for example, making the sacrificial victim a thirteen-year-old girl instead of a mature woman) and adding more background information. The bulletin board was removed and new labels that explained the controversy were installed. A few of the visitor comments have since been printed and are available in the museum's Native American Resource Center.

67. Danielle Rice, "On the Ethics of Museum Education," *Museum News* 65, no. 5 (1987): 17-19.

Chapter 3. **Education as** Experience

1. See page 54 for fuller context.

2. Studies confirming this view include Laurie P. Eason and Marcia C. Linn, "Evaluation of the Effectiveness of Participatory Exhibits," *Curator* 19, no. 1 (1976): 45–62; Herbert D. Thier and Marcia C. Linn, "The Value of Interactive Learning Experiences," *Curator* 19, no. 3 (1976): 233–245; and Sherman Rosenfeld and Amelia Terkel, "A Naturalistic Study of Visitors at an Interactive Mini Zoo," *Curator* 25, no. 3 (1982): 187–212.

3. In some cases, devices like these interpret not objects per se but ideas or themes. Generally, those ideas and themes function to provide an interpretive context for understanding objects. Thus, visitors are increasingly experiencing collections through means other than the objects that constitute them.

4. Art historian Ernst Gombrich spoke for many when he said:

> I have gloomy visions of a future museum in which the contents of Aladdin's cave will have been removed to the storeroom, and all that will be left will be an authentic lamp from the period of the Arabian Nights with a large diagram beside, explaining how oil lamps worked, where the wick was inserted and what was the average burning time.

E. H. Gombrich, "The Museum: Past, Present and Future," *Ideals and Idols: Essays on Values in History and in Art* (Oxford: Phaidon, 1979).

5. "Stuffed birds on sticks" was the way one visitor described the Field Museum's bird halls in a focus group conducted at the museum by Beverly Serrell in 1990. For an excerpt from the unpublished report, see Beverly Serrell and Barbara Becker, "Stuffed Birds on Sticks: Plans to Re-do the Animal Halls at Field Museum," *Visitor Studies: Theory, Research, and Practice,* ed. By Stephen Bitgood et al. (Jacksonville, Ala.: Center for Social Design, 1990), 3:263–69.

6. The "Rearing Young" exhibit not only presented biological and anthropological views of rearing young, it also provided a space for parents to observe their (and other) children at play and to exchange information about parenting.

7. This number rose to 1,200 with the opening of the second part of the exhibit, "Pacific Spirits."

8. Michael B. Alt, "Visitors' Attitudes to Two Old and Two New Exhibitions at the British Museum (Natural History)," *Museums Journal* 2, no. 3 (1983): 145–48; Bob Peart, "Impact of Exhibit Type on Knowledge Gain, Attitudes, and Behavior," *Curator* 27, no. 3 (1984): 220–37; Stephen Bitgood, *The Role of Simulated Immersion in Exhibition,* technical report no. 90-12 (Jacksonville, Ala.: Center for Social Design, 1990); Steven A. Griggs, "Perceptions

of Traditional and New Style Exhibitions at the Natural History Museum, London," *ILVS Review* 1, no. 2 (1990): 78-90; and Serrell and Associates, "'From Stuffed Birds on Sticks' to 'Vivid Feathers, Gleaming Talons, and Sparkling Beaks,'" unpublished report, 1992, Field Museum, Chicago.

9. Edward P. Alexander, *Museum Masters: Their Museums and Their Influence* (Nashville: American Association for State and Local History, 1983); Pierre Cabanne, *The Great Collectors* (New York: Farrar, Straus, 1963); Lillian B. Miller, *Patrons and Patriotism: The Encouragement of the Fine Arts in the United States, 1790–1860* (Chicago: University of Chicago Press, 1966); Aline B. Saarinen, *The Proud Possessors: The Lives, Times, and Tastes of Some Adventurous American Art Collectors* (New York: Random House, 1958); and Niels von Holst, *Creators, Collectors, and Connoisseurs* (New York: G. P. Putnam's Sons, 1967).

10. Douglas and Elizabeth Rigby, *Lock, Stock, and Barrel: The Story of Collecting* (New York: J. B. Lippincott and Company, 1944); and Alma S. Wittlin, *Museums: In Search of a Usable Future* (Cambridge: MIT Press, 1970).

11. Joel Orosz, *Curators and Culture: An Interpretive History of the Museum Movement in America, 1740–1870* (Tuscaloosa: University of Alabama Press, 1986).

12. Neil Harris, *Humbug: The Art of P. T. Barnum* (Chicago: University of Chicago Press, 1973).

13. Helen Lefkowitz Horowitz, *Culture and the City: Cultural Philanthropy in Chicago from the 1880s to 1917* (Chicago: University of Chicago Press, 1976).

14. Germain Bazin, *The Museum Age,* trans. Jane van Nuis Cahill (New York: Universe Books, 1967); Nathaniel Burt, *Palaces for the People: A Social History of the American Art Museum* (Boston: Little, Brown and Company, 1977); H. H. Frese, *Anthropology and the Public: The Role of Museums* (Leiden: E. J. Brill, 1960), 38-44; and Wittlin, *Museums.* Numerous books about the histories of individual museums also provide in-depth descriptions and illustrations of how collections were displayed.

15. Miles Orvell, *The Real Thing: Imitation and Authenticity in American Culture, 1880–1940* (Chapel Hill: University of North Carolina Press, 1989).

16. Orvell, *Real Thing,* xv.

17. Orvell, *Real Thing,* xv.

18. Orvell, *Real Thing,* 59.

19. Orvell, *Real Thing,* 58.

20. Orvell's interpretation is in complete accord with Neil Harris's characterization of people's delight at the deceptions posed by nineteenth-century hucksters (see pages 26-27).

21. Thomas Greenwood, "The Place of Museums in Education," *Science* 22, no. 561 (1893): 247.

22. Neil Harris, "Museums, Merchandising, and Popular Taste: The Struggle for Influence," in *Material Culture and the Study of American Life,* ed. Ian Quimby (New York: W. W. Norton and Company, 1978), 152.

23. See, for example, Burton Benedict (with contributions by Marjorie M. Dobkin et al.), *The Anthropology of World's Fairs: San Francisco's Panama Pacific International Exposition of 1915* (Berkeley: Lowie Museum of Anthropology in association with Scholar Press, 1983); Robert Rydell, *All the World's a Fair: Visions of Empire at American International Expositions, 1876–1916* (Chicago: University of Chicago Press, 1984); and Robert Rydell, *World of Fairs: The Century-of-Progress Expositions* (Chicago: University of Chicago Press, 1993).

24. Ralph Hower, *History of Macy's of New York, 1858–1919* (Cambridge: Harvard University Press, 1943), 53, quoted in Orvell, *Real Thing,* 54.

25. For a provocative analysis of the effect of scientific and technological discoveries on human perception, see Stephen Kern, *The Culture of Time and Space, 1880–1918* (Cambridge: Harvard University Press, 1983).

26. Terry Zeller, "The Historical and Philosophical Foundations of Art Museum Education in America," *Museum Education: History, Theory, and Practice,* ed. Nancy Berry and Susan Mayer (Reston, Va.: National Art Education Association, 1989), 33.

27. T. R. Adam, *The Civic Value of Museums* (New York: American Association for Adult Education, 1937), 7-8.

28. Dean MacCannell, *The Tourist: A New Theory of the Leisure Class* (New York: Schocken Books, 1976).

29. MacCannell, *Tourist,* 13-14.

30. Jean Baudrillard, *Simulations,* trans. Paul Foss, Paul Patton, and Philip Beitchman (New York: Semiotext[e], 1983), 5.

31. Orvell, *Real Thing,* xxiii.

32. Baudrillard, *Simulations,* 49.

33. No analysis of authenticity will be complete until questions about its meaning and importance are posed to visitors—and other partakers. The few studies that have dealt with questions about authenticity suggest that it is an important and valued quality, but that an object or setting does not have to be truly authentic to be experienced as such. In other words, if a reproduction is accurate and well-produced, it can offer a satisfyingly "authentic" experience. See, for example, Gianna M. Moscardo and Philip L. Pearce, "Historic Theme Parks: An Australian Experience in Authenticity," *Annals of Tourism Research* 13, no. 3 (1986): 467-79; Philip L. Pearce, *The Ulysses Factor: Evaluating Visitors in Tourist Settings* (New York: Springer-Verlag, 1988); and SRI Research Center, *Florida Tourism and Historic Sites: A Study Sponsored by Florida Department of State, Florida Department of Natural Resources, Florida Department of Commerce,*

National Trust for Historic Preservation (Tallahassee, Fla.: State of Florida, 1988), 6.

34. See pages 57–58 for another elaboration of these developments.

35. Ferdinand de Saussure, *Course in General Linguistics,* ed. Charles Bally et al., trans. Wade Baskin (New York: McGraw-Hill Book Company, 1966), 65–78.

36. Umberto Eco, "Travels in Hyperreality," *Travels in Hyperreality: Essays,* trans. William Weaver (New York: Harcourt Brace Jovanovich, 1986), 44.

37. What we have not even touched on in this chapter, and that warrants a book unto itself, is the growing use of media technology to interpret and represent collections. Computers, CD-ROMS, videodiscs, World Wide Web sites, and "virtual reality" all have raised serious questions about the quality of representations and the nature of the experience they afford. The issues are many and include concerns about preserving the value of the original; providing access to collections that may otherwise be inaccessible; and extending the means by which collections are interpreted and experienced.

Chapter 4. **Education as** Ethics

1. See page 54 for a broader elaboration of this decision.

2. William T. Stearn, "An Introduction to the *Species Plantarum* and Cognate Botanical Works of Carl Linnaeus," *Species Plantarum: A Facsimile of the First Edition, 1753* (London: Ray Society, 1957), 1:44.

3. For a translation of all twenty-four of Linnaeus's classes, see Stearn, "Introduction to the *Species Plantarum,*" 1:24–35.

4. See page 54 for a more complete description of this decision.

5. See page 77.

6. What the interpretation did not do, and what would have helped avoid possible misunderstanding, was to clarify for visitors how language such as this was used and regarded during Linnaeus's time.

7. For a penetrating articulation of this view, see Donna Haraway, "Teddy Bear Patriarchy: Taxidermy in the Garden of Eden, New York City, 1908–1936," *Social Text* 4, no. 2 (1984): 20–64.

8. The Smithsonian Institution, for example, caused no small uproar when it added "dilemma labels," pointing out violations against gender and race embedded in the displays, to existing exhibits in its Museum of Natural History.

9. See Chapter 2, notes 47–49 for examples.

10. National Museum of American Art, Washington, D.C., 1991.

11. For a complete exposition of the curators' intentions, see the exhibition catalogue: William H. Truettner, ed., *The West as America: Reinterpreting Images of the Frontier, 1820–1920* (Washington, D.C.: Smithsonian Institution Press, 1991).

12. Both the Denver Art Museum and the St. Louis Art Museum canceled the show because of "financial constraints."

13. "The Last Act: The Atomic Bomb and the End of World War II" (originally titled "The Crossroads: The End of World War II, the Atomic Bomb, and the Onset of the Cold War"), National Air and Space Museum, Smithsonian Institution, Washington, D.C., cancelled 1995.

14. "Into the Heart of Africa," Royal Ontario Museum, Toronto, 1989–1990.

15. Scott Tyler, student exhibition, School of the Art Institute, Chicago, 1989. It is worth noting that this work did include, as part of the installation, a visitor comment book in which viewers were invited to write their responses.

16. In 1990 Congress passed the Native American Grave Protection and Repatriation Act, which laid out the terms for repatriating human remains and certain classes of objects.

17. "The Perfect Moment," Institute of Contemporary Art, Philadelphia, 1988–1989, and traveling to six other cities through 1990.

18. Two photographs depicting child nudity along with several images of nude men, primarily couples and African Americans, caused the outcry. Interestingly, not one critic made mention of the fact that numerous photographs of nude women were also a part of the show. This blinding hypocrisy only drives home the point that interpretation is linked inextricably to social values.

19. Dennis Barrie was acquitted by jury.

20. During the controversy surrounding the Mapplethorpe show, another artist facing similar obscenity charges was frequently cited alongside the photographer. Interestingly, Andres Serrano faced the opposite problem as Mapplethorpe: his photograph "Piss Christ" was considered offensive not because of its image but because of its title, which changed an otherwise innocuous image of fluid into urine. Like "The West," offense rested not in the artwork itself but in the language surrounding it. Such is the power of language to alter what we see.

21. Ironically, perhaps symbolically, Robert Mapplethorpe died of AIDS midway through the exhibit's tour.

22. DeWitt Clinton, "Address before the American Academy," *Historic Annals of the National Academy of Design,* ed. Thomas Cummings (Philadelphia, 1865), 8, quoted in Lillian B. Miller, *Patrons and Patriotism: The Encouragement of the Fine Arts in the United States, 1790–1860* (Chicago: University of Chicago Press, 1966), 96.

23. *South Carolina Gazette and General Advertiser,* 5–7 February 1784, quoted in Miller, *Patrons and Patriotism,* 122.

24. Robert Dale Owen, quoted in "Proceedings of the Twenty-Ninth

Congress, April 22, 1846," *The Smithsonian Institution: Documents Relative to its Origin and History 1835–1899,* 2 vols., comp. and ed. William Jones Rhees (Washington, D.C.: Government Printing Office, 1901), 1:347-48.

25. Sir Henry Cole, quoted in George Brown Goode, "The Museums of the Future," *Smithsonian Institution Report of the National Museum, 1888–1889* (Washington, D.C.: Government Printing Office, 1891), 431.

26. Paul Marshall Rea, *The Museum and the Community with a Chapter on the Library and the Community: A Study of Social Laws and Consequences* (Lancaster, Pa.: Science Press, 1932).

27. Grace Fisher Ramsey, *Educational Work in Museums of the United States: Development, Methods, and Trends* (New York: H. W. Wilson Co., 1938).

28. Laurence Vail Coleman, *The Museum in America: A Critical Study,* 3 vols. (Washington, D.C.: American Association of Museums, 1939).

29. Marguerite Bloomberg, *An Experiment in Museum Instruction,* American Association of Museums New Series, no. 8 (Washington, D.C.: American Association of Museums, 1929); Louis Powell, "Evaluating Public Interest in Museum Rooms," *Museum News* 11, no. 15 (1934): 7; Louis Powell, "A Study of Seasonal Attendance at a Midwestern Museum of Science," *Museum News* 16, no. 3 (1938): 7-8.

30. See, for example, Lewis Mumford, "The Marriage of Museums," *The Scientific Monthly* 7, no. 3 (1918): 252-60; T. R. Adam, "Science, Industry, and Commerce," *The Museum and Popular Culture* (New York: American Association for Adult Education, 1939), 123-35.

31. André Malraux, "Museum without Walls" (originally published in France with the title, "Le Musée Imaginaire"), *The Voices of Silence,* trans. Stuart Gilbert (Garden City, N.Y.: Doubleday and Company, 1953).

32. Haraway, "Teddy Bear Patriarchy."

33. Helen Horowitz, "Animal and Man in the New York Zoological Park," *New York History* 56, no. 4 (1975): 426-55.

34. Michael McMahon, "The Romance of Technological Progress: A Critical Review of the National Air and Space Museum," *Technology and Culture* 22 (1981): 281-96. For a more general discussion of the portrayal of science and technology in museums, see George Basalla, "Museums and Technological Utopianism," *Curator* 17, no. 2 (1974): 105-18.

35. Carol Duncan and Alan Wallach, "The Museum of Modern Art as Late Capitalist Ritual: An Iconographic Analysis," *Marxist Perspectives* 1, no. 4 (1978): 28-51.

36. Robert Hodge and Wilfred D'Souza, "The Museum as Communicator: A Semiotic Analysis of the Western Australian Museum Aboriginal Gallery, Perth," *Museum* 28, no. 3 (1976): 251-67.

37. James Clifford, "Histories of the Tribal and the Modern," *Art in America* 73, no. 4 (1985): 164-77, 215.

38. Four publications resulting from four conferences and seminars demonstrate the breadth of commentary on this subject. See Ivan Karp and Steven D. Lavine, eds., *Exhibiting Cultures: The Poetics and Politics of Museum Display* (Washington, D.C.: Smithsonian Institution Press, 1991); Ivan Karp, Christine Mullen Kreamer, and Steven D. Lavine, eds., *Museums and Communities: The Politics of Public Culture* (Washington, D.C.: Smithsonian Institution Press, 1992); Association of Art Museum Directors, *Different Voices: A Social, Cultural, and Historical Framework for Change in the American Art Museum* (New York: Association of Art Museum Directors, 1992); Jane R. Glaser and Artemis A. Zenetou, eds., *Gender Perspectives: Essays on Women in Museums* (Washington, D.C.: Smithsonian Institution Press, 1994).

39. Of course, whether deconstruction is indeed a "movement"—or a theory, philosophy, or methodology—is an issue, but not one we need tackle here.

40. Robert Harbison, "Contracted World: Museums and Catalogues," *Eccentric Spaces* (New York: Alfred A. Knopf, 1977), 140-53.

41. Susan Stewart, *On Longing: Narratives of the Miniature, the Gigantic, the Souvenir, the Collection* (Baltimore: Johns Hopkins University Press, 1984), 151-69.

42. James Clifford, "Objects and Selves: An Afterword," *Objects and Others,* ed. George Stocking, 236-46.

43. Brian O'Doherty, *Inside the White Cube: The Ideology of the Gallery Space* (San Francisco: Lapis Press, 1986).

44. Umberto Eco, "Travels in Hyperreality," *Travels in Hyperreality: Essays,* trans. William Weaver (New York: Harcourt Brace Jovanovich, 1986).

45. Some notable exceptions are discussed on pages 76-78.

46. For a provocative discussion of the role of gallery lighting on visitors' perceptions, see Victor M. Cassidy, "Night Comes to the Field Museum," *The New Criterion* 5, no.7 (1987): 77-80.

47. Eugenio Donato, "The Museum's Furnace: Notes toward a Contextual Reading of *Bouvard and Pécuchet*," *Textual Strategies: Perspectives in Post-Structuralist Criticism,* ed. Josue Harari (Ithaca, N.Y.: Cornell University Press, 1979), 223.

Chapter 5. **Conclusion: Education as a** Narrative Endeavor

1. From this point on, when I speak of "education" I am referring to its application to both visitors and museums, both its "learning" and "teaching" aspects.

2. Nelson Goodman, *Of Mind and Other Matters* (Cambridge, Mass.: Harvard University Press, 1984), 33-34.

3. Jerome Bruner, *Actual Minds, Possible Worlds* (Cambridge, Mass.: Harvard University Press, 1986), 46.

4. This is not to be confused with the same term popularized by Thomas Kuhn. Thomas Kuhn, *The Structure of Scientific Revolutions* (Chicago: University of Chicago Press, 1962).

5. Bruner, *Actual Minds,* 11.

6. Ibid., 50.

7. This is my language, not Lyotard's; but its appropriateness will become clear in the ensuing few pages.

8. Lyotard has borrowed from Wittgenstein the concept of language games in treating scientific and narrative forms of thought: "Each of the various categories of utterance can be defined in terms of rules specifying their properties and the uses to which they can be put." This is simple linguistics; indeed, linguistic categories like "denotative," "performative," and "prescriptive" utterances form the basis for Lyotard's comparison between scientific and narrative thought. Jean-François Lyotard, *The Postmodern Condition: A Report on Knowledge,* trans. Geoff Bennington and Brian Massumi (Minneapolis: University of Minnesota Press, 1984), 10.

9. Lyotard, *Postmodern Condition,* 29.

10. Ibid., 19.

11. Wolfgang Iser, *The Act of Reading: A Theory of Aesthetic Response* (Baltimore: Johns Hopkins University Press, 1981), 21.

12. Perhaps the most compelling findings about the social aspects of museum visits have been uncovered by Lois Silverman, who, by arming visitors with tape recorders, captured their conversation as they tour the museum. Limited to what visitors said to one another, her data nevertheless provide a glimpse at visitors' immediate and hopefully spontaneous reactions to what they see. For obvious reasons, this methodology is particularly suited to documenting evidence of socializing. Lois Silverman, "Of Us and Other 'Things': The Content and Functions of Talk by Adult Visitor Pairs in an Art and a History Museum" (Ph.D. diss., Indiana University, 1991). For additional evidence, see Melora McDermott-Lewis, *The Denver Art Museum Interpretive Project,* ed. Steve Grinstead and Margaret Ritchie (Denver: Denver Art Museum, 1990); and Amy Walsh, ed., *Insights: Museums, Visitors, Attitudes, Expectations— A Focus Group Experiment* (Los Angeles: Getty Center for Education in the Arts, 1991).

13. Lois Silverman, "Of Us and Other 'Things'"; Britt Raphling and Beverly Serrell, "Capturing Affective Learning," in *Current Trends in Audience Research and Evaluation* (Washington, D.C.: American Association of Museums Committee on Audience Research and Evaluation, 1993), 7:57-62.

14. Walsh, ed., *Insights;* Raphling and Serrell, "Capturing Affective Learning"; Gail Edington, Janice Siska, and Deborah Perry, "'The Intrigue Is with the Detail': Probing for Affective Responses," in *Current Trends in Audience Research and Evaluation* (Washington, D.C.: American Association of Museums Committee on Audience Research and Evaluation, 1993), 7:12–16.

15. McDermott-Lewis, *Denver Art Museum Interpretive Project;* Raphling and Serrell, "Capturing Affective Learning"; Silverman, "Of Us and Other 'Things'"; Walsh, ed., *Insights*.

16. Research on museums' restorative function has been largely carried out by psychologist Stephen Kaplan. Kaplan has been working to apply attention-restoration theory, which was originally developed in the context of natural environments, to museums. Basically, he is studying the prospect that museums are capable of creating a sense of peace and calm that "permits people to recover their cognitive and emotional effectiveness." Stephen Kaplan et al., "The Restorative Experience as a Museum Benefit," *Journal of Museum Education* 18, no. 3 (1993): 15–18; and Stephen Kaplan et al., "The Museum as a Restorative Experience," *Environment and Behavior* 25, no. 6 (1993): 725–42.

17. Frequent visitors, those who come three or more times a year, typically sought the following in their leisure time experiences: the opportunity to learn, the challenge of new experiences, and the chance to do something worthwhile. Nonparticipants sought the three leisure attributes that were least important to frequent visitors: being with people, participating actively, and feeling comfortable and at ease in their surroundings. Occasional visitors, coming one to two times per year, resembled nonparticipants in their leisure interests. They perceived that some of these attributes were available in museums but not in sufficient quantity to warrant regular visits. Marilyn G. Hood, "Adult Attitudes toward Leisure Choices in Relation to Museum Participation" (Ph.D diss., Ohio State University, 1981).

18. John R. Kelly, "Leisure Socialization: Replication and Extension," *Journal of Leisure Research* 9, no. 2 (1977): 121–32; John H. Falk, *Leisure Decisions Influencing African-American Use of Museums* (Washington, D.C.: American Association of Museums, 1993); Jeffrey K. Smith et al., "Cross Cultural Learning in Two Art Museums: The Poushkin and the Metropolitan," *Current Trends in Audience Research and Evaluation,* vol. 8 (Washington, D.C.: American Association of Museums Committee on Audience Research and Evaluation, 1994).

19. John H. Falk and Lynn D. Dierking, *The Museum Experience* (Washington, D.C.: Whalesback Books, 1992).

20. Lois H. Silverman, "Visitor Meaning-Making in Museums for a New Age," *Curator: The Museum Journal* 38, no. 3 (1995): 161–70.

21. The question whether "who visitors are" or "what exhibits are like"

has greater influence over visitor learning and behavior was the subject of an informal survey administered to forty-five museum professionals. Their opinions as well as their reasoning varied widely. See Beverly Serrell, "Point-Counterpoint Quiz," *Current Trends in Audience Research and Evaluation* (Washington, D.C.: American Association of Museums Committee on Audience Research and Evaluation, 1993), 7:63–67.

22. Howard Gardner, *Frames of Mind: The Theory of Multiple Intelligences* (New York: Basic Books, 1983).

23. Bruner, *Actual Minds,* 103.

24. Lev Vygotsky, *Mind in Society: The Development of Higher Psychological Processes,* ed. Michael Cole et al. (Cambridge, Mass.: Harvard University Press, 1978).

25. Blythe McVicker Clinchy, "The Development of Thoughtfulness in College Women: Integrating Reason and Care," *American Behavioral Scientist* 32, no. 6 (1989): 647–57. See also Mary Field Belenky et al., *Women's Ways of Knowing: The Development of Self, Voice, and Mind* (New York: Basic Books, 1986).

26. Jean Baudrillard, *For a Critique of the Political Economy of the Sign,* trans. Charles Levin (St. Louis: Telos Press, 1981); and Umberto Eco, *A Theory of Semiotics* (Bloomington: Indiana University Press, 1976).

27. At a recent conference, seven academicians from a variety of disciplines were invited to consider what their fields had to offer the study of visitors and museums. Their papers considered the influence on learning of prior knowledge and experience; subsequent, reinforcing experiences; motivation and attitudes; culture and background; social mediation; design and presentation; and physical setting. See John H. Falk and Lynn D. Dierking, *Public Institutions for Personal Learning: Establishing a Research Agenda* (Washington, D.C.: American Association of Museums, 1995).

28. Bruner, *Actual Minds,* 25.

29. Ibid., 35.

30. For a description of these methods and the results of their evaluation, see McDermott-Lewis, *Denver Art Museum Interpretive Project.*

31. Bruner, *Actual Minds,* 123.

32. Of course, not all these manifestations have been welcomed by the museum community. In 1970 an accreditation program was established by the American Association of Museums in order to assure the quality and standards of the institutions they represent.

33. For a review of the use of the term "museum" along with its various connotations and metaphors, see Marilyn Hood, "What's in a Name?" *Visitor Behavior* 6, no. 3 (1991): 4–6.

34. "Education: What's Next?" *Museum News* 68, no. 3 (1989): 51.

35. While the recent passage of legislation on repatriation has assured the return of some cultural properties to native populations, most accessions remain in museum hands. Some museums have made a special effort to address the concerns of native peoples by allowing objects to be borrowed for ceremonial purposes and by ensuring that objects are properly "fed" and housed.

36. "Te Maori," traveling exhibition, 1984–1986.

37. "The Great Eastern Temple: Treasures of Japanese Buddhist Art from Todai-ji," Art Institute of Chicago, Chicago, 1986.

38. Elaine Heumann Gurian, "A Blurring of the Boundaries," *Curator: The Museum Journal* 38, no. 1 (1995): 32, 33.

39. Where original "natives" are lacking, museums have responded with costumed interpreters and living dramatizations (though, thankfully, these have primarily been used for historical, not cultural, interpretation).

40. Indeed, the Smithsonian Institution's annual homage to folkcrafts is even called the "Festival of American Folklife"; likewise, the enormously popular "Festival of India," which traveled to museums throughout the United States from 1985 to 1986.

41. Margaret J. King, "Theme Park Thesis," *Museum News* 69 no. 5 (1990): 60.

42. Allon Schoener, "Can Museums Learn from Mickey and Friends?" *New York Times,* 30 November 1988, H39.

43. This journal later became the *Journal of Museum Education.*

44. American Association of Museums, *Excellence and Equity: Education and the Public Dimension of Museums* (Washington, D.C.: American Association of Museums, 1992).

45. Anthropologist John Terrell published his scathing critique of visitor-centered exhibits ("Disneyland and the Future of Museum Anthropology," *American Anthropologist* 93, no. 1 [1991]: 149–153) shortly before the formal presentation of *Excellence and Equity* at the 1991 annual American Associations of Museums meeting. Mocking his charge that museum educators have been "deputized by museum presidents and boards of trustees to do whatever needs to be done to boost attendance figures" (p. 149), dozens of conference participants donned shiny tin stars for the duration of the four-day meeting.

46. Data collected from the 1989 National Museum Survey (representing fiscal year 1988) revealed that 57 percent of the nation's museums have budgets of $100,000 or less and, of these, two-thirds have budgets of $50,000 or less. When budget size is adjusted for museum type, fully four out of five museums can be classified as small. American Association of Museums, *Museums Count* (Washington, D.C.: American Association of Museums, 1994), 23, 32.

Bibliography

Adam, T. R. *The Civic Value of Museums.* New York: American Association for Adult Education, 1937.

———. *The Museum and Popular Culture.* New York: American Association for Adult Education, 1939.

Alexander, Edward P. "The American Museum Chooses Education." *Curator* 31, no. 1 (1988): 61–80.

———. *Museum Masters: Their Museums and Their Influence.* Nashville, Tenn.: American Association for State and Local History, 1983.

———. *Museums in Motion: An Introduction to the History and Functions of Museums.* Nashville, Tenn.: American Association for State and Local History, 1979.

Alt, Michael B. "Visitors' Attitudes to Two Old and Two New Exhibitions at the British Museum (Natural History)." *Museums Journal* 2, no. 3 (1983): 145–48.

American Association of Museums. *Excellence and Equity: Education and the Public Dimension of Museums.* Washington, D.C.: American Association of Museums, 1992.

———. *Museums Count.* Washington, D.C.: American Association of Museums, 1994.

———. *Museums for a New Century.* Washington, D.C.: American Association of Museums, 1984.

———. *Museums: Their New Audience.* Washington, D.C.: American Association of Museums, 1972.

————. *A Statistical Survey of Museums in the United States and Canada*. Washington, D.C.: American Association of Museums, 1965.

Annis, Sheldon. "The Museum as Symbolic Experience." University of Chicago, Division of Social Sciences, 1974. Photocopy.

Association of Art Museum Directors. *Different Voices: A Social, Cultural, and Historical Framework for Change in the American Art Museum*. New York: Association of Art Museum Directors, 1992.

Baudrillard, Jean. *Simulations*. Trans. Paul Foss, Paul Patton, and Philip Beitchman. New York: Semiotext(e), 1983.

Bazin, Germain. *The Museum Age*. Trans. Jane van Nuis Cahill. New York: Universe Books, 1967.

Belenky, Mary Field, et al. *Women's Ways of Knowing: The Development of Self, Voice, and Mind*. New York: Basic Books, 1986.

Benedict, Burton. *The Anthropology of World's Fairs: San Francisco's Panama Pacific International Exposition of 1915*. With contributions by Marjorie M. Dobkin et al. Berkeley, Calif.: Lowie Museum of Anthropology in association with Scholar Press, 1983.

Berrin, Kathleen. "Activating the Art Museum Experience." *Museum News* 56, no. 4 (1978): 42-45.

Betts, John Rickards. "P. T. Barnum and the Popularization of Natural History." *Journal of the History of Ideas* 20, no. 3 (1959): 353-68.

Bitgood, Stephen. *Effect of Label Characteristics of Visitor Behavior*. Technical report no. 86-55. Jacksonville, Ala.: Center for Social Design, 1986.

————. *The Effects of Instructional Signs on Museum Visitors*. Technical report no. 86-70. Jacksonville, Ala.: Center for Social Design, 1986.

————. *The Role of Simulated Immersion in Exhibition*. Technical report no. 90-12. Jacksonville, Ala.: Center for Social Design, 1990.

Blackmon, Carolyn, Teresa LaMaster, Lisa Roberts, and Beverly Serrell. *Open Conversations: Strategies for Professional Development in Museums*. Chicago: Field Museum of Natural History, 1988.

Bloom, Allan. *The Closing of the American Mind: How Higher Education Has Failed Democracy and Impoverished the Souls of Today's Students*. New York: Simon and Schuster, 1987.

Bloomberg, Marguerite. *An Experiment in Museum Instruction,* American Association of Museums New Series, no. 8. Washington D.C.: American Association of Museums, 1929.

Borun, Minda, et al. "Naive Knowledge and the Design of Science Museum Exhibits." *Curator* 36, no. 3 (1993): 201-19.

Borun, Minda. "Naive Notions and the Design of Science Museum Exhibits."

Proceedings of the 1989 Visitor Studies Conference. Ed. Stephen Bitgood, et al. Jacksonville, Ala.: Center for Social Design, 1989.

———, and Maryanne Miller. *What's in a Name? A Study of the Effectiveness of Explanatory Labels in a Science Museum.* (Philadelphia: Franklin Institute, 1980).

Brooking, Dolo. "Play, in All Seriousness." *Museum News* 56, no. 5 (1978): 21–24.

Brooks, Joyce A. M., and Philip E. Vernon. "A Study of Children's Interests and Comprehension at a Science Museum." *British Journal of Psychology* 47 (1956): 175–82.

Bruner, Jerome. *Actual Minds, Possible Worlds.* Cambridge, Mass.: Harvard University Press, 1986.

Burden, W. Douglas. "A New Vision of Learning." *Museum News* 21, no. 2 (1943): 9–12.

Burt, Nathaniel. *Palaces for the People: A Social History of the American Art Museum.* Boston: Little, Brown and Company, 1977.

Cannon-Brookes, Peter, and Caroline Cannon-Brookes, eds. "Editorial: False Gods." *International Journal of Museum Management and Curatorship* 8, no. 1 (1989): 5–9.

Carbanne, Pierre. *The Great Collectors.* New York: Farrar, Straus, 1963.

Cassidy, Victor M. "Night Comes to the Field Museum." *The New Criterion* 5, no. 7 (1987): 77–80.

Chambers, Marlene. "Improving the Esthetic Experience for Art Novices: A New Paradigm for Interpretive Labels." *Program Sourcebook.* Washington, D.C.: American Association of Museums, 1988.

Cheney, Lynne V. *Humanities in America: A Report to the President, the Congress, and the American People.* Washington, D.C.: National Endowment for the Humanities, 1988.

Clifford, James. "Histories of the Tribal and the Modern." *Art in America* 73, no. 4 (1985): 164–77, 215.

———. "Objects and Selves—An Afterword." In *Objects and Others: Essays on Museums and Material Culture.* Ed. George Stocking. Madison: University of Wisconsin Press, 1985.

Clinchy, Blythe McVicker. "The Development of Thoughtfulness in College Women: Integrating Reason and Care." *American Behavioral Scientist* 32, no. 6 (1989): 647–57.

Coleman, Laurence Vail. *The Museum in America: A Critical Study.* 3 vols. Washington, D.C.: American Association of Museums, 1939.

Connolly, Louise. *The Educational Value of Museums.* Newark, N.J.: Newark Museum Association, 1914.

Cooke, Edmund. "A Survey of the Educational Activities of Forty-Seven American Museums. *Museum News* 12, no. 4 (1934): 4-8.

Corrin, Lisa G. "Mining the Museum: Artists Look at Museums, Museums Look at Themselves." In *Mining the Museum: An Installation by Fred Wilson.* Ed. Lisa G. Corrin. New York: New Press; Baltimore: Contemporary, 1994.

Cremin, Lawrence A. "The Dilemmas of Popularization." In *American Education: The National Experience 1783–1876.* New York: Harper and Row, 1980.

Csikszentmihalyi, Mihaly. *Beyond Boredom and Anxiety.* San Francisco: Jossey-Bass Publishers, 1975.

———. "Leisure and Socialization." *Social Forces* 60, no. 2 (1981): 332-40.

———, and Eugene Rochberg-Halton. *The Meaning of Things: Domestic Symbols and the Self.* Cambridge: Cambridge University Press, 1981.

Dana, John Cotton. "In a Changing World Should Museums Change?" In *Papers and Reports Read at the Twenty-First Annual Meeting of the American Association of Museums.* Washington, D.C.: American Association of Museums, 1926.

———. *The New Museum,* nos. 1 and 2. Woodstock, Vt.: Elm Tree Press, 1917.

Diamond, Judy. "The Behavior of Family Groups in Science Museums." *Curator* 29, no. 2 (1986): 139-54.

Dixon, Brian, Alice E. Courtney, and Robert H. Bailey. *The Museum and the Canadian Public.* Montreal: Culturcan Publications, 1974.

Donato, Eugenio. "The Museum's Furnace: Notes toward a Contextual Reading of *Bouvard and Pécuchet.*" In *Textual Strategies: Perspectives in Post-Structuralist Criticism.* Ed. Josue Harari. Ithaca: Cornell University Press, 1979.

Duncan, Carol, and Alan Wallach. "The Museum of Modern Art as Late Capitalist Ritual: An Iconographic Analysis." *Marxist Perspectives* 1, no. 4 (1978): 28-51.

Eason, Laurie P., and Marcia C. Linn. "Evaluation of the Effectiveness of Participatory Exhibits." *Curator* 19, no. 1 (1976): 45-62.

Eco, Umberto. "Travels in Hyperreality." In *Travels in Hyperreality: Essays.* Trans. William Weaver. New York: Harcourt Brace Jovanovich, 1986.

Edington, Gail, et al. "'The Intrigue Is with the Detail': Probing for Affective Responses." *Current Trends in Audience Research and Evaluation,* vol. 7. Washington, D.C.: American Association of Museums Committee on Audience Research and Evaluation, 1993.

"Editorial: A Major Museum Goes 'Populist.'" *Nature* 345 (1990): 1-2.

"Education: What's Next?" *Museum News* 68, no. 3 (1989): 49-51.

Eisner, Elliot W., and Stephen M. Dobbs. *The Uncertain Profession: Observations on the State of Museum Education in Twenty American Art Museums.* Los Angeles: J. Paul Getty Center for Education in the Arts, 1986.

Fagaly, William, Gilbert Wright, and Frederick Dockstader. "Thoughts on the Audio-Visual Revolution." *Museum News* 51, no. 5 (1973): 13-14.

Falk, John H., and Lynn D. Dierking. *The Museum Experience*. Washington, D.C.: Whalesback Books, 1992.

———. *Public Institutions for Personal Learning: Establishing a Research Agenda*. Washington, D.C.: American Association of Museums, 1995.

Farrington, Robert, et al. "Tyrannosaurus Label Study." *Current Trends in Audience Research and Evaluation*. New Orleans: American Association of Museums Evaluation and Research Committee, 1989.

Frese, H. H. *Anthropology and the Public: The Role of Museums*. Leiden: E. J. Brill, 1960.

Gardner, Howard. *Frames of Mind: The Theory of Multiple Intelligences*. New York: Basic Books, 1983.

Gilman, Benjamin Ives. *Museum Ideals of Purpose and Method*. Cambridge: Harvard University Press, 1923.

Glaser, Jane R., and Artemis A. Zenetou, eds. *Gender Perspectives: Essays on Women in Museums*. Washington, D.C.: Smithsonian Institution Press, 1994.

Glueck, Grace. "The Ivory Tower versus the Discotheque." *Art in America* 59 (1971): 80-85.

Gombrich, E. H. "The Museum: Past, Present, and Future." In *Ideals and Idols: Essays on Values in History and in Art*. Oxford: Phaidon, 1979.

Goode, George Brown. "Museum-History and Museums of History." In *Papers of the American Historical Association*, vol. 3. Ed. Herbert Baxter Adams. New York: G. P. Putnam's Sons, 1888.

———. "The Museums of the Future." In *Smithsonian Institution Report of the National Museum, 1888–1889*. Washington, D.C.: Government Printing Office, 1891.

Goodman, Nelson. *Of Mind and Other Matters*. Cambridge: Harvard University Press, 1984.

Graburn, Nelson. "The Museum and the Visitor Experience." In *The Visitor and the Museum*. Ed. Linda Draper. Berkeley: Lowie Museum of Anthropology, University of California at Berkeley, 1977.

Greenhalgh, Paul. "Education, Entertainment, and Politics: Lessons from the Great International Exhbitions." In *The New Museology*. Ed. Peter Vergo. London: Reaktion Books, 1989.

Greenwood, Thomas. "The Place of Museums in Education." *Science* 22, no. 561 (1893): 246-48.

Griggs, Steven A. "Perceptions of Traditional and New Style Exhibitions at the Natural History Museum, London." *ILVS Review* 1, no. 2 (1990): 78-90.

Gurian, Elaine. "A Blurring of the Boundaries." *Curator: The Museum Journal* 38, no. 1 (1995): 31-37.

———. "Noodling Around with Exhibition Opportunities." In *Exhibiting Cultures: The Poetics and Politics of Museum Display*. Ed. Ivan Karp and Steven D. Lavine. Washington, D.C.: Smithsonian Institution Press, 1991.

Haraway, Donna. "Teddy Bear Patriarchy: Taxidermy in the Garden of Eden, New York City, 1908-1936." *Social Text* 4, no. 2 (1984): 20-64.

Harbison, Robert. "Contracted World: Museums and Catalogues." In *Eccentric Spaces*. New York: Alfred A. Knopf, 1977.

Harris, Neil. *Humbug: The Art of P. T. Barnum*. Chicago: University of Chicago Press, 1973.

———. "Museums, Merchandising, and Popular Taste: The Struggle for Influence." In *Material Culture and the Study of American Life*. Ed. Ian Quimby. New York: W. W. Norton and Company, 1978.

———. "Polling for Opinions." *Museum News* 69, no. 5 (1990): 46-53.

Hills, Philip, and Michael Shallis. "Scientists and Their Images." *New Scientist* 67, no. 964 (1975): 471-75.

Hirschi, K. D., and Chandler Screven. "Effects of Questions on Visitor Reading Behavior." *ILVS Review* 1 (1988): 50-61.

Hodge, Robert, and Wilfred D'Souza. "The Museum as a Communicator: A Semiotic Analysis of the Western Australian Museum Aboriginal Gallery, Perth." *Museum* 28, no. 3 (1976): 251-67.

Holst, Niels von. *Creators Collectors and Connoisseurs*. New York: G. P. Putnam's Sons, 1967.

Hood, Marilyn. "Adult Attitudes toward Leisure Choices in Relation to Museum Participation." Ph.D. diss., Ohio State University, 1981.

———. "What's in a Name?" *Visitor Behavior* 6, no. 3 (1991): 4-6.

Horowitz, Helen L. "Animal and Man in the New York Zoological Park." *New York History* 56, no. 4 (1975): 426-55.

———. *Culture and the City: Cultural Philanthropy in Chicago from the 1880s to 1917*. Chicago: University of Chicago Press, 1976.

Iser, Wolfgang. *The Act of Reading: A Theory of Aesthetic Response*. Baltimore: Johns Hopkins University Press, 1981.

Kaplan, Stephen, et al. "The Restorative Experience as a Museum Benefit." *Journal of Museum Education* 18, no. 3 (1993): 15-18.

———. "The Museum as a Restorative Experience." *Environment and Behavior* 25, no. 6 (1993): 725-42.

Karp, Ivan, and Steven D. Lavine, eds. *Exhibiting Cultures: The Poetics and Politics of Museum Display*. Washington, D.C.: Smithsonian Institution Press, 1991.

Karp, Ivan, et al. *Museums and Communities: The Politics of Public Culture.* Washington, D.C.: Smithsonian Institution Press, 1992.

Katz, Herbert, and Marjorie Katz. *Museums U.S.A.: A History and Guide.* Garden City, N.Y.: Doubleday and Company, 1965.

King, Margaret J. "Theme Park Thesis." *Museum News* 69, no. 5 (1990): 60-62.

Korn, Randi. "Redefining the Visitor Experience." *Journal of Museum Education* 17, no. 3 (1992): 17-19.

Kuhn, Thomas. *The Structure of Scientific Revolutions.* Chicago: University of Chicago Press, 1962.

LaFollette, Marcel C. *Making Science Our Own: Public Images of Science, 1910–1955.* Chicago: University of Chicago Press, 1990.

Learner, Howard. *White Paper on Science Museums.* Washington, D.C.: Center for Science in the Public Interest, 1979.

Lears, T. J. Jackson. *No Place of Grace: Antimodernism and the Transformation of American Culture, 1880–1920.* New York: Pantheon Books, 1981.

Leavitt, Thomas. "Can Research Find a Home in Museums?" *History News* 39, no. 9 (1984): 28-29.

Leavitt, Thomas W., and Dennis O'Toole. "Two Views on Museum Education." *Museum News* 64, no. 2 (1985): 26-31.

Lilla, Mark. "The Great Museum Muddle." *New Republic,* 8 April 1985, pp. 25-30.

Low, Theodore. *The Museum as a Social Instrument: A Study Undertaken for the Committee on Education of the American Association of Museums.* New York: Metropolitan Museum of Art, 1942.

———. "The Museum as a Social Instrument: Twenty Years After." *Museum News* 40, no. 5 (1962): 28-30.

Lumley, Robert, ed. *The Museum Time Machine: Putting Cultures on Display.* London: Routledge, 1988.

Lyotard, Jean-François. *The Postmodern Condition: A Report on Knowledge.* Trans. Geoff Bennington and Brian Massumi. Minneapolis: University of Minnesota Press, 1984.

MacCannell, Dean. *The Tourist: A New Theory of the Leisure Class.* New York: Schocken Books, 1976.

McDermott-Lewis, Melora. *The Denver Art Museum Interpretive Project.* Ed. Steve Grinstead and Margaret Ritchie. With contributions by Marlene Chambers et al. Denver: Denver Art Museum, 1990.

McLennan, Ian. "Excerpts from American Association of Museums Annual Meeting." *Museum News* 50, no. 1 (1971): 17-48.

McLuhan, Marshall, Harley Parker, and Jacques Barzun. *Exploration of the Ways, Means and Values of Museum Communication with the Viewing Public.* Transcript of a seminar held on 9 and 10 October 1967, at the Museum of

the City of New York, sponsored by the New York State Council on the Arts. New York: Museum of the City of New York, 1969.

McMahon, Michael. "The Romance of Technological Progress: A Critical Review of the National Air and Space Museum." *Technology and Culture* 22 (1981): 281-96.

Malraux, André. "Museum without Walls" ["Le Musée Imaginaire"]. In *The Voices of Silence*. Trans. Stuart Gilbert. Garden City, N.Y.: Doubleday and Company, 1953.

Melton, Arthur W. "Distribution of Attention in Galleries in a Museum of Science and Industry." *Museum News* 14, no. 3 (1936): 6-8.

———. *Problems of Installation in Museums of Art*. American Association of Museums New Series, no. 14. Washington, D.C.: American Association of Museums, 1935.

———. "Studies of Installation at the Pennsylvania Museum of Art." *Museum News* 10, no. 14 (1933): 5-8.

Meyer, A. B. "Studies of the Museums and Kindred Institutions of New York City, Albany, Buffalo, and Chicago, with Notes on Some European Institutions." In *Report of the United States National Museum for 1903*. Washington, D.C.: Government Printing Office, 1905.

Miller, Lillian B. *Patrons and Patriotism: The Encouragement of the Fine Arts in the United States, 1790–1860*. Chicago: University of Chicago Press, 1966.

Morris, Rudolph. "Leisure Time and the Museum." *Museum News* 41, no. 4 (1962): 17-21.

Moscardo, Gianna M., and Philip L. Pearce. "Historic Theme Parks: An Australian Experience in Authenticity." *Annals of Tourism Research* 13, no. 3 (1986): 467-79.

Mumford, Lewis. "The Marriage of Museums." *Scientific Monthly* 7, no. 3 (1918): 252-60.

Murdin, Lynda. "'Director's Gone Disney' Claims South Kensington Union." *Museums Journal* 90, no. 6 (1990): 8-9.

National Endowment for the Arts. *Museums USA: Art, History, Science, and Others*. Washington, D.C.: Government Printing Office, 1974.

Naumer, Helmuth J. "A Marketable Product." *Museum News* 50, no. 2 (1971): 14-16.

Nedzel, Lucy Nielsen. "The Motivation and Education of the General Public through Museum Experiences." Ph.D. diss., University of Chicago, 1952.

O'Doherty, Brian. *Inside the White Cube: The Ideology of the Gallery Space*. San Francisco: Lapis Press, 1986.

Orosz, Joel. *Curators and Culture: An Interpretive History of the Museum Movement in America, 1740–1870*. Tuscaloosa: University of Alabama Press, 1986.

Orvell, Miles. *The Real Thing: Imitation and Authenticity in American Culture, 1880–1940.* Chapel Hill: University of North Carolina Press, 1989.

Pach, Walter. *The American Art Museum.* New York: Pantheon Books, 1948.

Patterson, Joseph Allen. "Points of View." *Museum News* 40, no. 1 (1961): 3.

Pearce, Philip L. *The Ulysses Factor: Evaluating Visitors in Tourist Settings.* New York: Springer-Verlag, 1988.

Peart, Bob. "Impact of Exhibit Type on Knowledge Gain, Attitudes, and Behavior." *Curator* 27, no. 3 (1984): 220–37.

Pion, Georgine M., and Mark W. Lipsey. "Public Attitudes toward Science and Technology: What Have the Surveys Told Us?" *Public Opinion Quarterly* 45, no. 3 (1981): 303–16.

Powell, Louis. "Evaluating Public Interest in Museum Rooms." *Museum News* 11, no. 15 (1934): 7.

———. "A Study of Seasonal Attendance at a Midwestern Museum of Science." *Museum News* 16, no. 3 (1938): 7–8.

Price, Sally. *Primitive Art in Civilized Places.* Chicago: University of Chicago Press, 1989.

Ramsey, Grace Fisher. *Educational Work in Museums of the United States: Development, Methods, and Trends.* New York: H. W. Wilson Company, 1938.

Rand, Judy. "Fish Stories That Hook Readers: Interpretive Graphics at the Monterey Bay Aquarium." In *American Association of Zoological Parks and Aquaria 1985 Annual Conference Proceedings.* Columbus, Ohio: American Association of Zoological Parks and Aquaria, 1985.

Raphling, Britt, and Beverly Serrell. "Capturing Affective Learning." *Current Trends in Audience Research and Evaluation,* vol. 7. Washington, D.C.: American Association of Museums Committee on Audience Research and Evaluation, 1993.

Rea, Paul Marshall. *The Museum and the Community with a Chapter on the Library and the Community: A Study of Social Laws and Consequences.* Lancaster, Pa.: Science Press, 1932.

Rhees, William Jones, ed. *The Smithsonian Institution: Documents Relative to its Origin and History, 1835–1899,* 2 vols. Washington, D.C.: Government Printing Office, 1901.

Rice, Danielle. "Making Sense of Art." *Journal of the Washington Academy of Science* 76, no. 2 (1986): 106–14.

———. "Museum Education Embracing Uncertainty." *Art Bulletin* 77, no. 1 (1995): 15–20.

———. "On the Ethics of Museum Education." *Museum News* 65, no. 5 (1987): 13–19.

Rich, Daniel Catton. "Museums at the Crossroads." *Museum News* 39, no. 6 (1961): 36-38.

Richardson, Brenda. "Berkeley and the Women's Movement." *Museum News* 51, no. 7 (1973): 40-44.

Rigby, Douglas, and Elizabeth Rigby. *Lock, Stock, and Barrel: The Story of Collecting*. New York: J. B. Lippincott and Company, 1944.

Ripley, Dillon. *The Sacred Grove*. Washington, D.C.: Smithsonian Institution Press, 1969.

Robertson, Bryan. "The Museum and the Democratic Fallacy." In *Museums in Crisis*. Ed. Brian O'Doherty. New York: George Braziller, 1972.

Robinson, Edward S. *The Behavior of the Museum Visitor*. American Association of Museums New Series, no. 5. Washington, D.C.: American Association of Museums, 1928.

———. "Exit the Typical Visitor." *Journal of Adult Education* 3, no. 4 (1931): 418-23

———. "Psychological Problems of the Science Museum." *Museum News* 8, no. 5 (1930): 9-11.

Rosenfeld, Sherman. "The Context of Informal Learning in Zoos." *Roundtable Reports* 4, no. 2 (1979): 1-3, 15-16.

———, and Amelia Terkel. "A Naturalistic Study of Visitors at an Interactive Mini Zoo." *Curator* 25, no. 3 (1982): 187-12.

Rydell, Robert. *All the World's a Fair: Visions of Empire at American International Expositions, 1876–1916*. Chicago: University of Chicago Press, 1984.

———. *World of Fairs: The Century-of-Progress Expositions*. Chicago: University of Chicago Press, 1993.

Saarinen, Aline B. *The Proud Possessors: The Lives, Times, and Tastes of Some Adventurous Art Collectors*. New York: Random House, 1958.

Saussure, Ferdinand de. *Course in General Linguistics*. Ed. Charles Bally, et al. Trans. Wade Baskin. New York: McGraw-Hill Book Company, 1966.

Schoener, Allon. "Can Museums Learn from Mickey and Friends?" *New York Times,* 30 November 1988, sec. p. H39.

Screven, Chandler. "The Effectiveness of Guidance Devices on Visitor Learning." *Curator* 18, no. 3 (1975): 219-43.

———. "Exhibitions and Information Centers: Some Principles and Approaches." *Curator* 29, no. 2 (1986): 109-37.

Sellers, Charles Coleman. *Mr. Peale's Museum: Charles Willson Peale and the First Popular Museum of Natural Science and Art*. New York: W. W. Norton and Company, 1980.

Serrell, Beverly. *Exhibit Labels: An Interpretive Approach*. Walnut Creek, Calif.: Alta Mira Press, 1996.

————. *Making Exhibit Labels: A Step-by-Step Guide.* Nashville, Tenn.: American Association for State and Local History, 1983.

————. "Point-Counterpoint Quiz." *Current Trends in Audience Research and Evaluation,* vol. 7. Washington, D.C.: American Association of Museums Committee on Audience Research and Evaluation, 1993.

————. "Zoo Label Study at Brookfield Zoo." *International Zoo Yearbook* 21 (1981): 54-61.

————, and Barbara Becker. "Stuffed Birds on Sticks: Plans to Re-do the Animal Halls at Field Museum." *Visitor Studies: Theory, Research, and Practice,* vol. 3. Ed. Stephen Bitgood et al. Jacksonville, Ala.: Center for Social Design, 1990.

Shannon, Joseph. "The Icing Is Good, But the Cake Is Rotten." *Museum News* 52, no. 5 (1974): 29-34.

Shettel, Harris, et al. *Strategies for Determining Exhibit Effectiveness,* report no. AIR E95-4/68-FR (Washington, D.C.: American Institutes for Research, 1968).

Silverman, Lois. "Making Meaning Together: Lessons from the Field of American History." *Journal of Museum Education* 18, no. 3 (1993): 7-11.

————. "Of Us and Other 'Things': The Content and Functions of Talk by Adult Visitor Pairs in an Art and a History Museum." Ph.D. diss., Indiana University, 1991.

————. "Visitor Meaning-Making in Museums for a New Age." *Curator: The Museum Journal* 38, no. 3 (1995): 161-70.

Spinden, Herbert J. "The Curators in the New Public Museum." *Museum News* 18, no. 6 (1940): 7-8.

SRI Research Center. *Florida Tourism and Historic Sites: A Study Sponsored by Florida Department of State, Florida Department of Natural Resources, Florida Department of Commerce, National Trust for Historic Preservation.* Tallahassee: State of Florida, 1988.

Stapp, Carol B. "Defining Museum Literacy." *Journal of Museum Education* 9, no. 1 (1984): 3-4.

Stearn, William T. "An Introduction to the *Species Plantarum* and Cognate Botanical Works of Carl Linnaeus." In *Species Plantarum: A Facsimile of the First Edition, 1753,* 2 vols. London: Ray Society, 1957.

Stewart, Susan. *On Longing: Narratives of the Miniature, the Gigantic, the Souvenir, the Collection.* Baltimore: Johns Hopkins University Press, 1984.

Stites, Raymond. "Leisure Time and the Museum: A Reply." *Museum News* 41, no. 6 (1963): 29-33.

Stocking, George, ed. *Objects and Others: Essays on Museums and Material Culture.* Madison: University of Wisconsin Press, 1985.

Stone, Robert L., ed. *Essays on "The Closing of the American Mind."* Chicago: Chicago Review Press, 1989.

Taylor, Francis Henry. *Babel's Tower: The Dilemma of the Modern Museum.* New York: Columbia University Press, 1945.

————. "Museums in a Changing World." *Atlantic Monthly* 164, no. 6 (1939): 785-92.

Tayor, Samuel M. "Understanding Processes of Informal Education: A Naturalistic Study of Visitors to a Public Aquarium." Ph.D. diss., University of California, Berkeley, 1986.

Terrell, John. "Disneyland and the Future of Museum Anthropology." *American Anthropologist* 93, no. 1 (1991): 149-53.

Thier, Herbert D., and Marcia C. Linn. "The Value of Interactive Learning Experiences." *Curator* 19, no. 3 (1976): 233-45.

Truettner, William H., ed. *The West as America: Reinterpreting Images of the Frontier, 1820–1920.* Washington, D.C.: Smithsonian Institution Press, 1991.

Tucker, Louis Leonard. "'Ohio Show-Shop': The Western Museum of Cincinnati, 1820-1867." In *A Cabinet of Curiosities: Five Episodes in the Evolution of American Museums.* Ed. Walter Muir Whitehill. Charlottesville: University Press of Virginia, 1967.

Vygotsky, Lev. *Mind in Society: The Development of Higher Psychological Processes.* Ed. Michael Cole et al. Cambridge, Mass.: Harvard University Press, 1978.

Walker, John. "The Genesis of the National Gallery of Art." *Art in America* 32, no. 4 (1944): 157-77.

Wallace, Michael. "Visiting the Past: History Museums in the United States." In *Presenting the Past: Essays on History and the Public.* Ed. Susan Porter Benson, Stephen Brier, and Roy Rosenzweig. Philadelphia: Temple University Press, 1986.

Walsh, Amy, ed. *Insights: Museums, Visitors, Attitudes, Expectations—A Focus Group Experiment.* Los Angeles: Getty Center for Education in the Arts, 1991.

Washburn, Wilcomb. "Joseph Henry's Conception of the Purpose of the Smithsonian Institution." In *A Cabinet of Curiosities: Five Episodes in the Evolution of American Museums.* Ed. Walter Muir Whitehill. Charlottesville: University Press of Virginia, 1967.

————. "Professionalizing the Muses." *Museum News* 64, no. 2 (1985): 18-25, 70-71.

————. "Scholarship and the Museum." *Museum News* 40, no. 2 (1961): 16-19.

Weiner, George. "Why Johnny Can't Read Labels." *Curator* 6, no. 2 (1963): 143-56.

Williams, Patterson. "Making the Human Connection: A Label Experiment." In *The Sourcebook*. Washington, D.C.: American Association of Museums, 1989.

————. "Object Contemplation: Theory into Practice." *Journal of Museum Education* 9, no. 1 (1984): 10–14, 22.

Winchell, Newton Horace. *Museums and Their Purposes: A Lecture before the Saint Paul Academy of Sciences,* no. 1. St. Paul, Minn.: Brown, Treacy and Company, 1891.

Wittlin, Alma S. *The Museum: Its History and Its Tasks in Education.* London: Routledge and Kegan Paul, 1949.

————. *Museums: In Search of a Usable Future.* Cambridge, Mass.: MIT Press, 1970.

Wolf, Robert L., and Barbara L. Tymitz. *"Do Giraffes Ever Sit?": A Study of Visitor Perceptions at the National Zoological Park, Smithsonian Institution.* Washington, D.C.: Smithsonian Institution, 1979.

Worts, Douglas. "Extending the Frame: Forging a New Partnership with the Public." In *Art in Museums,* New Research in Museum Studies, an International Series, vol. 5. Ed. Susan Pearce. London and Atlantic Highlands, N.J.: Athlone, 1995.

Zeller, Terry. "The Historical and Philosophical Foundations of Art Museum Education in America." In *Museum Education: History, Theory, and Practice.* Ed. Nancy Berry and Susan Mayer. Reston, Va.: National Art Education Association, 1989.

————. "The Uncertain Profession: A Review." *Museum News* 65, no. 3 (1987): 17–28.

Index

AAM. *See* American Association of
Museums
Aborigine culture: Eurocentrist
prejudices, 125
Adam, T. R., 64, 95
Addams, Jane, 31
African American perspectives: Colonial
Williamsburg, 70
African art and artifacts, 76, 125
African people: Euro-Americans'
language representations, 100
Akeley, Carl, 95, 96
American Academy of Fine Arts, New
York, N.Y., 121
The American Art Museum (Pach), 64
American Association of Museums
(AAM), 34, 66, 123; Committee on
Education, 35, 65, 66, 150; establish-
ment, 32; Standing Professional
Committee on Museum Education,
66, 150
American Museum of Natural History,
New York, N.Y.: African Hall, 125;
founding of, 28
Andromeda polifolia, 106, 112

Anniston Museum of Natural History,
Anniston, Ala., 68
anthropomorphism: language of
Linnaeus, 51, 109, 112
art, works of: as aesthetic phenomena,
63-64; "canon" debate, 59, 76; insti-
tutionalization by museums, 76-77,
124-25, reflective artwork, 4, 76-77
Art Gallery of Ontario, Toronto,
Canada, 71
Art Institute of Chicago, Chicago, Ill.,
32, 62, 117; founding of, 28; Japanese
Buddhist art exhibit, 149
art museums: early establishments, 28-29,
92, 121; innovative programs, 61-64;
museum education study (1986), 6; vis-
itors' restorative experiences, 139. *See
also* Art Institute of Chicago; Boston
Museum of Fine Arts; Corcoran Gal-
lery; Denver Art Museum; Fine Arts
Museum; Metropolitan Museum of
Art; National Gallery of Art; National
Museum of American Art; Toledo
Museum of Art; Wichita Art Museum
authenticity studies, 94-104